**Norton
Museum of Art**

26043

D1294785

GREAT LAKES MUSE

American Scene Painting in the Upper Midwest

1910 - 1960

MICHAEL D. HALL AND PAT GLASCOCK

THE INLANDER COLLECTION
in THE FLINT INSTITUTE OF ARTS

Library of Congress Control Number: 2003113979

ISBN 0-939896-23-0 (pbk.)

ISBN 0-939896-24-9

Copyright 2003 Flint Institute of Arts

Director: John B. Henry, III

Curator of Collections and Exhibitions: Lisa Baylis Ashby

Funded by the Isabel Foundation, The Michigan Council for Arts & Cultural Affairs,
 Michael D. Hall and Pat Glascock

Printed in the United States by PrintComm, Inc.

10 9 8 7 6 5 4 3 2 1

Copyright ©2003 Flint Institute of Arts. All rights reserved. No part of this publication may be
reproduced in any form without the prior written consent of the Flint Institute of Arts, 1120 E.
Kersley Street, Flint, Michigan 48503-1991.

Front Cover: Edmund Brucker, *BAG EARS*, 1944. Oil on canvas, 40 x 24 inches.
 The Inlander Collection of Great Lakes Regional Painting

Back Cover: Edmund Lewandowski, *GREAT LAKES SHIPBUILDING*, 1949.
 Oil on canvas, 30 x 24 inches.
 The Inlander Collection of Great Lakes Regional Painting

Table of Contents

Acknowledgements

The Flint Institute of Arts is extremely pleased to present *The Inlander Collection of Great Lakes Regional Painting*, a special exhibition organized to celebrate the museum's seventy-fifth anniversary and the receipt of this significant collection of 105 works of art into the FIA's collection. We are most grateful to the Isabel Foundation for the permanent loan of the majority of works in this collection, and to Michael Hall and Patricia Glascock for their donation of a portion of it. The Inlander Collection comprehensively represents an important national and regional movement that took place in the first half of the twentieth century. It is most fitting that a regional museum such as the Flint Institute of Arts should have a strong collection of regional art and, through their generosity, we are well on our way.

The Flint Institute of Arts was founded in 1928 by a group of citizens who felt that the community needed a place where the public could be inspired and educated by art, and where students could pursue studio courses. In 1957, the FIA moved into its current location in the cultural and academic center of Flint, igniting activity in acquisitions, exhibitions, and educational programming. Major acquisitions in the past decade have again brought a period of significant enhancement to the permanent collection, as well as in the areas of exhibitions and educational programming—in all, attracting national and international recognition to the museum.

It was not until 1997, when the FIA presented the exhibition *Painters of the Great Lakes Scene: Highlights from the Inlander Collection of Great Lakes Regional Painting*, that the museum gave more serious consideration both to the importance of this material and to the further need to augment its holdings in the area. It is a museum's role to develop intuitions about what is and will be important in the history of art, and what should be collected and shared with its public. With the acquisition of the Inlander Collection, the FIA is fully recognizing the poignancy with which this material captures the American dilemmas and dreams of its time, its celebration of nationalism through the acceptance of our country's regional diversity, and the uniqueness and high quality of the art produced by these American artists and their contemporaries.

The Flint Institute of Arts is grateful to the Isabel Foundation for their permanent loan to the FIA of a very large portion of this important collection. We are also indebted to Michael Hall and Patricia Glascock for their recognition of the importance of regionalism in the history of American Art, for assembling this wonderful collection, for their generous donation of works of art to the FIA, and for their contributions to this publication.

I extend my appreciation to the curatorial staff at the Flint Institute of Arts, including Regina Schreck, Michael Martin, Duncan Cardillo, Bryan Christie, and Donald Howell, for their collaborative efforts in planning and implementing this publication and the exhibition that it accompanies. The FIA is also grateful to PrintComm for their efforts to produce this publication. We also acknowledge Charles H. Cloud III and Paul Primeau, who photographed all of the artwork for this book, Nannette V. Maciejunes for her insightful introduction, and Martin Fox for his thoughtful editing of the text. Finally, I would like to thank the FIA's Director, John B. Henry III, whose knowledge, insight, and vision identified both the importance of acquiring this collection and the interpretation of its beauty and meaning within the context of the FIA's collection.

Lisa Baylis Ashby
Curator of Collections and Exhibitions:
Flint Institute of Arts

Preface

It is with great enthusiasm and appreciation that the Flint Institute of Arts presents *The Inlander Collection of Great Lakes Regional Painting* on the occasion of our seventy-fifth anniversary. Assembled over the past decade by the intuitive and discriminating collectors, Michael Hall and Pat Glascock, the collection has become part of the FIA's permanent collection. The majority is housed at the FIA on permanent loan from the Isabel Foundation, which purchased the collection for the express purpose of enhancing the FIA's collection of regional art. As Claire White, President of the Isabel Foundation, observed: "The FIA's permanent collection is an important window on our world. The Inlander Collection of Great Lakes Regional Painting will create a view of a region in which Flint has played a major role. This was a rare opportunity to acquire such a comprehensive and astutely assembled collection. The Isabel Foundation, which Harding Mott established and named for his wife, is happy to have a part in adding significant works of art to the FIA's already outstanding collection." The remaining fifteen paintings came to the FIA's permanent collection as a gift from Michael Hall and Pat Glascock. The loan and gift will be an outstanding complement to the FIA's exceptional collection of American Art.

The 105 paintings in the Inlander Collection form a remarkable tribute to sixty artists working in the region between 1910 and 1960. The collection is defined geographically, featuring artists who worked in those states surrounding the Great Lakes basin: Minnesota, Wisconsin, Michigan, Illinois, Indiana, Ohio, Pennsylvania, and New York. All of the artists had formal training, here or abroad, and many had met or worked with art world notables such as Frank Duveneck, William Merritt Chase, Robert Henri, Hans Hofmann, John Sloan, and William Zorach. Their work had been exhibited and collected by some of the country's most prestigious institutions: the Metropolitan Museum of Art, the Whitney Museum of American Art, the Pennsylvania Academy of the Fine Arts, the Art Institute of Chicago, the Detroit Institute of Arts, and the Cleveland Museum of Art, yet they chose to make art in a region outside of the mainstream.

The Inlander Collection is also a tribute to the region itself, strong in tradition, rich in subject matter, and proud in spirit.

The half-century of time represented by these paintings is arguably a period of the greatest changes to the land, its people, their work, and their play—changes brought about by wars, by recession and prosperity, by industry, and by innovation. Changes occurred within the art world during these decades as well, stimulated by influences from abroad, shifts in aesthetic philosophies, and artistic experimentation. Intense observations of an evolving region combined with the personal commitment to portray the American heartland led to the creation by Great Lakes artists of images with a distinct regional character. Immersed in the milieu, many were compelled to seek and portray the unaffected truth of a place understood fully only by living there. The Inlander Collection is remarkably balanced in its portrayal of place and time, as well as its selection of artists from within the region. It will become not only a major resource for scholars, but also a core onto which to add other regional paintings in the years to come.

Flint is at the epicenter of the Great Lakes region, as defined by the collection. As Claire White pointed out, the region around the city has provided subjects and inspiration for artists in the Inlander Collection. Carved out of a woodland wilderness, Flint was first a lumber town; then a carriage town; then an automobile town; and then a labor town. Flint played a part in both world wars through its people and its industrial know-how. Like many cities in the region, its people are born here, have simple pleasures, are hard working, raise families, and live out their lives here. Flint is also a town with a longstanding commitment to culture and the arts. Seventy-five years ago, the Flint Institute of Arts began offering classes to area artists. Over the years, thousands of artists participated in classes at the Institute, some of whose works can be found in the Inlander Collection. Through it, the FIA now has the opportunity to portray a place in time that Flint played a significant role in forming. The Inlander Collection of Great Lakes Regional Painting will reflect the pride that the Institute takes in serving the region in its galleries, as well as its classrooms.

John B. Henry III
Director: Flint Institute of Arts

Introduction

"Context" for (Michael) Hall is clearly a metaphor for community,
and the cultural object for the self. Both are more clearly in analytic
focus when they are experienced through participation rather than
abstractly.

— Donald Kuspit, preface, *Stereoscopic Perspective:*
Reflections on American Fine and Folk Art, 1988

I often use very ordinary local subjects in my artwork. I filter my real
experience through my imagination, memories and cultural beliefs.
Some images in my work document observed regional scenes, while
others represent a "reality" I create.

— Pat Glascock, artist statement,
The Genius of Place, 1997

Collectors are a breed apart. The world at large often identifies collectors with their collections. Many collectors, however, frequently find themselves defined less by what they collect, than by the activity of collecting itself. It is the meaning with which collectors invest their collections that truly defines collecting as a highly personal activity. Collecting becomes an integral part of a collector's sense of self. A collection can become literally an "autobiography in objects," affirming a journey of self-discovery that links the collector's past, present and future. The objects in the collection are not simply possessions to own, but touchstones in the narrative of an interior life.[1] Collecting is at its heart an act of imagination and a highly personal expression of creativity.

As collectors, Michael Hall and Pat Glascock have come to appreciate the Inlander Collection as something much more than a unique re-creation of an historic moment in the art world of the Great Lakes states. They have come to see it as an extension of their own identity as artists now living and working in that same region. Pat is a painter, who works chiefly in water-based media, and Michael is a sculptor who headed the Cranbrook Academy of Art sculpture program for two decades. Michael is also well known as a collector of

American folk art. The Inlander Collection is very much about Michael and Pat's journey as a couple. Indeed, their relationship and the collection were born in late 1990 at almost the same moment. The Collection provided an opportunity for them to start something new together—to explore a subject about which neither of them had extensive knowledge and to which both brought unique perspectives.

Michael's experience as a veteran collector of folk art had significant, but ultimately limited, relevance to the challenge of collecting American Scene painting. His initial insight into the parallel issues of place and community that inform both folk art and regional art was useful to his new collecting focus. In addition, his drive to develop intellectual constructs guided his effort to establish the conceptual parameters of the new collection. The historic art world of the Great Lakes and the American Scene, however, was as foreign to him as it was to Pat as a novice collector. Indeed it would be Pat's astute eye as a painter and her intimate knowledge of watercolor and its traditions that would prove invaluable as they discovered the central importance of watercolor in the art culture of the Upper Midwest. The Inlander Collection is the result of a true partnership, and as someone who has witnessed the develop-

[1] These observations are based on recent literature on the subject of collecting, see Susan Pearce, *Museums, Objects and Collections: A Cultural Study* (Leicester, 1992), Susan Pearce, *On Collecting: An Investigation into Collecting in the European Tradition* (New York, 1995) and Susan Stewart, *On Longing: Narratives of the Miniature, the Gigantic, the Souvenir, the Collection* (Baltimore and London, 1984).

ment and refinement of the Collection, I know that the distinc-
tive texture of the Collection would be different if it had been
formed by either of them alone. (fig. 1)

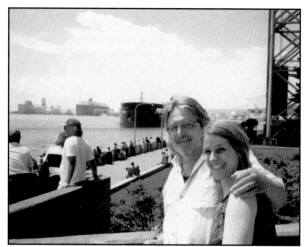

*Fig. 1. Pat Glascock and Michael Hall on a site research trip to
Duluth, Minnesota, July 2000. Documentation for the painting: ORE
DOCKS, DULUTH by Constance Richardson (plate 12)*

Eight years ago, I invited Michael to join me as co-curator for
the 1997 exhibition, *The Paintings of Charles Burchfield:
North by Midwest*, which was organized by the Columbus
Museum of Art and toured to the National Museum of
American Art. This exhibition presented a new interpretation
of Burchfield that embraced for the first time his role as a
founder of the American Scene. Michael also served with me
on the curatorial team for the 2000 exhibition *Illusions of
Eden: Visions of the American Heartland*, which toured the
U.S. and Europe, bringing a new view of historic and contem-
porary Midwest regionalism to an international audience.
Although Pat had an unofficial role in both projects, her
thoughts, insights and prodding questions are everywhere
apparent in both exhibitions.

The status-quo challenging scholarship that emerged from
these exhibitions benefited immeasurably from the simultane-
ous development of the Inlander Collection. The Collection
in turn benefited from the on going curatorial work. The
Burchfield exhibition served as the first formal test in which
the known biography of a major figure from the region could
be compared against those of the numerous less well-known
contemporaries in whose work Michael and Pat found them-
selves immersed. Many of the new ideas about the American
Scene that were first explored in the Burchfield exhibition
were expanded to provide the conceptual framework for

Illusions of Eden. For Michael and Pat, this second exhibition
created an opportunity to compare what was going on in the
Upper Midwest against the broader Midwest region, and to
see if the paintings they were collecting held up aesthetically
against the acknowledged regionalist classics from the more
familiar Central Plains region often designated as the Corn
Belt. Seen in the context of *Illusions of Eden*, the paintings
of the Great Lakes, we all realized, not only held up, but
completed a picture of the Midwest, which is both rural and
urban, agricultural and industrial.

Like many collectors, Michael and Pat describe their collect-
ing experience as a voyage of discovery—in their case a
learning process by which they re-imagined the art culture of
the Great Lakes in the first half of the twentieth century "city
and hamlet by city and hamlet." The Collection's origins lay
in two early acquisitions that helped define the direction the
Collection would ultimately take. The first was a painting by
Carl Hall entitled *Lot For Sale* (plate 100). Stumbled upon in
a local art sale in Michigan, the painting, they immediately
realized, was the work of a trained artist—moreover a talent-
ed, trained artist they had never heard of. This realization
was followed by a quick trip to the library to discover exactly
who Carl Hall was and an equally quick return trip to the
sale "to snatch up the painting before anyone else could."
Although Michael and Pat had already dabbled in collecting
anonymous regional works found in thrift stores and antique
malls, they realized with the Carl Hall purchase that those
pictures lacked a sustained connection to a regional and a
national context of community. Unlike the paintings by quirky
amateurs they had acquired previously, the painting by Carl
Hall was about something much more than just itself or what
a viewer could impose upon it. It existed as part of a real art
world that Michael and Pat wanted to connect to their own
regional art experiences.

The other painting was Charles Burchfield's 1917 *Brick Kiln
in Autumn* (plate 40), which like the Carl Hall is still in the
Collection. Purchased in New York from the dealer for the
artist's estate, Michael was first attracted to the painting
because he was considering writing a book on American pot-
tery face vessels. He thought the painting, whose subject is an
Ohio kiln, would make a perfect illustration for the back of
the book jacket. He was both amused and somewhat horrified
by the loss of local knowledge reflected in the title the paint-
ing bore at the time—*Building With Domed Top*. Because of

his folk art background, Michael was also attracted to Burchfield's reputation as something of an art world outsider, who was absorbed in nature and his own childhood memories. Only after he acquired the painting did he begin to consider its importance in relationship to his new interest in regionalism. Through conversations with Pat, who was familiar from her own training with the watercolor tradition to which Burchfield was connected, Michael was also introduced to a Burchfield who was very much a part of the art world.

The Burchfield watercolor focused Michael and Pat's attention on what would become another key focus for the collection—the celebration of the local. Burchfield introduced them to the poetry of place. My memories of Michael and Pat during their first years of collecting include the photo album of the Collection that they carried with them everywhere, which paired each painting with a photograph of the site it depicted. It always seemed to me that a new acquisition only truly became part of the Collection for them after they had made a pilgrimage to the locale that had inspired it. The Collection's sympathy with place, however, was always more than a simple formula of this equals that. The specificity of place also revealed the artist's eye, letting the viewer truly appreciate, as Michael and Pat did, the fact that painters never merely paint just what they see.

Learning the region and its artists took time. What Michael and Pat still felt was something of a conundrum in 1992, a puzzle whose pieces did not quite fit together, by 1994 had developed into what they considered to be "a fairly enlightened hit list." They had sorted out the region's various centers and identified Chicago and Cleveland as its two leading hubs. They had targeted the major artists who needed to be represented in the Collection, developing what they called their "must have list." In time they began to consider the balances and tensions within the Collection. The various interwoven layers—of style, geography, gender, and ethnicity—that needed to exist in the Collection for it to become a true composite portrait of the modern Great Lakes region. They briefly toyed with the idea of including the Canadian side of the Great Lakes in the Collection or expanding its media to include not only unique works on paper, but prints. In the end, they chose to do neither.

In the course of their search, they discovered that a wealth of knowledge could be unearthed about the art culture of the

Great Lakes—the problem was that the information had remained isolated in local communities. The collectors, dealers, and scholars who knew Chicago of the 1920s and 1930s, knew nothing of the contemporary art world of Cleveland, Milwaukee or Detroit—and, of course, the reverse was just as true. Traversing the region again and again, Michael and Pat became acquainted with a host of dealers, collectors, librarians, dilettantes and scholars who had varying interests in regional art. They also sought out surviving Great Lakes artists from the era of the American Scene and interviewed them in order to better appreciate their work. (fig. 2) From these contacts and alliances they created the network they needed to become authorities on the entire region. They came to decipher the connections between the communities of the Upper Midwest; to trace the lineage and bloodlines of its artists, the schools where they trained and the galleries and museums that exhibited their work; and to understand the attitudes and values that shaped the region's cultural identity. An integral counterpart of the Collection became the library and extensive documentary files that Michael and Pat compiled to support it.

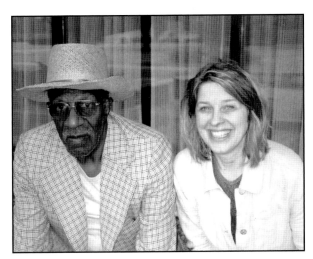

Fig. 2. Pat Glascock and artist Roman Johnson. A conversation with an Inlander painter in Columbus, Ohio, July 2003. Documentation for the painting: DAD by Roman Johnson (plate 33)

As they expanded and refined the collection, Michael and Pat remained steadfast to the three parameters that had originally inspired them—their working definition of the Collection demanded three things: First; that each painting be from the hand of a known artist. Second; that each artist in the collection have some professional training and be part of a real and knowable art world. Third; that the subject of the work be a real person and/or place from the Great Lakes region.

Financial resources and the availability of paintings then imposed further constraints. Despite the intensely focused nature of their quest, their search also had to remain flexible; the plan had to allow for unexpected opportunities. The Collection grew in fits and starts. There was always a process of trial and error—with a fair share of both bum leads and productive tips. Most importantly, however, Michael and Pat believed that they had to be sure to "listen to the pictures" that they were finding. If they failed to listen, they knew that instead of discovering the vitality of a real art world, they would begin imposing themselves on the material and in the end the Collection would be poorer because "they would find only what they had gone looking for."

The Collection has born the title—The Inlander Collection—since its earliest days. The phrase is taken from a passage in Charles Burchfield's journal, in which he describes himself as an inlander. The passage, cited at the opening of Michael's essay that follows this introduction, holds considerable meaning for both collectors. In it, they hear an early modern regional artist assert a sense of self that is inexorably bound to a sense of place. Designating their ensemble of oils and watercolors as the Inlander Collection, Michael and Pat acknowledge the specific regional identity of the works they have brought together. I can think of no more fitting title for a collection that celebrates the passion of two Michigan artist/collectors for the same region that once inspired the Ohio inlander Charles Burchfield.

Nannette V. Maciejunes
Acting Executive Director:
Columbus Museum of Art, Ohio

Inlanders and the American Scene:
Modern Great Lakes Painting

I will always be an inlander in spirit. The ocean … does not lure my imagination. Without discounting its awe-inspiring grandeur, it is not for me, and surely it has a worthy rival in a hay or wheat field on a bright windy day.

— Charles Burchfield, journal entry, July 12, 1954

When he wrote his reflection on being an inlander, Charles Burchfield was looking back on sixty-one years of his life and articulating something he understood to be fundamental to his identity. This was the same Charles Burchfield who, in one version of art history is identified as a pioneer American modernist and, in others, as a father of the American regionalist movement. In the big picture, he was both, but more importantly, to himself, he was an inlander. By 1954 Burchfield had concluded that his identity had everything to do with an idea of self that could not be separated from an idea of place. The modernist and the regionalist in him were both entwined in his identity as an inlander. The complete Burchfield was the inlander who recorded his experience of modern America as a regional painter in eastern Ohio and western New York State. At the end of his life, Burchfield could look back over a long historic confluence in which his personal experience of self and place became part of a much larger panorama of experience in which thousands of artists across the United States had collectively defined and imagined modern America.

The Inlander Collection presents part of that panorama in a selection of oil paintings and watercolors created by a group of very diverse painters active in the Great Lakes basin between 1910 and 1960. Broadly speaking, the Inlander Collection is an assembly of landscape paintings that address the issue of place as it informs American cultural identity. The Collection is also a text written by artists attempting to center themselves and their regional/local communities with-

in a changing political, technological and cultural American geography. Finally, the Collection is a visual record of the aesthetic issues that attended the coming of age of modern America. It surveys the modern art of inlander painters like Charles Burchfield and it celebrates the desire to "paint America" that inspired the art of the American Scene.

The American Scene

The term, "American Scene," emerged in the early 1930s as a popular characterization of the native subject matter beginning to dominate mainstream American art. Intrigued and flattered by the recently discovered "art-worthiness" of homegrown American subjects, critics and commentators of the day proclaimed the American Scene to be a new artistic expression in which the national spirit of America and its people was finding a voice. They rallied to the work of artists inspired by the American "scene" instead of, say, the Parisian scene or the British scene or any other non-native source. Though never expressly defined as a pictorial style or a specific genre, the American Scene nonetheless became a catch-all reference for "the majority of representational pictures produced in the United States during the 1930s."[1]

From the start, the term "the American Scene" was arbitrary and simplistic. Its arbitrary presumption that the American themes and subjects portrayed in paintings of the thirties were new ignored the fact that serious American artists had been painting American subjects for decades. The popular usage of the term as a ubiquitous label that lumped all kinds

[1] Nancy Heller and Julia Williams, *Painters of the American Scene* (New York, 1982), p. 17.

of artists together into a big amorphous movement was simplistic. Real confusion set in when it occurred to someone to clarify the term by taxonomically splitting the American Scene into two antithetical subcategories. Paintings depicting rural and small-town America (usually scenes from the agricultural Midwest) were classified under the rubric of regionalism. Those documenting the inequality and injustice in American society (usually images from the urban Northeast) were designated as social realism. In short order, this bifurcation polarized the idiom's appeal and forever set one group of artists and their work over and against another. After 1950, the whole confused and fractured issue of the American Scene went into the dustbin of history. Tainted by its evocation of the Great Depression and sundered by the sectional and ideological schisms built into its binary identity, the American Scene has generally been dismissed as an embarrassing, misguided period style. It has survived as little more than a footnote in most texts on American art published over the past forty years.

There are, however, reasons to reconsider and even rehabilitate the American Scene. Early twentieth-century American artists did put a lot of effort into an extended search for their artistic self-identity and that search did create a mountain of works addressed to American subjects—particularly landscapes. The sheer number and quality of these works begs a reassessment of the social and artistic forces that brought them into being and which may, perhaps, direct them to some new utility in our own time.

To do this effectively, the idea of the American Scene needs to be broadened and extended. Though the accepted time frame delimiting the American Scene was the decade of the 1930s, the cultural and artistic impulses that spawned it began well before the World War I and sustained it beyond the Korean War. From the late nineteenth century on, American artists sought to imagine and create a uniquely American art that would exalt the cultural identity of their nation. Winslow Homer's realist style was applauded as characteristically American by the critics and connoisseurs of his era.[2] By the time George Bellows and the Ashcan painters of New York had retooled realism for the twentieth century, the dream of a uniquely American art was widespread among American painters. The Ashcan School and others turned to American subject matter in an effort to reveal something loosely identified as the American character. Convinced that place and identity were conditions of each other, they came to envision the painting of their native landscape as an affirmation of themselves. This perception was not restricted to artists from the realist tradition. The modernists in the circle around Alfred Stieglitz in New York during the 1920s also believed that American art would inevitably have to grow from an American soil. In her recent study of these East Coast modernists, art historian Wanda Corn noted:

> The second Stieglitz circle put the word "place" in the same celestial orbit as "soil" and "spirit." The concept was sacred to them, describing both their philosophy and practice. As philosophy, place connoted commitment to drawing one's art from deep personal experience with an American locale—not from imagination or from literature but from a sustained engagement with some small piece of the planet…As practice it meant not traveling here and there looking for picturesque subjects, and certainly not living abroad, but settling in, and having continual and repeated contact with, a particular geographical space…[3]

This place-linked search for identity undertaken by early twentieth century American artists of every stripe essentially set the course for the history of modern American painting.

Though the Americanness the early painters sought can be retrospectively criticized as a rather narrowly defined commodity, their search itself was a heady and important cultural enterprise in its time. It was not without a down side, of course. Predictably, the quest for America did produce a healthy measure of nationalistic rhetoric and boosterism. This rhetoric, in turn, conspired to render the matter of place and identity increasingly problematic as the fascists in Europe began to exploit the propaganda value of nationalist art. The dark legacy of the project initiated by the modernists and the realists of the early American Scene was the perpetuation of "the ubiquitous importance attached to place and race."[4] The negative critique of the American Scene has always centered on the question of just exactly whose America the early modern American painters identified and celebrated in their art. Without question, power, ignorance, insensitivity and prejudice did exclude disempowered and dispossessed minorities. However, a fully pluralist modern world was then (and still is) a work in progress. Finding inspiration in their particular American scene, the Ashcan painters, the Stieglitz modernists, and others in their time collectively articulated an idea of art as a culturally prescribed and socially addressed activity that would evolve into an ethos embraced by most American painters through the first half of the twentieth century.

[2]See Bruce Robertson, *Reckoning with Winslow Homer: His Late Paintings and Their Influence* (Cleveland, 1990), pp. 148–49.
[3]Wanda Corn, *The Great American Thing: Modern Art and National Identity, 1915–1935* (Berkeley, 1999), p. 249.
[4]Robertson, p. 67.

To focus on the issues of art, self, and place within the specific context of Great Lakes modern art, the Inlander Collection takes an inclusive historical view of the American Scene. The early paintings in the Collection speak to the first stirrings of interest in regional subject matter in the modern painting traditions of the Great Lakes region. The late paintings witness to the durability of the American Scene in the Upper Midwest well into the 1950s. The year 1910 was selected to mark the beginning of the history narrated in the Collection because it was a year that would directly connect Great Lakes painting to the larger currents of regional modern painting being produced elsewhere in the United States. In the winter of 1910, George Bellows surveyed a snowy scene in a local New York park and painted his atmospheric, realist landscape, *Blue Snow, The Battery*. (fig. 3) At almost the same time, Aaron Harry Gorson in Pittsburgh was inspired to paint his moody tonalist industrial scene, *Barges Passing Under a Bridge*. (plate 78) Only three years later, William Sommer was painting a bright postimpressionist depiction of his Cleveland, Ohio, backyard entitled *The Rabbit Hutch*. (plate 39) American Scene painting had taken root in the Upper Midwest.

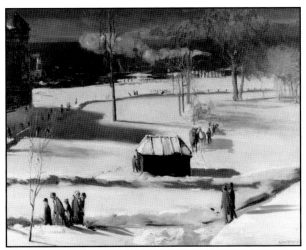

Fig. 3. George Bellows (1882–1925) BLUE SNOW, THE BATTERY, 1910. Oil on canvas. 34" x 44" Columbus Museum of Art, Ohio: Museum Purchase, Howald Fund.

The Inlander Collection includes works from the hands of a very heterogeneous company of artists, each with a distinctive political and artistic temper. Some of the works could be described as radical, others as reactionary. Some express a high measure of singular vision; others are more communitarian in spirit. Some of the paintings reflect the optimism of artists who viewed the modern age as a positive thing; others

betray a skepticism that borders on a kind of anti-modernism. Finally, certain works in the Collection express the passions of artists who were actively engaged in the social and political culture of their time, while others display a quiet remove. Throughout, the Collection suggests that the modern art of the Upper Midwest was peculiarly synthetic. The cliché-ridden "regionalists vs. social realists" understanding of the American Scene doesn't particularly advance a study of Great Lakes modern painting. The artists who created it were not, for the most part, ideologues—they were painters.[5] They were artists fascinated with the world as they observed it and deeply committed to the images they created on their canvases.

Beginnings

Through the first half of the twentieth century, American Scene painters in the Great Lakes region were not alone in their artistic efforts to understand their changing world. American artists and writers everywhere participated in the chronicling of their nation's coming of age. A changing world demanded a new identity and in the second decade of the new century, local and regional identity was being reshaped and newly asserted all across the United States. Major cities throughout the country began to sponsor professional sports teams that were passionately adored by their local fans. Architects began constructing the tall buildings that individuated the skylines of the large cities that were becoming America's regional hubs. Similarly, great art museums were built to house prestigious artifacts that signaled the cultural awareness of the nation's bustling new heartland metropolises. The sports teams, skyscrapers, and museums that would identify the major cities of the Great Lakes region were almost all in place by the 1930s. In the same period, the country was also experiencing enormous population shifts. By 1935, one out of every three Americans lived in the region bounded by the Great Lakes to the north, the Appalachian Mountains to the east, the Ohio River to the south and the Mississippi River to the west (fig. 4).

As the Great Lakes region built its modern identity, its artists responded. From the region's smoke-filled and frequently leaden skies, they derived a distinctive tonal palette favoring subtle grays and browns over strong blues and yellows. From the immigrant populations of their cities and small towns, they selected the cast of characters who animated their muted scenes. From the imposing freighters, bridges, blast furnaces,

[5] Aaron Bohrod, interview with the author, Madison, Wisconsin, Sept. 22, 1991.

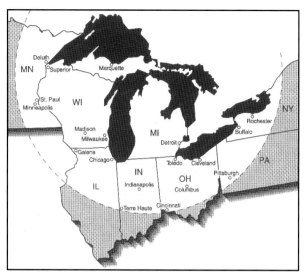

Fig. 4. The Great Lakes Basin. The geographic area surveyed by The Inlander Collection.

and grain elevators that supported the commerce of their region, they developed the icons that became the signature forms of their most distinctive pictures. In exactly the same spirit of nationalism that had shaped so much American art since Winslow Homer, the modern painters of the Upper Midwest dreamed of providing their nation a glimpse of its longed-for oneness.

A Landscape Tradition

Americans have always been preoccupied with their country's landscape. For them, land has symbolic as well as economic value. The diaries of eighteenth- and nineteenth-century travelers are filled with long descriptive passages concerning the land—its bounty, its beauty, and the spectacle of its natural monuments. In the nineteenth century, folk limners created hundreds of paintings depicting the harbors and hills of New England, the wilderness in the Hudson River Valley, and, of course, Niagara Falls. Their professionally trained contemporaries also painted Niagara and the Hudson Valley along with a whole array of scenic wonders they found in the American West. For all these artists and for their audiences, landscape was a symbol of the *idea* of America, and a metaphor for the renewal Americans could expect to experience in the New World.

Inheriting a landscape tradition in which place and identity were strongly linked, the Great Lakes artists of the twentieth century took their cues from both the popular and the elite traditions of their land—traditions that were literary and political as well as artistic. Representations of place, invested

with meaning, pervade modern Great Lakes pictures. Driftwood-strewn shorelines, flooding rivers, and ripening fields of wheat were all subjects that were attractive to the eyes of inlander painters. To them, these subjects symbolized the uniquely American richness and vitality of the Upper Midwest. Similarly, views of cities, factories, steel mills, and lake freighters spoke to their ideas of American ambition, inventiveness, and progress. Great Lakes painters even found wonder and identity in seemingly prosaic scenes filled with signs of home and family. They painted views of the back streets of their towns, the shops and bars in their neighborhoods and even their own cluttered backyards.

The landscape tradition in Great Lakes art was a tradition rooted in the idea of home. Eschewing European subjects (particular those associated with Paris) the painters of the American Scene have often been accused of being artistic and political isolationists. In point of fact, however, they were probably less concerned with rejecting foreign associations than they were with the discovery of the wonders in the world with which they were most familiar. Great Lakes painters in particular, were not so much hostile to European art as they were circumspect about the elitism that privileged European culture in the minds of so many museum directors and collectors. The American Scene artists were, after all, part of the groundswell of populism and egalitarianism that arose in the heady opening decades of the modern age. Their art flourished in the proletarian, populist soils of the Upper Midwest.

Local Identity

In 1920, the American philosopher John Dewey proclaimed: "The country is a spread of localities." Dewey's assessment of America seems as true today as it was in 1920. A national Social Security system and the dream of universal health care have not changed the fact that the American experience remains one of multiplicity. The motto, "E Pluribus Unum," reminds us that our nation is a multifaceted social and political entity scattered across a large and topographically varied land mass. American art, however, posits a conundrum in which "pluribus" and "unum" are distinctly at odds. In American art, the idea of the local has always been problematic. A nation seeking to establish a recognizable artistic identity for itself has been loath to acknowledge any localisms that would pluralize (and some would contend, mongrelize) its art. In the interest of concision, American visual culture has traditionally been packaged into a linear

and hierarchical history constructed as a progression of art styles sequenced into a mainstream narrative. The mainstream narrative, in turn, perpetuates itself by dismissing or ignoring anything outside of its purview. Still, (and here is the rub) in terms of their political expectations, Americans dream of a democratic, egalitarian and nonlinear world where individualism and local variation prevail over conformity and hegemony. In this dream, pluralism is a good thing wherein the local spawns (and nurtures) the conditions of difference that make pluralism a reality. Our response to the contradiction posed by our art history is generally ambivalent. The modern American art community has been alternately thrilled and appalled by the possibility that something of artistic value could come out of the American provinces.

A different but correlate issue comes into play when a monolithic art history posits abstract art as the mode of visual expression better suited to the representation of a sophisticated modern era than more representational art styles. Americans have tended to resist this idea. Modern Americans in general have had a difficult time reconciling the transcendent vision of abstract art with the particular, and often prosaic, day-to-day living of their own American experience. For example, though the taming of the American frontier can be abstracted as a mythology of manifest destiny, it was actually accomplished in a process that entailed the building of frontier cabins, one cabin at a time, and the establishment of settlements, one at a time. Similarly, if great cities and skyscrapers abstractly identify the modern American skyline, most Americans actually witness the creation of this skyline

as a plodding girder-by-girder enterprise of construction. Thus, although the painters John Marin, Joseph Stella, and Georgia O'Keeffe could abstract modern architecture into mountains and canyons of planes and cubes, other artists from the same period chose to depict the same modern structures naturalistically as walls, pilasters, cornices and windows. The latter group in no way can be said to have derived their art from any less modern a world.

The painters of the American Scene generally endorsed the credo, "to know a city is to know its streets." This approach inclined them to construct pictorial images shaped by what anthropologist Clifford Geertz calls "local knowledge."[6] For many of them, a painter's local knowledge was presumed to be the shaping force that would give specific character or spirit to a painting. These artists felt that local knowledge was something worthy—something not achieved through tourism, but garnered experientially over time. Most importantly, they recognized local knowledge as concrete—not abstract. Regional painting asserts its identity in terms of the concrete information that informs its imagery. It also connects with its local audience in terms of its specifics. (fig. 5a, 5b)

In yet another appropriation of their area's localisms, the painters of the American Scene often portrayed the landscapes in their workaday world as places inhabited by local people with whom they felt a certain kinship. In such works, the artists, their subjects, and their audiences were conjoined by the durable communitarian American social spirit (especially strong in the Midwest) already identified as an

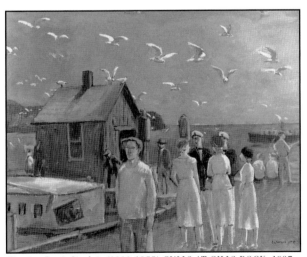

Fig. 5a. Gerrit Sinclair (1890-1955) GULLS AT GILLS ROCK, 1937. Oil on masonite. 20" x 24". Inlander Collection.

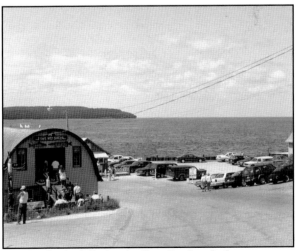

Fig. 5b. Inlander Collection site: Green Bay from the ferry ramp at Gills Rock, Wisconsin, 1992. Documentation for the painting: GULLS AT GILLS ROCK by Gerrit Sinclair.

[6]Clifford Geertz, *Local Knowledge: Further Essays in Interpretive Anthropology* (New York, 1983), p. 167.

American trait in the early nineteenth century by observers such as Alexis de Tocqueville. The artistic challenge facing American Scene painters was one of creating works filled with specific, local details that would somehow transcend specifics and communicate in the realm of the universal. Some were more successful in this than others. Historically, however, the self-consciously registered local knowledge in many American paintings produced from the time of World War I until well into the 1950s is the hallmark of a certain nonlinear American art history endlessly intersecting (and even contradicting) the official mainstream narrative.

The poetic case for the local was, perhaps, best articulated in 1938 by a curator in Buffalo named Gordon Washburn. In his introduction to the catalogue that accompanied the *Great Lakes Exhibition 1938–1939*, Washburn discussed the aesthetic power he felt had been harnessed by the Buffalo painter Charles Burchfield in his depictions of his region:

> *Where others have seen the picturesqueness of local houses and back dooryards, Charles Burchfield has, through a real love of them, penetrated into their very being until they would seem to have replaced for a time the actual tissues of his mind. In fact we sometimes feel, glancing at old houses in his neighborhood, that he must have built them himself, so much more clear to us is his vision of them transmitted through his pictures, than are the original objects of his affection.*[7]

Politics and Paintings

There is definitely a political turn to the act of defining American Scene painting as modern art. Two fundamental American beliefs collide when this idea enters any conversation on American art. The sacred cow of progress finds itself confronting the equally sacred cow of democracy. Modernism, as a style, has tended to find its support among a cultural elite. Through much of the twentieth century, this elite posited abstraction as the progressive mode of art. Each new modernist style regarded as a "breakthrough" was moved to the forefront of a history of presumed artistic progress. This model, however, fails when judged by democratic and pluralist ideas of what art is and how it functions in society. If the political goal of modern democracy is the creation of a more egalitarian world, then both artistic achievement and vision must be expected to evidence themselves broadly and to take many forms. They would also be expected to serve multiple (and interpenetrating) systems of taste and consumption. In short, an egalitarian vision presumes that talent and creativity are distributed randomly through a sociocultural matrix and that art, as a social production, cannot be elite or exclusive and still serve a democracy. Thus, given its democratic sympathies, American Scene painting subverts the presumed leadership of official modernism in a politicized mythology of cultural advancement and progress.

The regional disposition that shaped much of the art of the Great Lakes was not just a product of elite versus populist aesthetic agendas. It also entailed a measure of class distinction that caused the Great Lakes painters themselves to be indifferent (if not slightly hostile) to authority based on class and privilege. Their biographies provide some insight into the source of this bias. In general, they saw the world from a Main-Street perspective. Few of them belonged to the class of wellborn or well-married painters associated with the art scenes in New York, Gloucester, Taos, and Provincetown. They came from (and remained part of) the working middle class. Burchfield designed wallpaper in Buffalo until his art began to support him. Kenneth Wood in Cleveland worked as a commercial artist until retirement. Zoltan Sepeshy, Carl Gaertner, Gerrit Sinclair, Ethel Spears, and many others were all teachers through most of their careers. Finally, Lawrence McConaha was a telegraph operator for an Indiana brokerage house who painted at night and on weekends.

The decade of the 1930s was a uniquely democratic period for artists in the United States. Art clubs and watercolor societies proliferated through the era, welcoming amateurs and professionals alike. A good number of women gained recognition among the first ranks of American artists. When the organizers of the 1939 New York World's Fair compiled a roster of painters for the *American Art Today* exhibition, one out of every six names on the list was a woman's. In the *Great Lakes Exhibition 1938–1939*, the ratio was better than one out of four. The World's Fair roster also revealed considerable ethnic diversity. This pattern was consistent in the Upper Midwest, where, through the era, Anglo American painters shared recognition with artists of German, Polish, African, Italian, Hispanic, and Scandinavian descent. As Great Lakes industry and agriculture grew, immigrants from eastern and northern Europe and African Americans from the southern United States arrived seeking jobs. Their children became the region's artists. Recently, the cultural historian Bram Dijkstra has argued that the children of immigrants perceived the American myth of self-reliance as "quite meaningless

[7] Gordon Washburn, "An Artists' Society Sponsors a Regional Show," *in Great Lakes Exhibition 1938–1939* (Buffalo, 1938), n.p.

without a concept of community. . . This fundamental recognition produced a generation of humanists, of idealists, of people who were able to see beyond themselves."[8] This sense of identity, as it attended the immigrant experience in the Great Lakes region, was complemented by another factor that also maintained a sense of community. As the demographic complexion of the area changed with each influx of newcomers, one thing remained constant: the blue-collar ethos that gave the Upper Midwest its enduring cultural identity. This ethos is reflected everywhere in the paintings produced by the Great Lakes artists of the American Scene.

A Matter of Style

The question of style in American Scene painting is a complex subject obscured by much historical baggage. For decades, American Scene painting has been characterized as academic and banal. Upon close inspection, however, regional modern paintings from the Great Lakes exhibit a variety and richness of style that defies any such dismissive, generalized description. Over the five decades during which Great Lakes artists painted their regional scene, they seem to have divided their stylistic concerns between two poles: one broadly identifiable as naturalistic, the other as postimpressionist. Without question, the naturalistic style we know as impressionism was the pan-regional Great Lakes style at the time of the Armory Show. Impressionism suited Midwestern artists since it was essentially a realist style.

The impressionist tradition of painting *en plein air* inclined Great Lakes painters to go outdoors, to observe nature firsthand, and to paint light and atmosphere as they really appear to the eye. It should be noted, however, that although most of the region's early painters can be called impressionists, almost none of them attempted to paint like Monet or even like American Impressionists practicing in New York, such as Ernest Lawson and Childe Hassam. Midwestern painters were less interested in the impressionist brushstroke or impressionist color theory than they were in the idea of capturing an *impression* of some subject, usually a landscape. They understood impressionism to be an art that subjectified the objective. It was this *idea* of impressionism, as it related to problems of representation and expression, which captured and held the affection of modern Great Lakes painters. The region's only "pure" impressionist works came principally from central Indiana and nearby Cincinnati, Ohio. Even there, impressionism was not of the orthodox French sort.

Instead, it was a form indebted to Munich-trained painters who worked in a tonalist style of impressionism saturated with grays and browns rather than the brighter hues of the Parisian palette.

Postimpressionist styles entered the general repertoire of Great Lakes painters in the years just following the historic 1913 Armory Show in New York. Though the Armory Show traveled to Boston and Chicago, comparatively few Great Lakes painters actually saw it in person. Its impact lay in the additional authority it lent to the word of postimpressionism that was already circulating in the Great Lakes region before the landmark date of 1913. The area was hardly an isolated backwater—at least four major Cleveland painters had traveled to Europe to study the new art before the Armory Show, as had others from Detroit, Chicago, and Milwaukee.[9] The Armory Show, however, received major press coverage and created excitement about postimpressionism throughout the ranks of America's emerging modern painters. In the Midwest, the exhibition was a wake-up call; it inspired regional painters to enliven their works with bold, arbitrary colors and to rethink painting both as a visual experience and as a form of self-expression.

In the Great Lakes region, as in most of the United States, postimpressionism was understood to be a broad term embracing not only the work of Gauguin, Van Gogh, and Cézanne, but also that of various expressionists, fauves, cubists, and even futurists. Regional painters endlessly synthesized various stylistic aspects of this catchall postimpressionism. And, as with impressionism, their synthesis included the work of German painters. The raw immediacy of northern painting appealed to the artists of the upper Midwest. They especially responded to the mystical, folkloric spirit of German expressionist art.

Despite the appeal of postimpressionist styles, Great Lakes painters seemed disinclined to actually declare themselves cubists, fauves, or the like. Repeating their seizure of the *idea* underlying the impressionist style, they instead appropriated various postimpressionist *ideas* that would allow them to recast their realist/impressionist art in new forms. The painted record contradicts the often-heard complaint that regional artists simply became lost or overwhelmed in the face of the Armory Show challenge. Rather, it could be said that the Great Lakes artists of the 'teens were so perfectly centered between cosmopolitan and provincial America that

[8]Bram Dijkstra, *American Expressionism: Art and Social Change 1920–1950* (New York, 2003), p. 12.
[9]See William H. Robinson and David Steinberg, *Transformations in Cleveland Art 1796–1946* (Cleveland, 1996), pp. 71–101.

they could pick and choose their modernisms, and make of them whatever their regional and personal mandates prescribed. This conclusion is supported by a note published by a *Chicago Post* editor, Floyd Dell, who championed the new art through the 'teens. Assessing the meaning and impact of the Armory Show in his 1933 autobiography, Dell wrote:

> *[It] exploded like a bombshell within the minds of everybody who could be said to have minds. For Americans it could not be merely an aesthetic experience, it was an emotional experience which led to a philosophical and moral revaluation of life. But it brought not one gospel, it brought a half-dozen at least and from these one could choose what one needed.*[10]

The many gospels to which Dell alludes were soon folded into the multiplicity of styles already practiced in the Great Lakes area, forming a matrix of styles in which realist, impressionist, postimpressionist, and expressionist art were intertwined. Over the next four decades, the highly individualistic and often inventive works that grew out of this stylistic melding witnessed to the curious sophistication of Midwestern regional painters. Exercising what might be called their "local option," they mixed and matched whatever stylistic currents were flowing through the consciousness of their art community at various points in time. Ohio painters in the 'teens were experimenting with cloisonnism and fauvism; Michigan painters in the late twenties were exploring cubism and futurism; and Chicago painters at the same time were painting in a variety of expressionist styles. Significantly, however, these artists turned their work inward to harness style not for its own sake, but as a means to express the local and regional experience that they shared with the communities in which they lived and worked.

Centers and Influence

The story of early Great Lakes modern art is dominated by two urban centers: Cleveland to the east and Chicago to the west. Viable patronage evolved early in these centers and an important school dedicated to the training of young artists also emerged early in both. Cleveland was a city with strong cultural ties to northern Europe. Its art reflected this historic condition. Chicago was more of an ethnic melting pot. Its artists came from eastern and southern Europe as well as from Germany and Scandinavia. Some also came from the American South during the Great Migration of African Americans to the cities of the industrial North. In both Cleveland and Chicago, there were major

art museums that actively supported the artists of their regions by exhibiting their work and sponsoring competitions that attracted the support of local patrons. It is also important to note that in Cleveland and Chicago the local press embraced and supported the regional art scene. Critics and feature writers in both cities reviewed exhibitions and generally encouraged public interest in the activities of local artists and the institutions that supported them. Although most of the other Great Lakes cities also had museums, art schools and wealthy patrons, it was Cleveland and Chicago that cast the longest shadows across the region. Both of these cities had a particularly strong cultural identity that directly and indirectly shaped the identity of its art. Each also received national recognition for the achievements of its artists and employed this prestige to export its own version of a regional art culture to the smaller centers within its sphere of influence.

Cleveland's art culture was classically grounded in long-standing traditions of the arts and crafts. Since many of Cleveland's early modern painters were of German descent, they often looked to the academies of Munich and elsewhere in northern Europe for their training. Cleveland's German-trained artists practiced and taught art as a discipline built on a foundation of drawing and composition. Thus, many of the city's modern painters built their styles on formalist principals such as those propounded by Arthur Dow and other art theorists of the period who stressed design, color, and line as the most critical (and mystical) ingredients in successful painting.

Cleveland's patrons reinforced the classicism of the Cleveland style through their decided preference for well-designed and well-crafted works. Cleveland was, after all, a manufacturing city long known for its skilled workforce of tradesmen and artisans. In light of this local heritage, the city's art patrons were predisposed to an appreciation of art works that demonstrated an artist's manual skills and technical expertise. Most Cleveland artists worked in several disciplines. Many of the city's potters and enamellists were also painters. Some of its designers also painted and worked in various craft media. When the Cleveland Museum of Art first established an annual exhibition for Cleveland artists, local taste required that the exhibition "be as broadly based as possible, calling upon the entire spectrum of the fine and applied arts."[11] The exhibition became popularly known as

[10]Susan Noyes Platt, "The Little Review: Early Years and Avant-Garde Ideas," in Sue Ann Prince, ed., *The Old Guard and the Avant-Garde: Modernism in Chicago, 1910–1940* (Chicago, 1990), p. 140.
[11]Jay Hoffman, Dee Driscole, and Mary Clare Zahler, *A Study in Regional Taste: The May Show 1919–1975* (Cleveland, 1977), p. 9.

the May Show, but its official title was: *The Annual Exhibition of Work by Cleveland Artists and Craftsmen.*

Cleveland's regional painting style reflected the skill and versatility of the city's artists. Many of its best early painters earned their livings as illustrators, lithographers, or designers. Their paintings, particularly their works in watercolor, demonstrated their mastery of drawing. The watercolor tradition established by Cleveland's early modern painters became known and respected across the entire United States. The roster of great watercolorists from Cleveland in the early decades of the twentieth century is only matched by that representing the painters of the California watercolor school of the thirties and forties. Aspiring young painters from small towns all across Ohio came to Cleveland to study, to learn, and to master the skills they saw evidenced in the paintings of the several generations of regionally and nationally famous artists that sustained the primacy of Cleveland as the dominant art center of the eastern Great Lakes region.

On the list of Cleveland's most influential painters, we find the names of Carl Gaertner, William Sommer, and Clarence Carter. All three were virtuoso draftsmen. All three were gifted and well-trained. Carl Gaertner (plate 83) gained renown for his monumental oils depicting Cleveland's industrial landscape. His skills with line and paint imbued his pictures with an energized muscularity befitting their subjects. The sculptural use of light and shadow in Gaertner's work acknowledges the American realist tradition and its potential for stylistic adaptation. William Sommer (plate 22) was Cleveland's poetic sage. Intelligent and intellectually curious, Sommer read both English and German texts on art and philosophy. His airy, sensitive watercolor views of the rural Ohio landscape are both joyous and mystical. They have no equivalent in the whole of American regional art. Clarence Carter (plate 88) was one of the few American Scene painters identified as a magic realist. His tightly rendered style alternately reveals and obscures the subjective content in his landscapes. The space where the sky meets the earth in a Carter painting is a space filled with tension and mystery.

Other painters also enhanced Cleveland's reputation as a regional center. Henry Keller (plate 14) influenced generations of young painters as a teacher at the Cleveland School of Art. His work was included in the Armory Show of 1913. He was the most vocal and important advocate for postimpressionism in the years when Clevelanders were first establishing their identities as modern regional artists. The decorative and design-based aspects of the Cleveland style can be readily seen in the work of August F. Biehle, Jr. (plate 16) and Clara Deike (plate 69). Biehle subsumed landscape subject matter into *Jugendstil*-inspired arrangements of organic shapes and flat areas of color. Deike was a cubist who structured her geometric landscape compositions as intersecting planes of color and line. Perpetually reinvigorated by the influx of young artists drawn to its art school, Cleveland nurtured a lineage of American Scene painters. The African American painter Hughie Lee-Smith (plate 11) was trained in Cleveland during the Great Depression. Even into the 1990s, Lee-Smith's personal, realist style bespoke his Cleveland roots. His enigmatic depictions of figures in fantastical landscapes reflect the impress of his old mentors, Carl Gaertner and Clarence Carter.

The influence of Cleveland can be seen in art produced all across eastern Ohio, western Pennsylvania, and even into western New York State. Many of the best painters in Akron and Youngstown were trained in Cleveland. Youngstown's Roland Schweinsburg (plate 97) was one of them. His many public murals reflect his Cleveland training in drawing and design. Youngstown's most renowned American Scene painter, however, was decidedly not a Cleveland artist. Clyde Singer (plate 92) was trained in Columbus, Ohio, and in New York. Against the stylistic tide emerging from Cleveland, Singer was a realist who grafted his own version of Ashcan school painting onto the regional Ohio painting tradition. In the late 1930s, Clarence Carter took the artistic traditions of Cleveland to Pittsburgh, Pennsylvania, when he accepted a teaching position at the Carnegie Institute, influencing several classes of young Pittsburgh artists. The most distant Cleveland outpost might well have been Buffalo, New York. Charles Burchfield, (plate 46) the best-known Cleveland-trained painter, settled in Buffalo in 1922, and remained there for the rest of his life. Buffalo, like Cleveland, was a city with overlapping fine art and craft traditions. By the time Burchfield arrived, painters such as Alexander Levy (plate 81) had already found a niche within Buffalo's system of patronage, which favored well-designed paintings executed in various realist styles. Burchfield's presence brought important change to the history of art in western New York. His idiosyncratic landscape style and the commitment to watercolor that he brought with him from Cleveland challenged the Buffalo

art community to re-imagine its local modern style. Internationally known by 1935, Burchfield became a major influence on many of his contemporaries in the Buffalo area and ultimately far beyond the Great Lakes. Through Charles Burchfield, the Cleveland tradition indirectly extended its impact to the entire American Scene.

The Chicago side of the Great Lakes equation was very different from its Cleveland counterpart. This should not be surprising, for Chicago as a city was (and is) very different from Cleveland. Chicago was always a larger city with a more diverse population. Where Cleveland found a balance between its provincial and cosmopolitan outlooks early on, Chicago continually displayed confusion and frustration over its cultural identity. At the beginning of the modern era, Chicago was a city with dreams of glory that chafed against a persistent sense of inferiority. Entering the twentieth century, Chicago exhibited both pride and embarrassment over its frontier ethos and its reputation as a wide-open, brawling Midwestern center of trade and manufacturing. The story of the Armory Show at the Art Institute of Chicago illustrates the contradictory nature of Chicago as an art center in this era. The positive side of the story is that the show did travel to Chicago. In 1913, few American cities would have considered hosting the project. Even after the exhibition ignited a firestorm of complaint and controversy in New York, Chicago went forward with its plan to present the show. Once the exhibition was open, however, the good citizens of the Windy City rejected it out of hand with a howl of ridicule and outrage surpassing anything heard in New York. Modern Chicago was a volatile and conflicted place on many levels.

Whereas Cleveland had embraced modernism early (albeit at a certain remove), in the aftermath of its Armory Show disaster, Chicago resisted. The faculty at the School of the Art Institute refused to change or expand their conservative curriculum to accommodate anything connected to modern ideas or postimpressionist styles. It took George Bellows, a realist from New York, to open the school to modernism in any form at all. Accepting a two-month appointment as a visiting artist at the School in 1919, Bellows (through the force of his own reputation and personality) provided a bridge between the school and the new ideas of art being tested in other centers. It was Bellows's "espousal of the Ashcan School's non-genteel style of social realist painting

that caused the change."[12] In the wake of his departure, Chicago painters found their way to modern painting styles and the spirit of the American Scene.

The Chicago art world after 1920 became multifaceted. The Chicago painters who cast themselves as "radicals" eagerly embraced the postimpressionist mythology in which artists are considered cultural outsiders. They began to express a new idea of individuality in both their life styles and their work. Ironically, the durable Midwestern spirit of communalism compelled these new independents to join every art club and society with which they felt a kinship. The city literally bristled with art organizations pushing one or another issue into the Chicago art conversation. As Sue Ann Prince put it:

> From design guilds to artists' clubs, avant-garde exhibition clubs to conservative amateur painting societies, no-jury exhibitions to groups promoting 'aesthetic sanity,' nearly every cause, both conservative and modern, was represented by at least one organization.[13]

By the 1930s the major figures who shaped American Scene painting in Chicago were actively exhibiting their work regionally and nationally. The best of them energized the idiom with their uniquely Chicago-based approach to imagery and style. The *Annual Exhibition of Artists of Chicago and Vicinity*, which had been inaugurated by the Art Institute of Chicago in 1896, became an important showcase for the artists creating new art in and around the city. Some of them won important prizes for the American Scene paintings they submitted to the *Vicinity* show. The annual national painting and watercolor exhibitions also sponsored by the Art Institute gave the Chicago public a good perspective on the modern work being produced in their locale as well as that being created across the entire United States. They saw that their local product held up well in the competitive arena of the Art Institute's annual survey exhibitions.

A polyglot Chicago style blending surrealism, expressionism, and cubism evolved in the 1930s. Formulated (and perceived) principally as a mode of self-expression, this style of painting embodied the self-image and temperament of an art community enthralled by all forms of idiosyncratic and highly personal art gestures. In the complex Chicago art scene, however, traditionalists held their own with the new iconoclasts. Both could be found among the painters drawn to the American Scene movement. A short survey of Chicago painters from the twenties and thirties makes this fact self-

[12] Charlotte Moser, "In the Highest Efficiency: Art Training at the School of The Art Institute of Chicago," in Sue Ann Prince, ed., *The Old Guard and the Avant-Garde: Modernism in Chicago, 1910–1940* (Chicago, 1990), p. 202.
[13] Sue Ann Prince, p. xxii.

evident. The homegrown fauvism evidenced in the landscape and cityscape paintings of Jean Crawford Adams (plate 3) exemplifies both the naïve and savvy aspects of Chicago's regional style. Older than many of the Chicago avant-gardists painting the American scene, Adams nonetheless was one of the first artists in Chicago to explore direct painting and the power of unblended color laid down in broad strokes. William Schwartz (plate 41) followed a different path. His distinctive cubist-derived style exploited arbitrary color and the spatial complexity of competing aspects of flatness. A thoughtful and traditionally trained artist, Schwartz painted equally well in oil and water media. Aaron Bohrod (plate 66) became Chicago's best-known eccentric realist. Energetic and intelligent, Bohrod produced hundreds of oil and gouache paintings chronicling urban life on Chicago's north side. An unforgiving observer, Bohrod painted his city, "warts and all."[14] Following a more radical muse, Bernece Berkman (plate 71) became one of Chicago's most passionate social commentators. Her expressionist style owed its monumentality to the Mexican mural painters she most admired.

Chicago's influence on regional art in the western part of the Great Lakes basin extended north and south. To the north, painters in Milwaukee, Wisconsin, kept a watchful eye on the Chicago scene. Many had actually studied at the School of the Art Institute and all of them commuted regularly to Chicago to view exhibitions and share ideas with other artists in the city. Milwaukee painters alternately accepted and rejected the avant-garde strategies of their southern neighbors. Conservatively trained at the Art Institute in the period of the Armory Show, Gerrit Sinclair (plate 59) became a teacher at Milwaukee's Layton School of Art in 1920. He remained invested in the Chicago scene, however, exhibiting in various Art Institute annuals for over thirty years. Painting in a fairly traditional modern style that blended aspects of impressionism and realism, Sinclair chronicled Milwaukee in much the same way that Bohrod documented Chicago.

Studying under Sinclair at the Layton School, Joseph Friebert (plate 45) developed a style of moody expressionism that has a strong affinity for northern European painting. Like Sinclair, Friebert also exhibited regularly in Chicago. He was, nonetheless, a Milwaukee painter more concerned with the emotional content of his own work than with the exuberant postimpressionism of the Chicago scene. Santos Zingale (plate 28) was Milwaukee's painter of conscience—an artist concerned with the human condition. His mural and easel paintings reflect his belief in the heroic spirit of workers and minorities struggling against poverty and oppression. The Great Lakes precisionist Edmund Lewandowski (plate 89) also studied with Sinclair. His crisply rendered formal abstractions of architecture and machinery are stylistically far removed from anything done in Chicago. Still, like most of his Milwaukee contemporaries, Lewandowski exhibited his work in Chicago and can be considered a part of the city's extended circle of influence.

Elsewhere in Wisconsin, John Steuart Curry (plate 24) carried the standard for what might be called a style of narrative realism—a style he formulated in the late 1920s and brought to national prominence in his depictions of life in his native Kansas. Curry arrived in Wisconsin in 1936 to become Artist in Residence at the University of Wisconsin in Madison. Despite his great reputation as a mural painter and as one of the founders of the regionalist movement, Curry had little effect on the style or content of regional art in Wisconsin. Though he created several major oil paintings in Wisconsin depicting subjects from the region, his impact on the other professional painters around him seems to have been limited. The fact that he was not originally from the state may have isolated him from the local community of painters. In addition, his employment, which based him in Madison rather than in Milwaukee, may also have minimized his interactions with Wisconsin's larger artistic community.

Curry died unexpectedly in 1946. His lasting contribution to the state of Wisconsin may have been his involvement with the Rural Art Project. Curry's post at the University required him to travel throughout Wisconsin providing encouragement and mentoring to amateur and self-taught artists working in the state's small rural communities. His easy supportive manner made him popular with the artists he mentored. Under his management, the Rural Art Project became a successful outreach program for the University.[15] The painter Lois Ireland (plate 102) was one of the artists Curry encountered in the Project. With Curry's help and support, Ireland went on to have considerable success exhibiting and selling her distinctive and very regional paintings.

To the south, Chicago's sphere of influence reached into Indiana. As was the case in Wisconsin, painters in Indiana seem to have felt some ambivalence toward Chicago and its

[14] Bohrod interview.
[15] See John Rector Barton, *Rural Artists of Wisconsin* (Madison, 1948).

art culture. Though few of the important American Scene painters in Indianapolis had been trained in Chicago, they certainly stayed abreast of what was going on at the Art Institute and elsewhere in the Chicago scene. Rail service and highways linked the two cities. So too, did the venerable institution called the *Hoosier Salon*. The *Hoosier Salon* was the premiere exhibition for Indiana painters and was presented annually at the art galleries of Marshall Field's department store in Chicago.

A stylistically diverse American Scene developed late in Indiana. A hegemony of Brown County impressionism defined Indiana painting throughout the first three decades of the twentieth century. As the complexities of modern life encroached into provincial America, a certain nostalgia for an earlier time became a predictable response for a significant number of Americans uncertain about the future. For many in Indiana, the rustic scenes depicted by T. C. Steele, William Forsyth, and others in the Hoosier Impressionist group provided a link to a less challenging age. They were loath to give up Steele's idyllic world in exchange for the one promised by the Armory Show. As a result, Brown County impressionism was the one (and only) style of American Scene painting in Indiana into the 1930s. Only then did a much younger generation of Indianapolis artists break with the impressionists to create a modern style for the Hoosier state.

The most ambitious regional modern painting in Indiana was created by a small group of Indianapolis painters who were, for the most part, all trained at the John Herron School of Art in Indianapolis. Floyd Hopper (plate 77) emerged as one of the most talented and inventive artists in this group. Hopper was adept in oil paint, watercolor, and egg tempera. His paintings capture moments of activity in the lives of ordinary people and seem to freeze them in time. Working in a realist style enriched by arbitrary color and simplified design, Hopper was a fine draftsman with a keen eye for the artistic possibilities to be found in locally observed everyday subjects. Edmund Brucker (plate 37) was the Indiana scene painter with the most restrained and classic approach to his work. This is not surprising, for he was trained in Cleveland. Brucker's industrial and urban scenes often combine disparate figure and landscape elements drawn from the many sketchbooks he compiled as he traveled around Indiana and Ohio. Brucker's vision of the Great Lakes region, then, was a constructed place based in reality but filtered through the imagination of an artist with a sophisticated understanding of collage.

The most interesting postimpressionist in the Indiana scene was basically self-taught. A lack of academic training, however, was no deterrent to the artistic ambition of the Richmond painter, Lawrence McConaha. (plate 23) Discovering the paintings of Paul Gauguin on a visit to the Art Institute of Chicago in 1930, McConaha immediately abandoned his somewhat naïve experiments with impressionism. He booked passage to Tahiti, where he painted for three weeks in the footsteps of Gauguin. Returning home to Richmond, McConaha became a very unique American Scene artist. His colorful, flat postimpressionist views of his native state provide a thought-provoking commentary on the connections between local and mainstream art narratives. The most original of the Indiana painters may have been the magic realist, John Rogers Cox. (plate 104) After completing his art training in Philadelphia, Cox returned to his hometown of Terre Haute, Indiana, where he became director of the Sheldon Swope Art Museum in 1941. There, he assembled one of the great public collections of thirties and forties American Scene painting. Leaving Indiana in the late 1940s, Cox moved to Chicago where he taught at the School of the Art Institute between 1948 and 1965. His own signature landscape vistas are imaginary Midwestern places filled with emptiness—visual contradictions suffused with momentous and ominous signs.

Other Centers

Geographically distanced from both Chicago and Cleveland, two lesser centers of regional painting in the Upper Midwest should be acknowledged. In Minnesota, the twin cities of Minneapolis and St. Paul nurtured a vigorous production of American Scene paintings from the mid-1920s through the 1950s. Similarly, in Michigan, Detroit-based artists created some of the most interesting and independent works in the modern Great Lakes repertoire. Each of these centers supported a vigorous art museum as well as several active art schools where local artists received good training in the fundamentals of drawing, painting, and design. Both Minneapolis and Detroit were major hubs for the art activity in their respective regions and both functioned in a condition of independence and isolation relatively free of distraction or influence from either Cleveland or Chicago.

From the early 1920s on, Minnesota's regional scene had its own identity. Some of its artists were totally provincial in their outlook; others were very cosmopolitan, traveling to New York and Europe on a regular basis. Adolf Dehn (plate 25) was one of the latter. Born in a small farming town in southeastern Minnesota, Dehn became a political activist, an international traveler, and one of America's best-known printmakers. His major contribution to the American Scene was the large body of watercolors he created in Minnesota documenting the farms and wheat fields in the region where he was born. The Minnesota scene painter Dewey Albinson (plate 18) was painting in a bold cubist inspired style as early as 1925. Like Dehn, Albinson traveled widely. His signature paintings, however, depict the rugged landscape along the St. Croix River north of Minneapolis. An admirer of Cézanne, Albinson created works that are remarkable for their realization of the structural aspects of landscape forms.

The St. Paul painter Clara Mairs (plate 36) was a colorful bohemian who found her American Scene just outside the windows of her studio. Though Mairs studied in Europe and traveled widely, she painted principally for herself. She worked in a deceptively primitive expressionist style that belies the acute observation registered in her scenes and portraits. Mairs's whimsical etchings are often as original and beguiling as her paintings. The dean of the Minnesota scene was Cameron Booth. (plate 1) The only major figure in Minnesota trained in Chicago, Booth became an important American Scene painter in the early 1920s during a year he spent sketching and painting on a Chippewa Indian reservation in north-central Minnesota. Like Gauguin in Brittany, Booth discovered a connection between an indigenous culture and his own modern artistic sensibility. The landscapes and figure paintings he produced in this period record a most elusive American Scene.

Regional modern painting from Michigan is a blend of many elements, both worldly and naïve. At its best, however, it is conceptually straightforward and highly ambitious. The most compelling aspect of regionalism in Michigan is its stylistic theatricality. Michigan's painters saw both the great and the mundane aspects of their local landscape as being charged with energy and drama. The city of Detroit was the hub of the Michigan scene. In the Detroit area, the Art School of the Detroit Society of Arts and Crafts and the Cranbrook

Academy of Art provided art training for many of the state's most prominent painters and sculptors. As was the case in Cleveland, the art culture of Detroit favored a full spectrum of art that melded both the applied and fine arts. Many important potters and metalsmiths were trained at Cranbrook. Though some of the city's painters worked as illustrators— particularly in the automotive industry—few possessed the cross-media versatility found in Cleveland. *The Annual Exhibition for Michigan Artists* held at the Detroit Institute of Arts was restricted to painters and sculptors only.

Early regional painting in Michigan was fairly interchangeable with much of the typical impressionist landscape painting found throughout the Midwest. Change set in during the mid-twenties. A Hungarian immigrant named Zoltan Sepeshy, (plate 53) who had come to Detroit in 1922, painted some of the earliest modern regional landscapes in the state. Within six years of his arrival in Detroit, Sepeshy began painting canvases inspired by the factories and smelting plants built by the Ford Motor Company along the River Rouge. He also painted views of the busy commercial centers of downtown Detroit. All of Sepeshy's early works are abstract arrangements of shapes with layers of carefully observed details overlaid on them in bold strokes of line and color. Sepeshy's urban and industrial scenes use a somewhat radical futurist style to express the explosive energy and optimistic spirit of a city enthralled with the drama of its unfolding future. By 1940, Sepeshy had become one of America's masters of egg tempera painting and, thereafter, rendered his work in a realist style better suited to the subtleties inherent to the tempera medium.

Jack Keijo Steele, (plate 74) a student of Sepeshy, was a realist from the beginning. His poignant views of life in the rundown, skid row sections of Detroit are filled with pathos and, occasionally, a touch of melodrama. In his scenes of missions and burlesque houses, Steele captured the often bizarre theater played out in the back streets of his city. Amy Lorimer (plate 55) studied in Detroit under the New York modernist Samuel Halpert. Lorimer's stylized landscapes particularize (and localize) the decorative flat modern abstract style she learned from Halpert. Carl Hall (plate 100) was Michigan's only nationally recognized magic realist. Though he painted in Detroit for only a short time, Hall broadened and enriched the American Scene in Michigan with his dramatic and symbolic landscape scenes. Emigrating from Cuba to the U.S. in

1919, Carlos Lopez (plate 47) first studied painting in Chicago. His 1930 arrival in Detroit had several important consequences for the Michigan scene. As an outsider, he brought a fresh perspective to the Michigan subject matter he painted. As a teacher, he set several important painters (Carl Hall among them) on the path that would establish them as artists. Cited earlier as a Cleveland-trained artist, the painter Hughie Lee-Smith (plate 105) joined the Detroit art community during the 1950s. His presence enriched the art of Detroit much as it had that of his hometown. The arid tableaus from Lee-Smith's Michigan period frame solitary figures poised like dancers in landscapes of ambiguity and ambivalence. Lee-Smith's background as a stage-set designer unquestionably imparted a theatrical quality to his paintings that made them particularly appropriate to Detroit's American Scene tradition.

Art and Social Change

Although the general circumstances attending the advent of the American Scene in the modern Great Lakes region have been previously touched on, it is probably useful to examine the ways in which American Scene painting in the Upper Midwest evolved over time in response to the enormous changes that took place there between 1910 and 1960. It is possible to map the philosophical and stylistic evolution of the movement in a decade-by-decade survey in which the region's artists can be shown to have maintained a spirit of growth and discovery in their work over a fifty-year span. Although the cursory survey presented here obviously overlooks certain exceptional works, it can still illuminate general trends and directions and, ultimately, benefit a study still in progress.

As was previously stated, the Armory Show decade of 1910–20 was the decade of genesis for Great Lakes modern art. In fits and starts, the region awoke to its modern consciousness though this decade. So, too, did its painters. Before this period, most trained Midwestern artists were painting traditional portraits and pastoral landscapes. In general, a fairly academic realist style prevailed throughout the region at the turn of the century. Though a few artists were working in an impressionist manner, the pastoral subject matter and the restrained palette in their paintings conspired to render their impressionism rather bland and predictable. The first sign of change was the appearance of urban and industrial subject matter in canvases painted by Great Lakes artists.

By 1910, the great factories and steel mills in the region's port cities and along its river systems were beginning to inspire painters to refocus their vision. To capture the vitality of the urban landscape, the more adventuresome artists created a new tonalist form of impressionism tailored to the representation of industrial subjects engulfed by an overcast atmosphere of smoke and steam. In the process, they imparted a new energy and muscularity to their paintings. By the end of the decade, a number of Great Lakes painters had also folded postimpressionism into their stylistic lexicon. Cleveland's landscape painters, in particular, became bold and expressionistic in their landscape paintings. They began to flatten and brighten their compositions in ways that transformed both the man-made and the natural worlds into patterns of color and line remarkable for their evocative design. (see Biehle, plate 16) In other parts of the region, of course, change came slowly. The impressionists of central Indiana continued painting rustic, picturesque scenes in their traditional local style well into the 1930s.

The same decade that celebrated the advent of the modern also experienced an anti-modernism that remains a part of American life. In the Great Lakes region, many painters seemed alternately positive and skeptical about their changing world. Charles Burchfield was one such artist. The exuberant colors and expressionistic brushstrokes in his 1917 watercolors seem distinctly at odds with his images of brooding houses and decrepit barns. During the Armory Show decade, regional art in the Great Lakes was in transition. It was stylistically plural and sometimes quite vigorous and experimental. But, like Burchfield himself, it frequently seemed ambivalent. The generally progressive decade of the 'teens closed with the enactment by Congress of a highly conservative national prohibition on alcohol.

During the 1920s, Great Lakes painting took an appropriately sober turn. Just after World War I, the last generation of painters born in the nineteenth century reached their artistic maturity. They were justifiably circumspect about the modern. They had seen its grimmer side firsthand on the battlefields of Europe. Many of them returned to painting in naturalistic styles—abandoning postimpressionism as too arbitrary and decorative. Although their work often seems tentative, in its best moments it expresses the American preference for experience over theory, and body over spirit. The regional artists of the second decade of

Great Lakes modern painting reasserted the reality and physicality of their world.

The decade's most progressive painters focused their concerns on compositional structure. Having absorbed what they believed to be Cézanne's constructed approach to landscape painting, certain Great Lakes painters in the 1920s attempted to achieve a new solidity in their work. The machine aesthetic, architecture, and engineering all influenced their thinking in much the same way that it impacted the thinking of artists throughout the Western world. The best Great Lakes pictures from the 1920s have a constructed, often geometric appearance. (see Albinson, plate 18) The painters consciously seem to have wanted to incorporate the freewheeling painterly experimentation of the previous decade into a more disciplined and monumental vision of what a painting might be. The style of Great Lakes paintings in the 1920s often appears to be somewhat cautious. As serious creative gestures, however, many of the era's paintings distinguish themselves as remarkable visual embodiments of a complicated and uncertain time. In 1929 the stock market crashed, taking many modern dreams and illusions with it. Moving to the center of a national stage turned upside down, a new generation of American Scene painters would come into their own in the aftermath.

The decade of the 1930s was the golden age of regional painting. During the Great Depression, Americans became curiously introspective, self-critical, and distrustful of novelty. The nation embarked on a collective search for its lost identity and the creative focus of the era became one of retrieval and documentation. Photographers and writers went into the rural communities of the Appalachian South and into the migrant worker camps of California to record the stories and faces of Americans fighting adversity. Their goal was to document that which "dignifies the usual and levels the extraordinary."[16] They were seeking some sign that, at least at the grassroots level, America was still a place where people could stand their ground and prevail over hardship. The American Scene painters of the 1930s joined in the effort. They took on their nation's identity crisis frontally, documenting the America they knew from an earlier time and inventing the America they aspired to for the future. They tried to give a visual voice to the expectations and frustrations of the nation's ordinary people on whose shoulders they believed the rebuilding of a whole society would

rest. (see Berkman, plate 71) As a result, a certain number of their paintings became narrative, political, and sometimes preachy. Others, however, became icons that continue to resonate in the American imagination. Grant Wood's *American Gothic* and John Steuart Curry's *Wisconsin Landscape* come immediately to mind.

Art created for and about its audience precipitated a new popular interest in the art of painting. The American Scene became a favorite with the popular media. Journals such as *Life* published regular features on regional artists and their work. New Deal politicians also became involved. With the support of government work projects (The WPA and its several relatives) the artists of the 1930s American Scene began producing murals for public buildings all across the country. The public and the press followed their efforts enthusiastically. Elitists, of course, complained that the populist attitudes of the American Scene betrayed art and compromised culture. Their complaints, however, overlooked the fact that the regional art movement of the 1930s served art in a very tangible way. It brought contemporary painting to a broad cross section of modern Americans for the first time.

Too frequently, assessments of 1930s American Scene painting are distracted by issues of politics and the allegation that the WPA made propaganda artists out of the mural painters and other artists it employed. In truth, the bulk of the paintings from the Great Depression were created independently by artists working at easels in their own studios. Nobody prescribed a utility for the paintings they created there. The regional painters of the Great Lakes were particularly independent in their production through the 1930s. Some revived modernist styles and reintegrated them into their evolving regional idiom. Others began painting scenes intended to express highly personal visions in which landscape subjects became armatures supporting very free and fanciful art-for-arts-sake gestures. (see Sparks, plate 86) Consistently, however, the Great Lakes painters continued to eschew nonobjective abstraction and to revisit the touchstone of local knowledge in everything they created. Documenting, describing, remembering, and imagining America, the regional scene painters of the Great Depression created a vision of their nation and its people that portrays a longed-for egalitarian America still bought and sold in both the commercial and political culture of the present.

[16] William Stott, *Documentary Expression and Thirties America* (Chicago, 1986), p. 49.

The attack on Pearl Harbor signaled yet another turn in the fortunes of Great Lakes painting. The regional art community of the 1940s was disrupted when its young painters were drafted into the military. Its older artists also abandoned their easels in order to record the European and Pacific fronts as war artists for *Life*, *Fortune*, and other popular publications. When they returned home, these artists found their art newly challenged by talented European modernists who had fled their war-torn homelands and settled in the United States. The Europeans brought with them not only new forms of abstract and nonobjective painting but a culture that was international rather than regional. They also brought the style of surrealism. The surrealists introduced Americans to an art comprised of forms and images conjured in a subconscious interior world far removed from the local/regional landscape celebrated in the art of the American Scene.

Great Lakes painters (as was their habit upon encountering new styles) folded certain aspects of surrealism into their representational tradition. As early as 1940, Great Lakes painters began to subtly inflect their images with expressions of angst, alienation, and fantasy. Their most successful efforts to suffuse surrealism into the American Scene result-

ed in a style known as magic realism. (see Hall, plate 100) In practice, the style involved the precise rendering of highly realistic images intended to convince viewers "that extraordinary things are possible simply by painting them as if they existed."[17] The edgy magic realist landscapes created by a small number of highly imaginative Great Lakes painters transform otherwise believable vistas into mysterious evocations of dreams and memories. Elsewhere, other Great Lakes painters of the 1940s began overhauling their regional idiom in equally productive ways. Many began constructing composite vistas comprised of images from several sources superimposed one over the other. (fig. 6a, 6b) Paintings of this sort were often developed over long periods of time and brought together an assortment of source materials stored in the artist's memories or in their sketchbooks, or

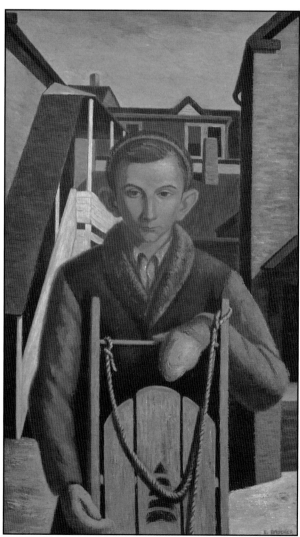

Fig. 6a. Edmund Brucker (1912–1999) STUDY OF AN ALLEY WAY IN CLEVELAND, OHIO, ca. 1937 Pencil and ink on paper 9 3/4" x 7 3/4" Documentation for the painting: BAG EARS by Edmund Brucker.

Fig. 6b. Edmund Brucker (1912–1999) BAG EARS, 1944 Oil on canvas 40" x 24"

[17] Lincoln Kirsten, "Introduction," *American Realists and Magic Realists* (New York, 1943), p. 7.

sometimes in systematized files of photographs direct-ly or torn out of magazines and newspapers. Great Lakes painting from the 1940s took the American Scene to a new level of visual and conceptual sophistication.

As the suburbs of the 1950s drew people away from city and town centers, the many artist clubs and community art soci-eties that had supported so much earlier regional art dis-solved. The energy went out of American Scene painting. An easy blended geometric realism (a kind of "modernism lite") became the contemporary mode illustrators used to depict the American landscape in popular magazines and travel brochures. This generic idiom served the public as modern art but was, in most applications, an empty form of expression that avoided issues of style and meaning. The few serious artists that continued painting the American Scene in the fifties were generally realist "hold-outs." Against the tide of abstract expressionism that would be celebrated as "the triumph of American painting" they managed to produce some of the most meditative and idiosyncratic works yet seen in the American Scene. (see Bohrod, plate 51) The last regional realists once again reinvented their tradition. Their figurative, narrative, and landscape works began to include a new expressly autobiographical message. Obsessive and deliberately obtuse, the last American Scene pictures became collages of identity that fully exploited the expressive poten-tials suggested in the composite landscapes painted by earlier Great Lakes artists.

American Scene painting exited the American stage as the Eisenhower presidency ended and the war in Vietnam began to escalate. Realism and its offshoots seemed *retar-dataire* in the post-Jackson Pollock era. *Plein air* painting became a hobby for amateurs and post office murals became curiosities. The manufacturing supremacy of Great Lakes industry was being challenged by global competi-tion and the city of Pittsburgh was aggressively removing the soot and smoke from its air. Most significantly, the regional community of people celebrated by the Great Lakes painters of an earlier time had ceased to invest its identity in the signs of its own local landscape and ethos. After 1960, the Great Lakes region became a made-for-TV place. In programs like *The Mary Tyler Moore Show*, *Laverne and Shirley*, *Good Times*, and *Home Improvement*, sitcom Midwesterners caricatured regionalism (and Americanism) for satellite broadcast, and Charles

Burchfield's inlander locale was repainted in pixels for a new postmodern culture.

Conclusion

Art is a cultural enterprise. As such, it becomes a part of a dialogue in which we talk to ourselves about the experience of being ourselves. In this conversation, our local voice is as important as any other. The painters of the Great Lakes scene found their artistic voice in a period that struggled endlessly with questions of regionalism versus cosmopolitanism. By 1960, history seems to have settled the matter. A global politi-cal and economic culture forced the United States to identify itself as cosmopolitan. Today, there is ample reason to recon-sider that determination. Pluralism is a vital and pressing issue in our time. As increasing numbers of minorities seek an identity in an emerging new American pluralism, we might well reconsider the art of regional painters from an earlier time whose work still confidently proclaims the real and enduring America as a spread of localities. Contemporary art critic Donald Kuspit makes a strong case for rethinking regional art in a pluralist world in which identity politics of race, gender, etc. denote a whole new constellation of locales where people "live." According to Kuspit:

> If there is to be democracy—and this is the all-American issue—there must be regional art. The minority environ-ment must recover its nerve—the provincial spirit must endure, whatever its expressionistic permutations.[18]

Kuspit's logic suggests that a reassessment of the most pro-found aspects of American Scene painting could provide an important perspective on the new regionalism of today. A truly comprehensive history of modern American art would recognize the fact that serious regional painting from all across the United States relates to the mainstream historical narrative in a very American way. As the idea of balanced and delegated power creates a bond between federal, state, and local government in American political practice, so too, there is a real and necessary distribution of artistic authority between local and national art. Ideally, the complex American ethos is a sum of parts: regional, ethnic, religious, and individual. American art has only recently begun to include the creative works of women, minorities, and other outsiders into a new made profile. Revised historical (and political) sense is being made from the idea of difference and from the related idea that national character in America results from the tension between the whole and its parts. By recovering an art based on an affirmation of local identity, we

[18]Donald Kuspit, "Regionalism Reconsidered," in *The Critic is Artist, The Intentionality of Art* (Ann Arbor, 1984), p. 287.

may discover a better way to navigate between the multiple poles of our own experience as individuals living within the increasingly layered contexts of our communities.

The Inlander Collection is a kind of meditation on America. It is both a social and an aesthetic document by design—a collage of art and history. As history, the Collection documents a period when the industrial and agricultural productivity of the Great Lakes region ushered in the modern era. It also recounts the shaping of that history as a cultural production undertaken (and shared) by men and women from a broad ethnic and racial cross-section of the population residing in the Upper Midwest. It recognizes their efforts to identify themselves individually and collectively within a very specific context of time and place. Artistically, the Collection celebrates the aesthetic achievements of a dedicated art subculture seeking to reconcile the two opposing views of art that have persistently confronted modern American artists. On one hand, the early twentieth century regional painters of the Great Lakes remained faithful to the traditional notion that art should function as a language in which the values, beliefs, and histories of a community (or a whole society) can be given a visual voice. On the other, they actively embraced the modern idea that a work of art is first, and foremost, a gesture of self-expression revealing the unique vision and self-identity of its maker. As a chorus of images invested with layers of aspiration, meaning and even contradiction, the paintings in the Inlander Collection remind us that compelling works of art can be found in places far removed from the straight—and often overly narrow—main roads that traverse our own locale and time.

Michael D. Hall

Water Media: Mixed Messages

From my perspective as a painter and a collector, I see that the modern painters of the Great Lakes region used watercolor to produce some of their most original work. Not surprisingly, therefore, the Inlander Collection showcases water media and oil paintings together to highlight this particular distinction of the artistic production in the Great Lakes region between 1910 and 1960. Combining their strengths as theorists and practitioners, watercolorist and oil painters, traditionalists and trendsetters, illustrators and fine artists, Great Lakes painters established an unusual set of balancing points as the hallmark of their artistic legacy.

In the mid-1970s, I majored in watercolor painting at Oregon State University's Art Department. At the time, I naïvely believed that watercolor held the same level of respect in the art world as oil painting. It didn't occur to me that although my teacher had introduced me to the art of dozens of modern American painters, only three of them worked extensively, or almost exclusively, in watercolor: Charles Burchfield, Charles Demuth, and John Marin. I did not know that water media was considered problematic for a serious fine art painter until I entered the graduate program in painting at the Cranbrook Academy of Art in Michigan. During my two-year study at the Academy, I found that I was one of the few painters who worked in water media and preferred it to oil paint. I was told that to be taken seriously as a painter, I should stop working in watercolor: I needed to start painting with oils. It took some time after graduate school to unlearn this lesson and to discover that watercolor does have its own significant terrain. This fact became even more apparent as Michael and I traveled through the Great Lakes region, meeting artists and dealers and adding water media paintings to the growing Inlander Collection.

Artists of the Great Lakes typically found their ways to watercolor down one of three paths. The most cosmopolitan studied in Europe or New York, learning their techniques in the academies and ateliers that taught watercolor as a part of European, particularly British, artistic tradition. They worked from direct observation, recording spontaneous and intimate responses to nature. Looking to create impressions of nature, they developed a watercolor technique in which thin washes were built up, layer upon layer, to achieve a luminous transparency. Regionally trained painters usually learned water media as a part of their commercial art and illustration training at local art schools. Still farther away from national and international centers, provincial artists were trained by other working artists or found their own ways to the medium, either in their studios or through the practice of painting *en plein air*. Regional artists were particularly interested in watercolor. The art form seemed to thrive best where artists were away from the centers of academic art—from the establishment forces of dealers, collectors, and museums. As a result, through the early decades of the twentieth century, the Great Lakes area, like California, experienced developments in watercolor largely unmatched by the more nationally recognized East Coast centers of artistic production. Because of their similar status as centers of regional art, it is helpful to compare the works and the working conditions found in the Upper Midwest and on the West Coast.

At the beginning of the twentieth century, the revolution of modernism had very little impact on the art of watercolor. The medium's long history of association with the decorative arts and crafts held it firmly in the grasp of premodern traditions. Many of the regional art schools obeyed tradition, and most of the old guard on their faculties were threatened by (and fought vehemently against) the new wave of modernist ideas flowing into the United States via Europe. As a younger generation began to replace this old guard, they found themselves at a crossroads. They found that "going modern" entailed a blend of holding on to tradition and letting go of it. At the end of the Arts and Crafts period the same would be true for watercolor. The medium was waiting for artists to transform it into a modern vehicle for artistic self-expression.

Students studying to be artists in the first quarter of the twentieth century were generally trained to be versatile and well-rounded so they could make a living with their art and design skills. Art school curricula were tailored to a practical educational philosophy. At the Cleveland School of Art the core mission was: "to support business and manufacturing, providing students with training in design, illustration, and the crafts."[1] Most students enrolled in the school because they

[1] William Robinson, *The Poetics of Place: Charles Burchfield and the Cleveland Connection* (Cleveland, Ohio: 2000), p.2.

wanted an education they considered practical. After their training they could follow either the path of the applied/commercial arts or that of the fine arts.

In the traditional art environment of the early modern era, watercolor had many obstacles to surmount if it was to come into a new identity as a fine art medium. Historically, water media paintings—watercolors in particular—have long been thought of as sketches, or preliminary studies for formal oil paintings made in the studio. They lacked the prestige reserved for oil painting. Water media works were also thought of as lesser works because of their associations as feminine and decorative. They have also been stigmatized because of their strong link to illustration and to the commercial arts. In the nineteenth century, watercolor took root in the popular American mind as the equivalent of *decoupage*, china decoration, and crewel embroidery—as an "ornamental" art relegated to the domain of women. (fig. 7) Lastly, watercolor paintings have long been more modest in size than most oils. Traditionally, water media work was done quickly and *en plein air* (making their more modest size a practical advantage). In comparison, oils were grander—more finished and "ambitious"—limited only by the size of an artist's studio wherein a noble subject could be worked and reworked on a large surface for months or years.

Fig. 7. Sophnia Camp FLORA THE GODDESS OF FLOWERS. ca. 1830 Watercolor and ink on paper 16" x 19 7/8" Flint Institute of Arts, Flint, Michigan.

Between 1910 and 1960, shifting perceptions of water media in the United States reflected a sexual identity crisis in American culture. In the early twentieth century, the role of women as the keepers of the "polite" arts began to change as the nation's schools and art societies became more integrated in regard to gender. The renowned Cleveland artist Henry Keller, for instance, was in the first class of men to attend the School of Design for Women, which would become the Cleveland Institute of Art. He returned later in 1913 to teach design and watercolor as a junior faculty member at his alma mater. And yet, the old gender biases surrounding watercolor were still strong. In 1922, the New York photographer Paul Strand praised the "virility" of John Marin's bold, expressionistic watercolors. At almost the same time, though, the critic Paul Rosenfeld questioned Charles Demuth's masculinity (and by implication his artistic credibility) when he alluded to the "almost female refinement in [Demuth's] wash."[2] Such discussions were predicated on the masculine identity established for American painting by the nineteenth-century realist, Winslow Homer. His oil paintings were described as big, virile, American, and real. In Homer's work, "'Big' was opposed to 'decorative' 'virile' was associated with the great outdoors; and both were balanced against 'the feminine', the domestic, and interior spaces."[3] It has always seemed ironic to me that those who wanted to emphasize the masculinity of Homer's paintings seem to have forgotten that he was also America's first great master of watercolor.

Historically, another problem with the perception of water media results from its association with commercial illustration rather than with the expressive realm of the fine arts. The illustrator was often considered a commercial craftsman with a facile hand and the ability to render realistically—an artisan rather than an artist. When Walt Kuhn wrote to his friend Henry Keller in Cleveland and invited him to submit paintings for the 1913 Armory Show, Kuhn told him to submit "his most serious, and noncommercial" work.[4] Keller's response was to send his large oil paintings, two of which were accepted. Pointedly, he left his watercolors at home. Such perceptions were not only a problem for Midwestern artists. Several of the California regionalists employed by the Disney Studio as animators also had to deal with the illustrator's stigma. In the thirties and forties, the California painter Phil Dike worked on the animated films *Snow White* and *Fantasia*. Defending his commercial affiliation with the studio, Dike stated: "One of the greatest things Disney offers an artist is the discipline of having to sell his stuff by making definite and specific statements in simple, uncomplicated

[2] Paul Strand, "American Watercolors at the Brooklyn Museum," *The Arts* (January 20, 1922), p. 151-52; Paul Rosenfeld, "American Painting," *The Dial* (December 1921), p. 663.
[3] Quoted in Bruce Robertson, *Reckoning With Winslow Homer: His Late Paintings and Their Influence* (Cleveland, Ohio: 1990), p. 63.
[4] Milton W. Brown, *The Story of the Armory Show* (New York: 1988), p. 78.

language, pictorially speaking."[5] Here, the illustrator invokes the rhetoric of the fine artist in what may seem an incongruous context. Such seeming incongruities compel us, however, to look seriously at our watercolor artists.

Indeed, many of my watercolor heroes built their art on a mastery of water media techniques used in illustration. Charles Burchfield had a brilliant calligraphic brushstroke and was so expert in his technique that he could keep a piece "alive" through revision after revision. (fig. 8) John Marin used dry, thick paint in combination with wet, loose passages, sometimes leaving areas of untouched white paper as part of his composition. Charles Demuth was a master of the so-called wet-on-wet technique, creating pebbled textures—a technique often described as a true master's "secret" in many how-to books on watercolor painting. Emphasis on the amazing skill and mastery of watercolor technique was made explicit when Marin and Dumuth were paired in an 1939 exhibition entitled *Wizards of Watercolor*.[6]

Fig. 8. Charles Burchfield (1893–1967) NORTH WOODS IN SPRING, 1951-64 Watercolor and gouache 56" x 40" Flint Institute of Arts, Flint, Michigan.

My own experience suggests that technique must be considered when an artist seeks to exploit any medium fully. The California watercolorist Millard Sheets eloquently expressed this sentiment when he said: "It's my belief that the medium of watercolor is infinite in scope. Unlike the generally accepted belief that watercolor is at its best when essentially transparent, I have found in the medium every possibility of solidity, texture, and subtlety of form that can be achieved in fresco, oil or tempera."[7] To Sheets and others, watercolor could serve to produce a quick sketch or a finished masterpiece.

In 1919 the Cleveland Museum of Art established a special category for watercolor paintings in the *Annual Exhibition of Work by Cleveland Artists and Craftsman* (the May Show). The special awards designated for watercolors demonstrated the Museum's belief that Cleveland could be "rightfully ranked as the leading city in American watercolor."[8] At least in Cleveland, watercolor was gaining parity with oil painting by the second decade of the twentieth century. In point of fact, by the 1920s many well-known American painters had created ambitious works in watercolor. Beyond Burchfield, Marin, and Demuth, the list would include Edward Hopper, Georgia O'Keeffe, and Charles Sheeler, to name only a few. These artists, however, all tend to be recognized in art history books for their large, iconic, oil paintings.

Clearly, painters of the Great Lakes found themselves split between the practical incentives to make a living in design and illustration and their desires to gain recognition within the arena of the fine arts. These artists were not afraid to stretch the role of artist, and they continually strove to balance and bridge these two art worlds. During the Great Depression, the government formed the WPA and other art projects to put artists to work painting murals in public buildings across the country. During World War II, it hired artists to document the American war effort on both the European and Pacific fronts. *Fortune* and *Life* magazines also employed numerous regional artists as illustrators. Many of the painters represented in the Inlander Collection cobbled their livelihoods together from several different vocations: creating stage sets, painting outdoor signs, printing posters for theaters and circuses, and designing wallpaper, fabrics, and record album covers. One even worked as a clay modeler in the automotive industry. These artists understood the multiple aesthetics that conditioned the art they produced in their multiple occupations. They were philosophically reconciled to the many roles they performed as artists. They were practical enough to do whatever it took to "make a living"

[5] "Disney's Dike," *Time* (March 1941), p. 61.
[6] Barbara Haskell, *Charles Demuth* (New York: 1987), p. 230.
[7] Eliot O'Hara, *Watercolor Fares Forth* (New York: 1938), p. 119.
[8] William Milliken, "Review of the Exhibition," The Bulletin of The Cleveland Museum of Art, (Cleveland: May 1929), p. 83.

using their creative skills. As idealists, however, they were equally determined to distinguish and identify themselves as fine artists, even if only a few, like Charles Burchfield, were able to move out of the commercial world and support themselves solely as fine artists. The California painter Rex Brandt seemed to embrace the complexity of the world that he and his contemporaries navigated when he said, "We in California live at an eclectic crossroads. The Orient and the Occident meet. The commercial demands of the moving picture, the beckoning landscape, each offers opportunities and makes demands on tradition. Out of this has sprung a full bodied lusty watercolor concept."[9]

In California and Ohio, watercolor artists concentrated themselves in the cities of Los Angeles and Cleveland. These artists joined together to form local and regional societies that promoted their work. While living in New York, the Cleveland painter William Sommer (plate 27) became familiar with an artists' organization known as the Kit Kat Club. When he returned to Ohio, Sommer became one of the co-founders of the Kokoon Club, which was modeled on the Kit Kat Club. The Kokoon Club was an artist's alliance in Cleveland that organized meetings, studio sessions, lectures, and exhibitions for those who worked outside the entrenched artistic institutions. Defining themselves as "different," this group wrote a symbolic definition of its initiative for a local Cleveland magazine: "'Kokoon' symbolized protecting and permitting the embryo of individual genius to develop within itself, so that it might break free of the naturalist tradition."[10]

Ultimately, Sommer's art synthesized drawing and watercolor simultaneously to capture what he described as the spirit or essence of his subjects. Sommer's lack of refinement in painting was intentional and deliberate. In a note he wrote to himself, Sommer cautioned, "Do not finish your work too much. An impression is not sufficiently durable for its freshness to survive a belated search for infinite details."[11] I would go so far as to say that Sommer's perception and spirit were often best communicated in watercolor.

In fact, the fluid qualities of water media seemed an ideal conduit for artists to step outside the traditions of pure realism. Already inextricably tied to the fluid and spontaneous qualities of drawing, watercolor fit well into the modernist belief that an artist's first expression of an idea or emotion was the purest.

Burchfield seems to have echoed Sommer's view of spontaneity when he said: "My preference for watercolor is a natural one—whereas I always feel self-conscious when I use oil. I have to stop and think how I'm going to apply the paint to the canvas, which is a detriment to complete freedom of expression. . . to me watercolor is so much more pliable, and quick."[12]

As watercolor became more popular and respectable in the American Scene, many books were written on watercolor painting featuring illustrations by nationally known artists. In the late 1940s regional watercolors were published (and commissioned) regularly by popular magazines promoting travel across America, such as *Ford Times*, published by the Ford Motor Company, and *Westways*, published by the Automotive Club of Southern California. In this climate, regional watercolor painters began to receive national and even international exposure. Their work was being exhibited across the country in art museums, traveling exhibitions, and in many other public venues: theaters, bookstores, schools, colleges, and department stores. Through these various exposures they broadened their markets and extended their circle of admirers. In other words, a populist ideal was emerging in the shifting and overlapping terrain charted by these artists.

A sampling of some of the biographies of the artists in the Inlander Collection demonstrates water media's importance in the Great Lakes scene. The widespread use of water media throughout the Upper Midwest generated original and distinctly modern uses for both gouache and watercolor. Charles Burchfield (plate 40) entered the Cleveland Institute of Art determined to become a commercial illustrator. In this curriculum, the bulk of his education was in the applied arts of decorative illustration and design theory. Ironically, it was under the influence of his design teacher, Henry Keller, that Burchfield developed his approach to fine art watercolor media, abstract ornament, and nonwestern design. In the early twentieth century nonwestern cultures were important to modernist theories for the new generation of American artists. One particularly influential nonwestern source for Burchfield was the tradition of Chinese scroll painting. Fine collections of scrolls were exhibited in Cleveland for him to study firsthand in 1914 and 1916. Keller reinforced Burchfield's interest in the scrolls by telling his student that he believed that Sung Dynasty painters structured their compositions in the same

[9]Rex Brandt, *Watercolor Techniques* (Corona del Mar, California: 1956), p. 11.
[10]D. Undine Baker, "An Evening with the Klub," *Cleveland Town Topics*, March 27, 1915.
[11]Elizabeth McClelland, *William Sommer: Cleveland's Early Modern Master* (Cleveland, Ohio: 1992), p.55.
[12]Charles Burchfield, *Modern Arts Criticism*, (Detroit: 1992), p. 40.

manner as the great French modernist, Paul Cézanne: "rather than rendering a landscape with single-point perspective and deeply receding space, Chinese artists transformed nature to simple, flat planes that were layered to advance up the surface of the composition."[13]

Burchfield later discovered more radical modernist influences and expressions when he attended a local exhibition that included the work of two of Cleveland's leading modernists, William Sommer and William Zorach. Sommer and his colleague Zorach were both trained commercial lithographers. They worked together in a lithography shop by day and spent their evenings and weekends making modernist paintings for the fine art world. By the early 1920s Burchfield himself was exhibiting his watercolors alongside Sommer and Zorach. All three of these painters ultimately became recognized as pioneers in the use of watercolor in a thoroughly modernist way.

Aaron Bohrod (plate 44) from Chicago, was another versatile Great Lakes artist with wide-ranging skills in drawing, design, graphics, and painting. In the course of his long

Fig. 9. Aaron Bohrod (1907–1992) Drapery Fabric PAGAN MAGIC, 1952. Bohrod designed this pattern for Associated American Artists. It was offered to the public in a range of colors.

career, Bohrod designed fabrics (fig. 9), created graphic decorations for handmade pottery, and entered national competitions for his oils and watercolors. He regularly submitted work to the annual *Exhibition of Watercolors by American Artists* at the Art Institute of Chicago, and to other exhibitions outside his region. He was awarded First Prize in watercolor at the Philadelphia Academy of Fine Arts and a First Award of Merit in the Los Angeles Watercolor Exhibition of 1940. His series of water media paintings portraying his war experiences were published by *Life* magazine.

Though he rarely painted using traditional transparent watercolor, Bohrod used gouache extensively. A large number of his works from the thirties and forties were produced in gouache as finished paintings for exhibition. In 1947 the J. L. Hudson Company department store brought several American Scene artists to Michigan to document the sites and scenery throughout the state. Bohrod (along with three other artists in the Inlander Collection: Zoltan Sepeshy, Carlos Lopez, and Adolf Dehn) was commissioned to travel and paint for over a year in Michigan. Each artist involved in the project was given "complete freedom in his selection of specific subjects and no restrictions were placed on his style of execution."[14] Hudson's then purchased one hundred of the paintings from the project and circulated them in numerous exhibitions around the state. Perusing the catalogue from this project, I was interested to note that over half of the works Bohrod submitted were executed in watercolor or gouache.

The Michigan painter Zoltan Sepeshy (plate 6) often created large watercolor paintings that rivaled his cubist-futurist oil paintings. A man of many talents, Sepeshy was excited by the challenge of technique. Attesting to his unusual preference of media, three-quarters of the works listed in his 1965 retrospective exhibition catalogue incorporated water media. Almost unique among of the Great Lakes painters, Sepeshy liked to have the sharp whites of his watercolor paper and gesso panels show through his transparent paint. Because of this technique, his watercolors and temperas have a distinctive luminosity. In 1946 he wrote a book entitled *Tempera Painting*, in which he compared watercolor to tempera in terms of their mutual qualities of luminosity and transparency. In his book Sepeshy declares: "A wider range of effects is possible (with tempera) than in oil painting or watercolor while the quality of both may be maintained."[15] Saying this, Sepeshy reveals his belief that paint media should not hold hierarchical importance; an artist

13. "Mr. Keller Takes Chinese Point of View for Paintings of West," *Cleveland Leader*, November 14, 1915, Dramatic section.
14. Florence Davies, "Forward," *Michigan on Canvas* (Detroit, Michigan: 1948), n.p.
15. Zolton Sepeshy, *Tempera Painting* (New York and London: 1946), p. 47.

must choose the paint medium that best suits his or her purpose and maintain its inherent qualities.

Henry Keller (plate 14) was trained at the Cleveland Institute of Art, and taught there for forty-three years. He is considered the founder of the watercolor tradition in northeastern Ohio, and he was an enormously influential painter, teacher, mentor, and theorist. He taught the useful and important qualities of water media in the outdoor summer art school he sponsored in rural Berlin Heights, Ohio. He also shared his experimental approach to the media with his students and colleagues at the Cleveland School of Art. In his own work, Keller experimented with water media by mixing transparent with opaque paints. His impact on his students is evident by the number of them who became successful painters, including Charles Burchfield, Clara Dieke, August Biehle, and Clarence Carter. His commitment to water media is clear when you realize that twice as many watercolors were included in his 1950 memorial exhibition than were oils.

Though volumes of information are available on the techniques of California's regional watercolor painters, it is very difficult to find information on watercolor as a specific medium in the art of Great Lakes painters. Perhaps this reflects the fact that Midwestern artists worked in many materials and thus generally identified themselves as artists first and only secondarily as painters in a particular medium. Their focus was on the messages they conveyed and, thus, their choice of media reflected their artistic objectives of the moment.

At specific junctures, however, the creativity of artists in the Upper Midwest turned to water media for its full expression. Painting their American Scene, these artists gave water media a new identity in the modern world that they celebrated in their art. Their legacy established watercolor in the field of the fine arts and helped water media secure a new visibility in the history of American art. At last, water media's mixed messages are beginning to be deciphered by a new audience—one without the old prejudices. Broad-based, populist, and now unencumbered by gender bias, the water media paintings of the Inlander Collection are, with their completeness of thought, scale, and seriousness of purpose, a true reflection of the art of the American Scene.

Pat Glascock

The Inlander Collection of Great Lakes Regional Painting 1910–1960

The Subjects of the Artists

The majority of the American Scene paintings produced in the Great Lakes region can be grouped into eight general subject/theme categories. Inspired by the natural and the manmade environment around them, Great Lakes painters produced a surprisingly diverse array of works depicting the waters, the landscape, the people, the cities and the industrial milieu of their region. They were also fascinated with the seemingly mundane architecture that identified their own local neighborhoods and painted numerous works addressed to this subject. Throughout, a sense of place suffuses Great Lakes regional modern painting. The specifics of place and locale lend authority and context to the chronicle of daily life created by the region's artists. Place also served as a backdrop against which painters memorialized the lore and history that shaped and sustained the cultural identity of their region and their nation.

The following segment of this book presents The Inlander Collection thematically. Works are grouped in sections reflecting the preferred subjects of the artists who painted the Great Lakes scene. This presentation is intended to highlight similarities and differences between thematically related works produced by painters with varied (and even oppositional) interpretative approaches to their subjects. Within each category, the paintings are sequenced chronologically—from the earliest to the most recent. The short captions accompanying each plate identify the specific site or place represented in a given image. Assessed individually, the works presented here speak eloquently to the artistic vision of the painters who created them. In concert, the paintings form a compelling visual record of a distinctive regional culture sustaining and celebrating itself through an era of great cultural growth and change.

Section 1
THE WATERS: Rivers, Lakes, Shorelines and Harbors

Section 2
THE LAND: Fields, Woods, Hills and Valleys

Section 3
THE PEOPLE: Rural, Urban, Young and Old

Section 4
EVERYDAY ARCHITECTURE: Houses, Barns, Storefronts and Local Landmarks

Section 5
CITIES: Skylines, Boulevards, Neighborhoods and Downtowns

Section 6
DAILY LIFE: Work, Play, Domestic Routine and Social Activity

Section 7
INDUSTRY AND COMMERCE: Mining, Shipping, Building and Manufacturing

Section 8
HISTORY AND IDENTITY: Events, Customs, Memories and Musings

THE WATERS:
RIVERS, LAKES, SHORELINES AND HARBORS

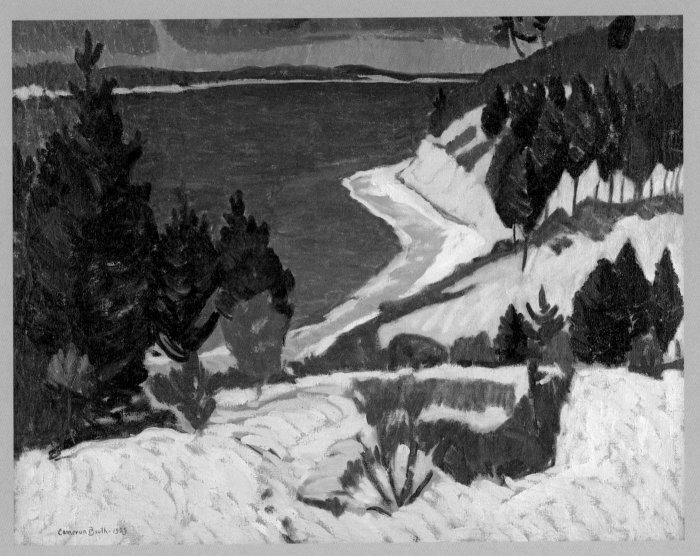

1. *Cameron Booth* LEECH LAKE, 1923 Oil on canvas: 26" x 34"
A winter scene along a lakeshore in north-central Minnesota

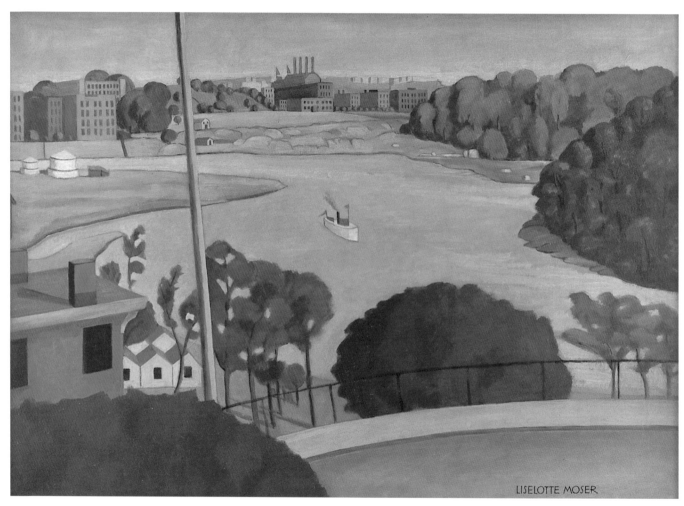

2. *Liselotte Moser* FACTORIES BY THE RIVER, 1929 Oil on canvas: 23" x 32"
Storage tanks and industrial buildings along a river near Detroit, Michigan

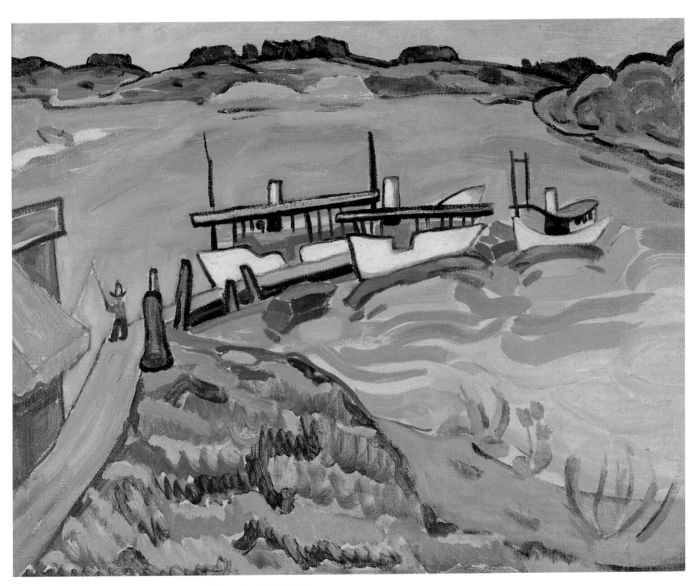

3. *Jean Crawford Adams* LAKE GENEVA, 1929 Oil on board: 16" x 20"
The shoreline of a popular resort lake in southeast Wisconsin

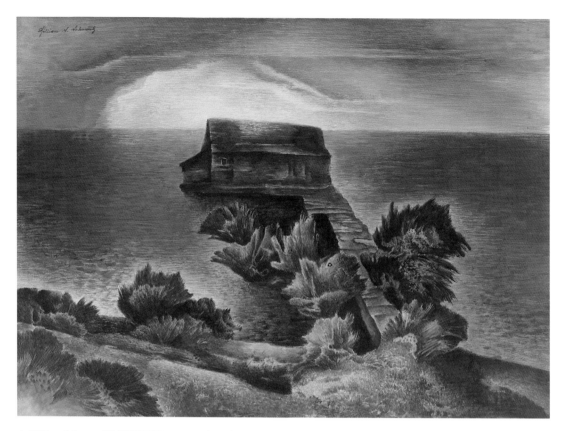

4. *William Schwartz* BOAT HOUSE, ca. 1936 Gouache on paper: 20"x 28" (sight)
Site unknown: Probably a view of Green Bay from the Door Peninsula in eastern Wisconsin

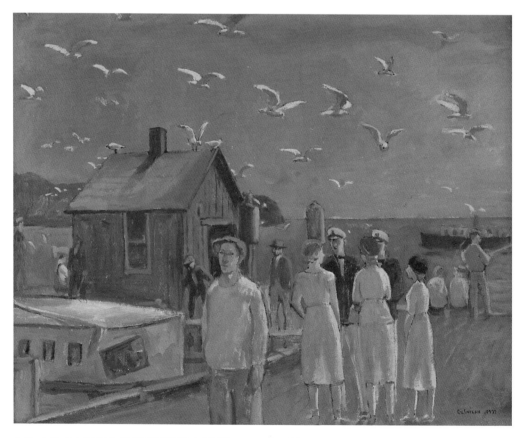

5. *Gerrit Sinclair* GULLS AT GILLS ROCK, 1937 Oil on masonite: 20"x 24"
The car ferry dock at the north end of the Door Peninsula in eastern Wisconsin

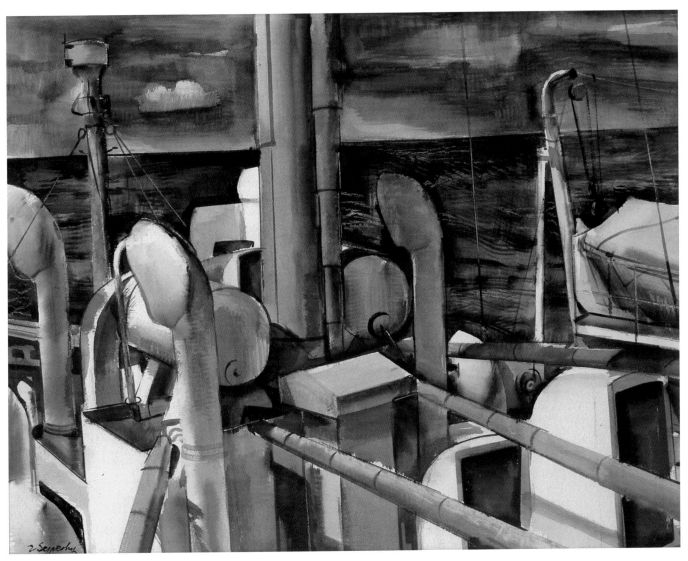

6. *Zoltan Sepeshy* DECK NO. 2, ca. 1936 Watercolor on paper: 21 1/4" x 27 1/4" (sight)
A view from one of the Lake Michigan car ferries operating between Wisconsin and Michigan

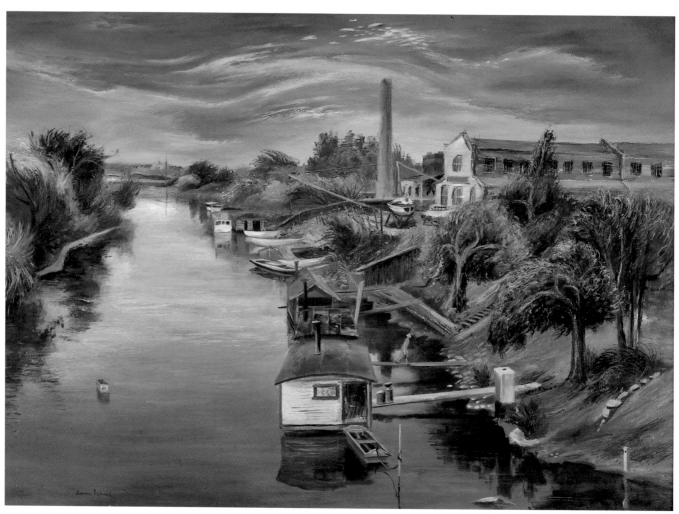

7. *Aaron Bohrod* HOUSEBOATS—CHICAGO RIVER, 1939 Oil on masonite: 29" x 40"

©Estate of Aaron Bohrod/Licensed by VAGA, New York, NY

Depression-era houseboats moored along the Chicago River in Illinois

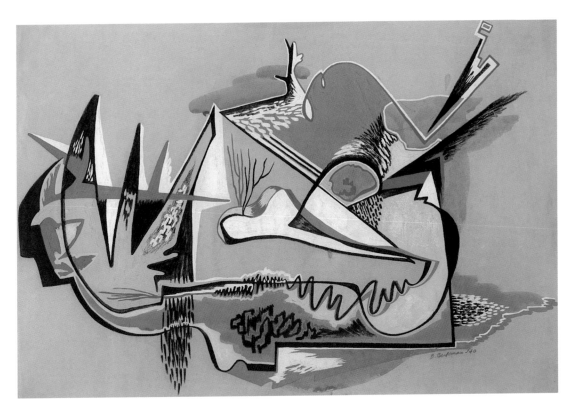

8. *Bernece Berkman* LAKE SHORE, 1940 Gouache on paper: 18" x 24" (sight)
An abstract representation of a Lake Michigan shoreline.

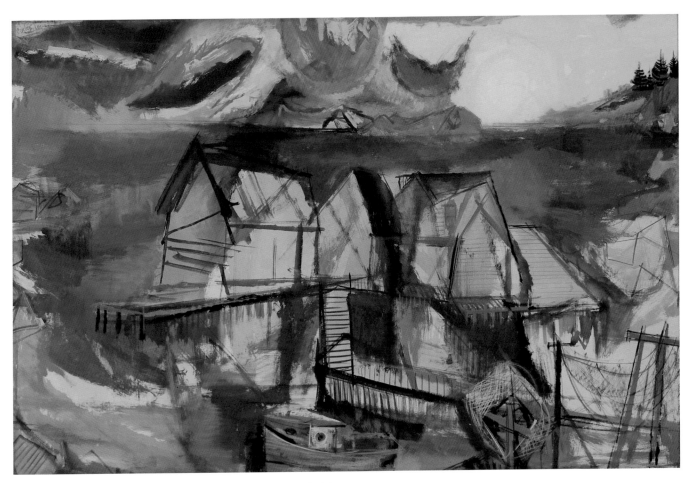

9. *Carlos Lopez* LIFTING FOG, ca. 1945 Watercolor on paper: 24" x 37" (sight)
Lake Michigan fishing shacks at the Oxbow Summer Art School near Saugatuck, Michigan

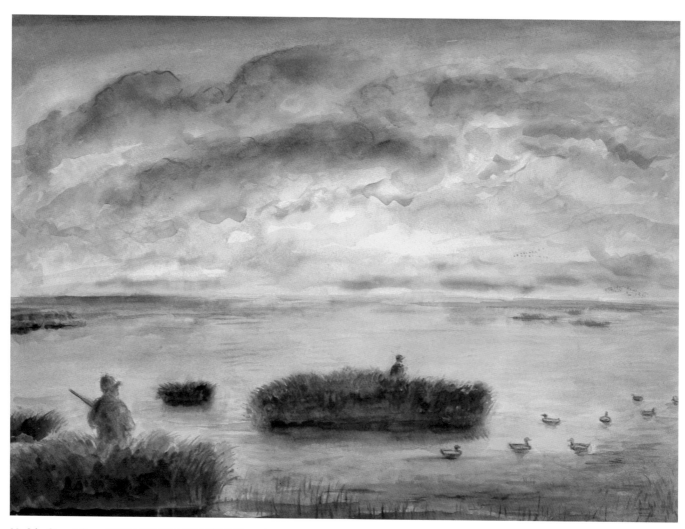

10. *John Steuart Curry* DUCK HUNTERS AND DECOYS, ca. 1943 Watercolor on paper: 22" x 30"(sight)
Hunters and duck blinds in the Horicon Marsh northeast of Madison, Wisconsin

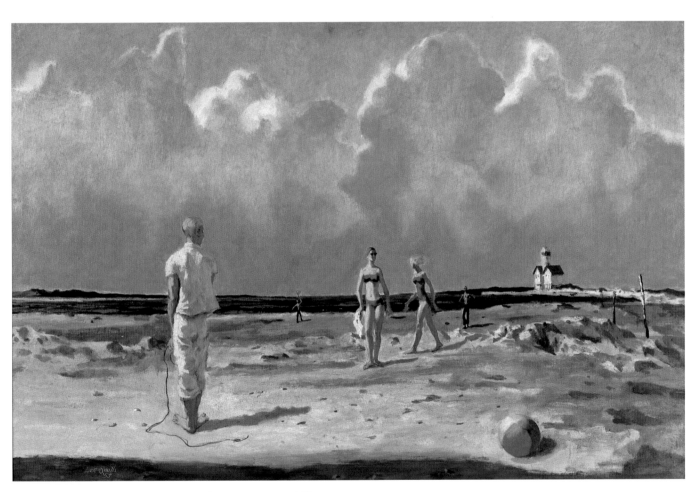

11. *Hughie Lee-Smith* BEACH SCENE, 1953 Oil on masonite: 23" x 35"
Figures and a composite Lake Michigan shoreline with a double-gabled lighthouse reminiscent of the one at Holland, Michigan

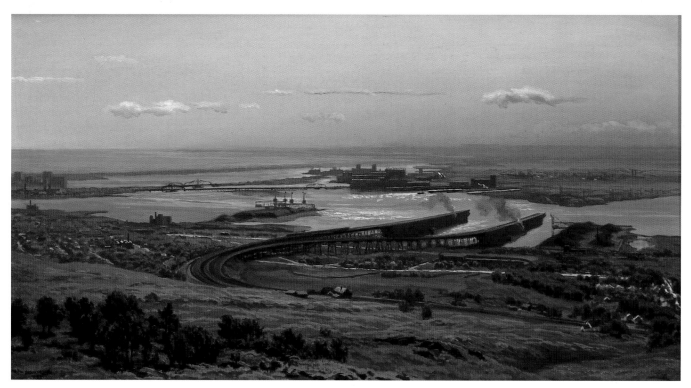

12. *Constance Richardson* ORE DOCKS, DULUTH, 1953 Oil on masonite: 16 1/2" x 31 1/2"
A view of Duluth Harbor as seen from the bluffs to the west of the city of Duluth, Minnesota

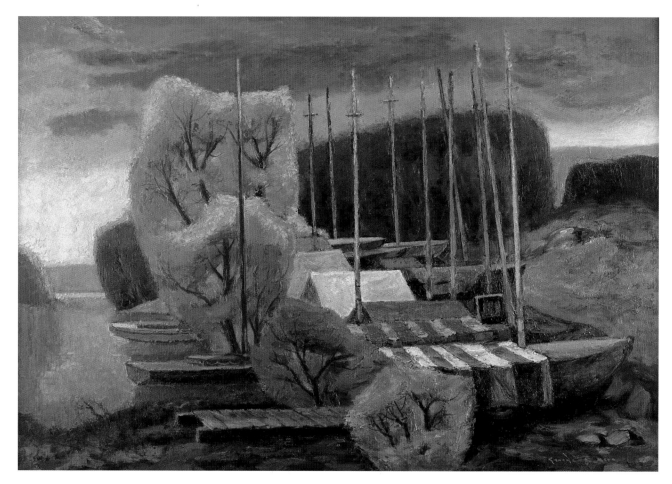

13. *George Jo Mess* DRY DOCK—GEIST LAKE, 1956 Oil on masonite: 25" x 36"
Boats docked along the shore of a reservoir north of Indianapolis, Indiana

THE LAND:

FIELDS, WOODS, HILLS AND VALLEYS

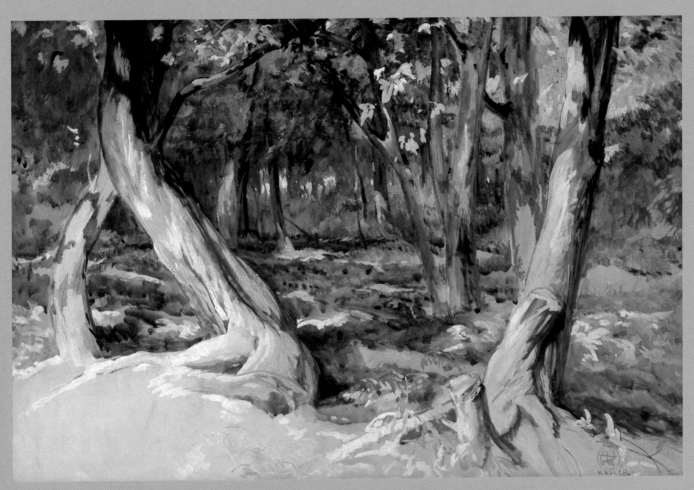

14. *Henry Keller* DEEP WOODS, ca. 1916 Gouache on board: 19 1/2" x 29 1/2" (sight)
A wooded park near The Cleveland Museum of Art on the north side of Cleveland, Ohio

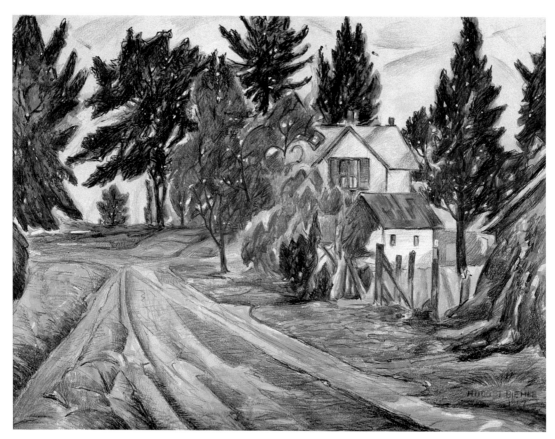

15. *August F. Biehle, Jr.* ZOAR OHIO, ROAD TO THE SCHOOLHOUSE, 1917
Watercolor and gouache on paper: 18 3/4" x 24 1/2" (sight)
The rural landscape on the outskirts of historic Zoar in eastern Ohio

16. *August F. Biehle, Jr.* HOLLYHOCKS, ca. 1919 Gouache on paper: 11" x 15" (sight)
The rural landscape near the town of Berlin Heights in northern Ohio

THE LAND

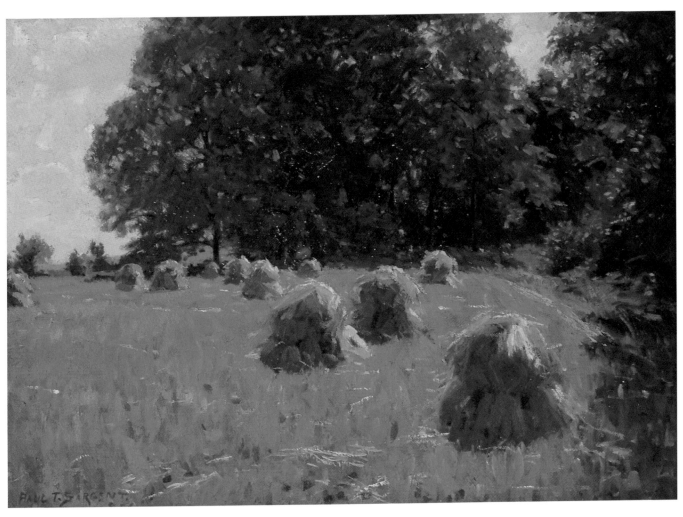

17. *Paul Sargent* HAY STACKS, 1921 Oil on canvas: 20" x 28 1/4"
A late summer view of harvested fields in central Illinois

18. *Dewey Albinson* TAYLORS FALLS, 1922 Oil on canvas: 26" x 26"
The bridge over the St. Croix River at Taylors Falls in eastern Minnesota

THE LAND

19. *Leo Henkora* FALL AT THE EDGE OF TOWN, 1927 Oil on canvas: 28" x 34"
A fall scene on the outskirts of Minneapolis, Minnesota

20. *Jean Crawford Adams* ILLINOIS FARM, ca. 1930 Oil on board: 18" x 24"
A farm and plowed fields in northern Illinois

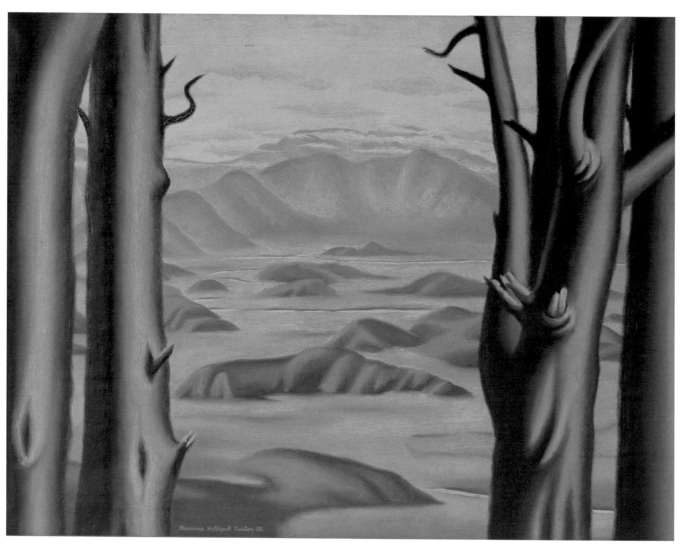

21. *Clarence Holbrook Carter* UNTITLED, 1932 Oil on canvas: 24" x 32"
Site unknown: Possibly a swamp area along the Ohio River in southern Ohio

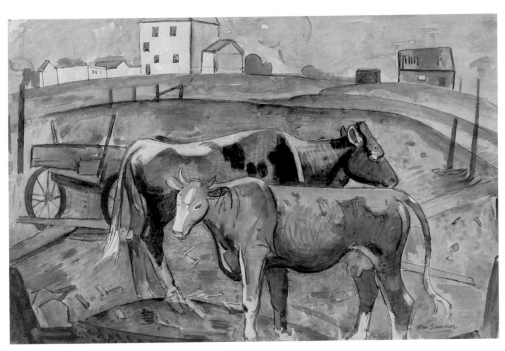

22. *William Sommer* COWS AT MIDDAY, ca. 1936 Watercolor on paper: 12" x 18" (sight)
Farmlands surrounding the artist's home in the Brandywine area south of Cleveland, Ohio

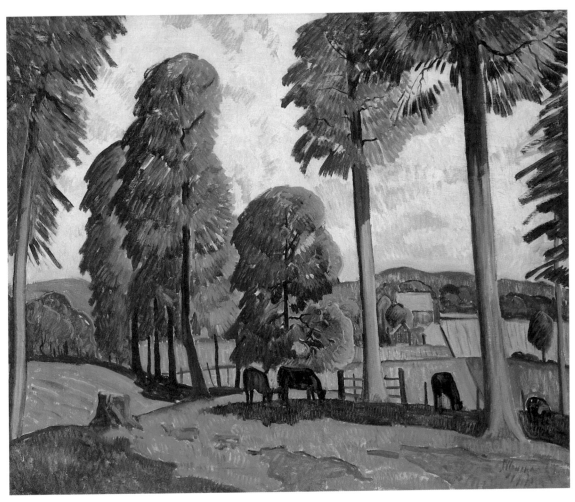

23. *Lawrence McConaha* INDIANA PASTORAL, ca. 1936 Oil on canvas: 30"x 36"
Fields and pastures in southern Indiana

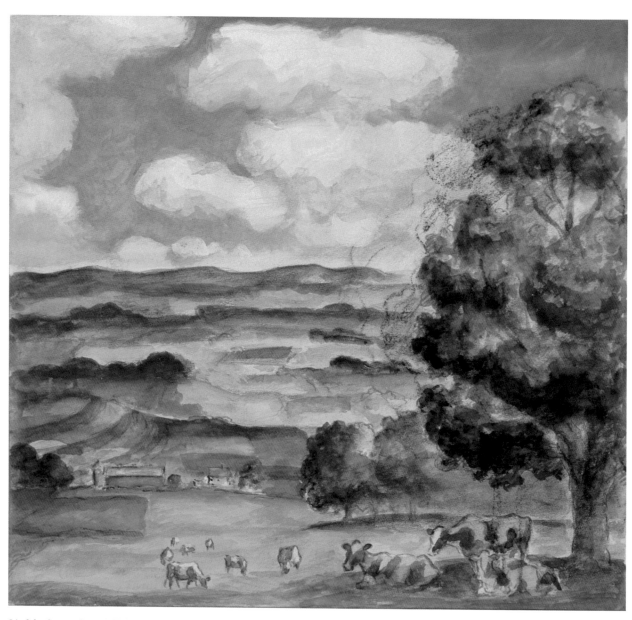

24. *John Steuart Curry* A WISCONSIN LANDSCAPE, *ca. 1936–40* Watercolor on paper: 12" x 12" (sight)
Dairy farm lands near the town of Belleville in southern Wisconsin

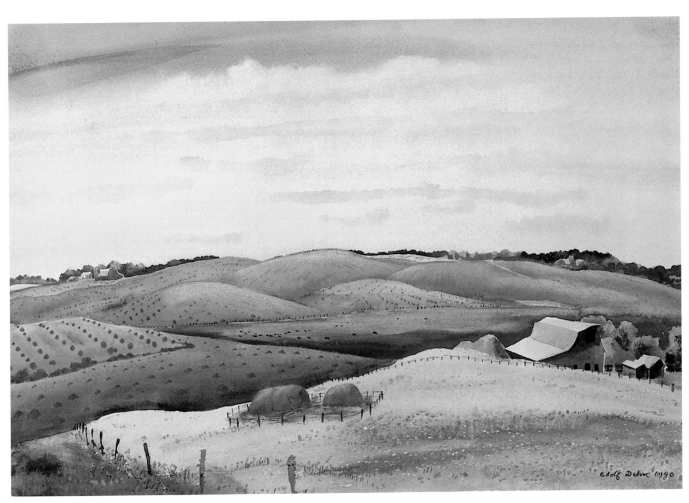

25. *Adolf Dehn* WHEAT FIELDS, 1940 Watercolor on paper: 14" x 21" (sight)
Wheat farms in summer near the town of Waterville in southern Minnesota

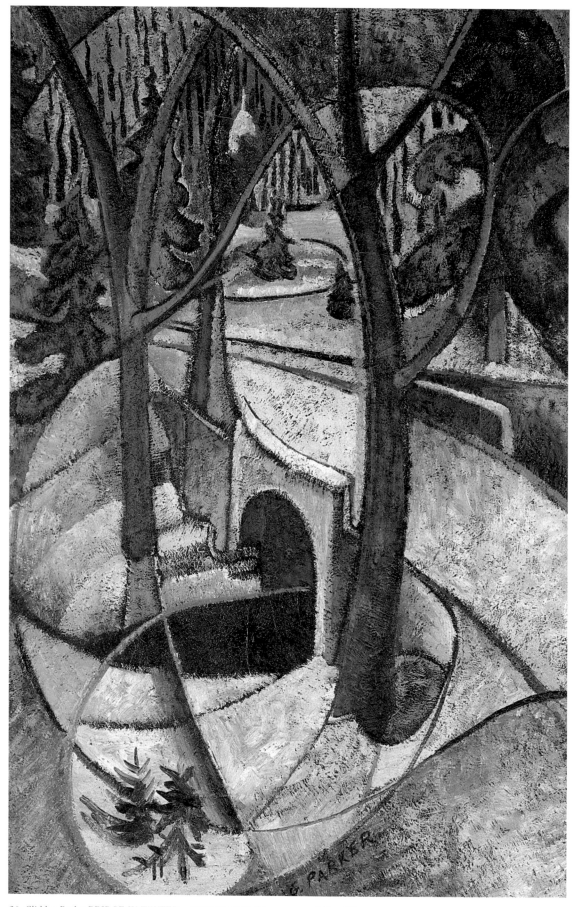

26. *Glidden Parker* BRIDGE IN WINTER—ALFRED, 1946 Oil on canvas: 36" x 25"
A bridge outside the town of Alfred in western New York

THE LAND

THE PEOPLE:
RURAL, URBAN, YOUNG AND OLD

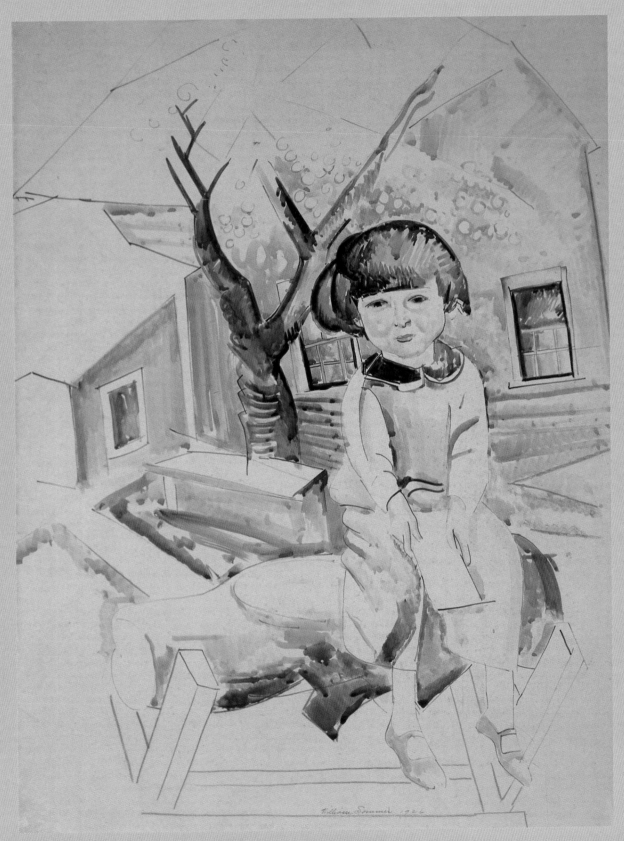

27. *William Sommer* SEATED GIRL, 1926 Watercolor on board: 25 3/4" x 19 3/4" (sight)
A child posed on a sawbuck in front of the artist's studio in rural northeast Ohio

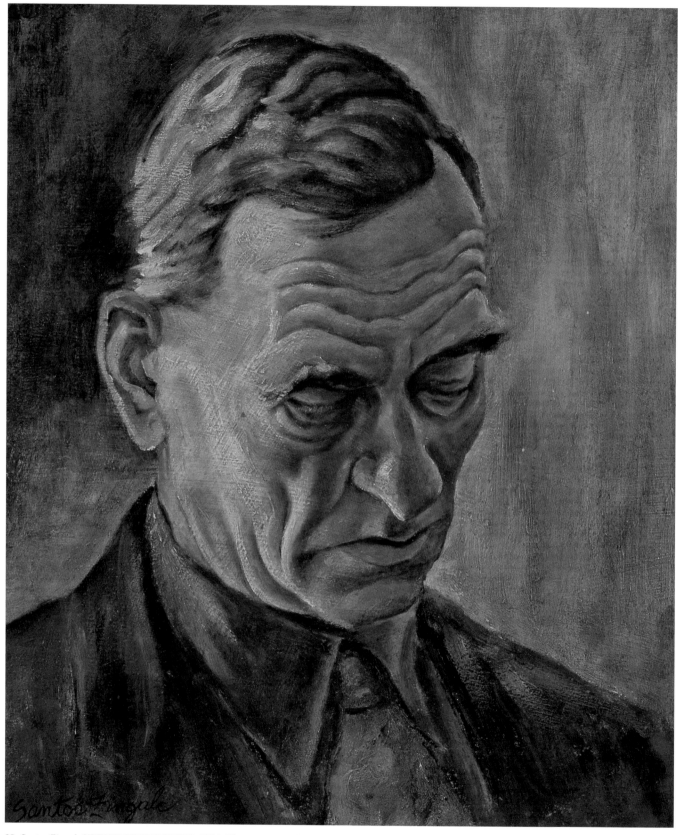

28. *Santos Zingale* UNEMPLOYED WORKER, 1934 Oil on canvas: 16" x 14"
A factory worker in Milwaukee, Wisconsin

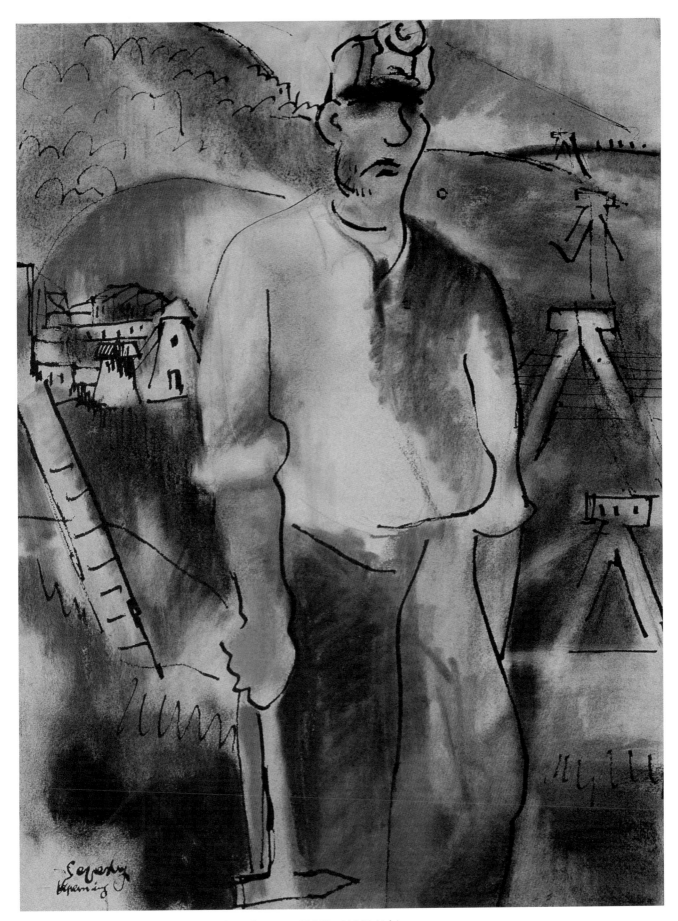

29. *Zoltan Sepeshy* ISHPEMING, ca. 1936 Ink and pastel on paper: 19 1/2" x 14 1/2" (sight)
A miner and a hillside iron mine near the town of Ishpeming in northern Michigan

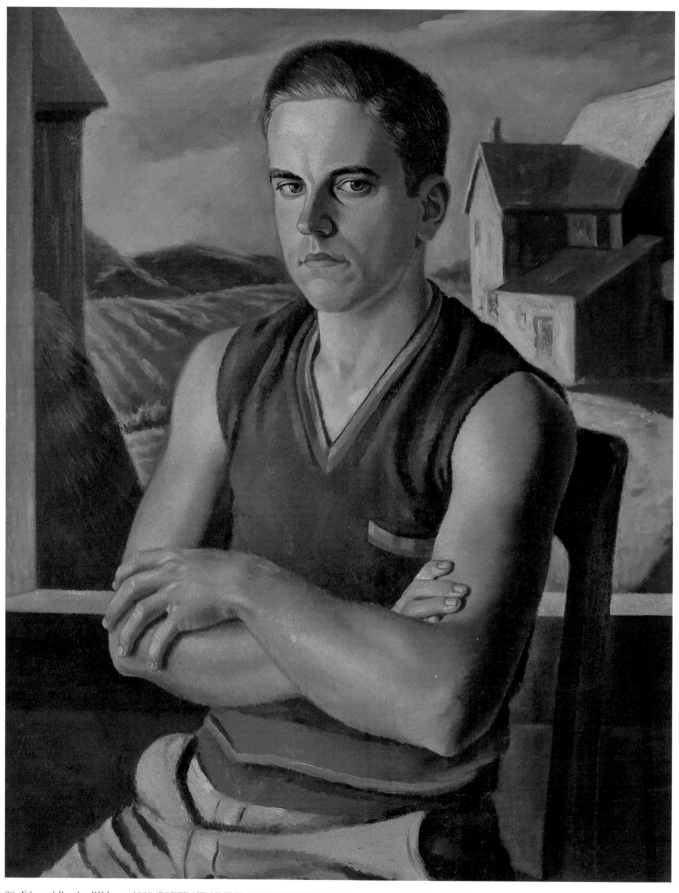

30. *Edmund Brucker* BILL, ca. 1938 (PORTRAIT OF THE ARTIST'S BROTHER) Oil on canvas: 32 1/2" x 26 1/2"
William Brucker and a composite landscape with farm house in eastern Ohio

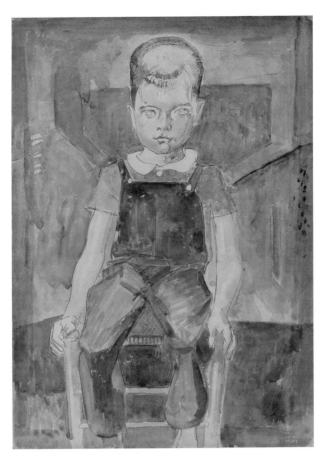

31. *William Sommer* FARM BOY, ca. 1936
Watercolor on paper: 16 1/2" x 12"
A child from a farm near the artist's studio in the
Brandywine Valley south of Cleveland, Ohio

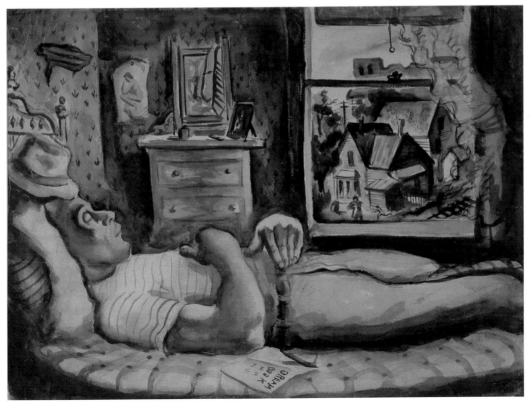

32. *Jack Keijo Steele* RESTING AUTO WORKER, 1940 Watercolor on paper: 21 1/2" x 29 1/2" (sight)
A worker who rented a room in the artist's boyhood home in Detroit, Michigan

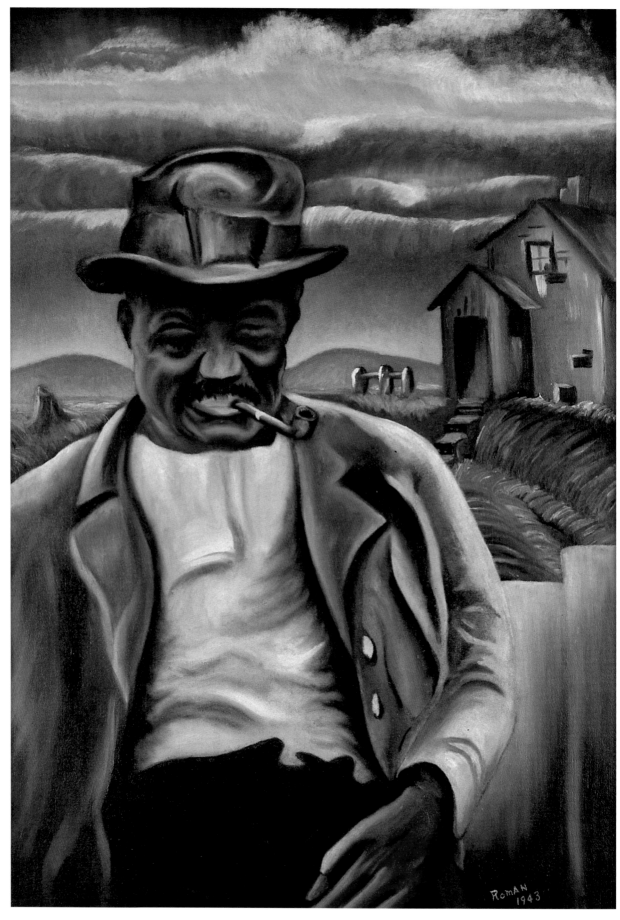

33. *Roman Johnson* DAD, 1939–43 Oil on canvas: 35" x 24"
The artist's father in a composite setting that includes an old house from Columbus, Ohio

34. *Clarence Holbrook Carter* NIGHT CARNIVAL, 1941
Watercolor on paper: 22" x 15" (sight)
A ticket seller in a booth at the entrance to a traveling
carnival in Portsmouth, Ohio

35. *Frances McVey* THE SCHOOL TEACHER, ca. 1942 Oil on canvas: 24" x 30"
A teacher at her desk in Illinois or Indiana

36. *Clara Mairs* TWO CHILDREN, ca. 1944 Oil on canvas: 40"x 32"
Two African American children posed outside a doorway in St. Paul, Minnesota

THE PEOPLE

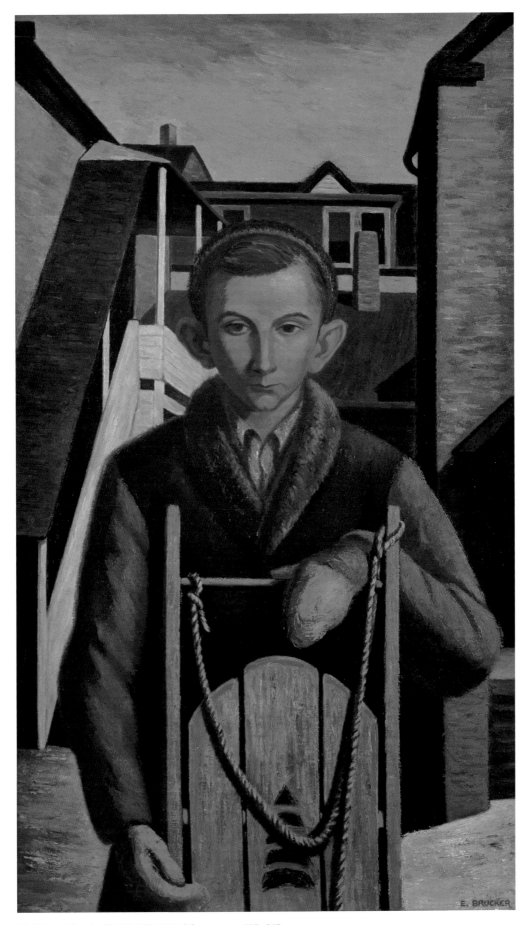

37. *Edmund Brucker* BAG EARS, 1944 Oil on canvas: 40"x 24"
A composite scene with the son of an immigrant steel worker from the south side of Cleveland and an alleyway from the area known as "Little Italy" on the north side of Cleveland, Ohio

38. *Jack Keijo Steele* BULL AND THE RED HEAD, 1951 Oil on canvas: 20"x 32"
A dancer and her admirers in the Gaiety Burlesque Theater in downtown Detroit, Michigan

EVERYDAY ARCHITECTURE:
HOUSES, BARNS, STOREFRONTS AND LOCAL LANDMARKS

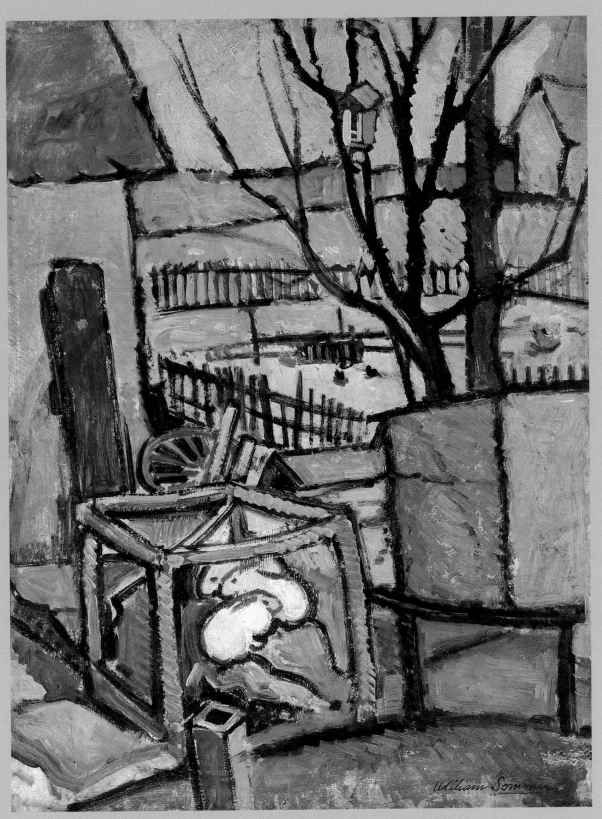

39. *William Sommer* THE RABBIT HUTCH, 1913 Oil on canvas: 26" x 20"
The backyard behind the artist's home in the west Cleveland suburb of Lakewood, Ohio

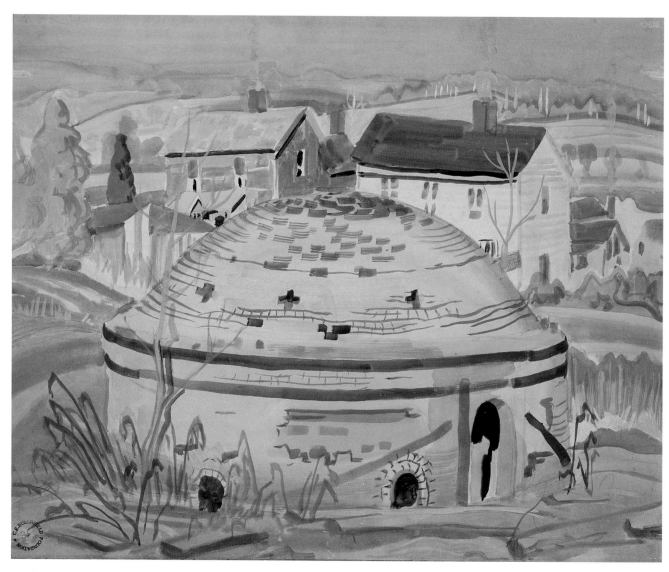

40. *Charles E. Burchfield* BRICK KILN IN AUTUMN, 1917 (BUILDING WITH DOMED TOP) Watercolor on paper: 17 1/2" x 21 1/2" (sight)
A commercial brick kiln and two houses near the town of Salem in northeast Ohio

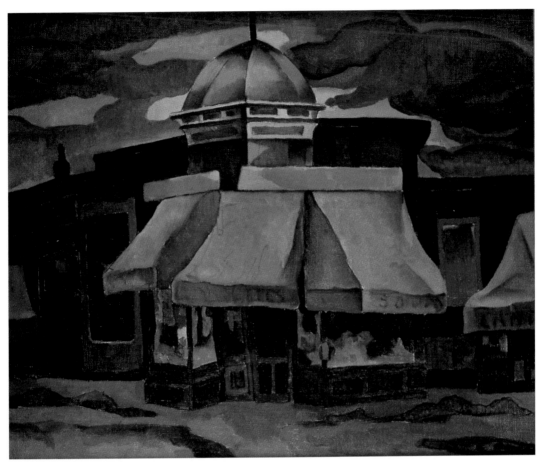

41. *William Schwartz* THE OLD CANDY STORE, 1926 Oil on canvas: 18" x 21 1/4"
A candy and confection shop on Michigan Avenue in downtown Chicago, Illinois

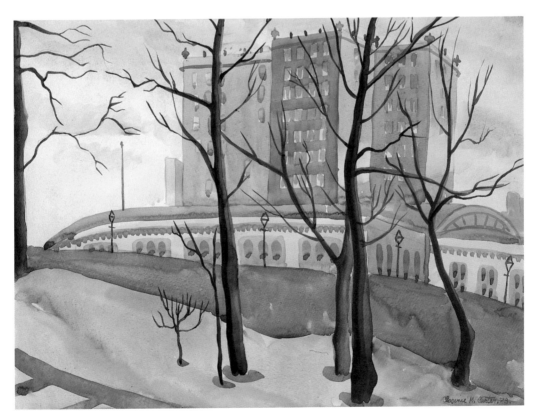

42. *Clarence Holbrook Carter* THE ELYSIUM, 1928 Watercolor on paper: 14 3/4" x 19 3/4" (sight)
A skating rink and several apartment buildings viewed from a park on the northeast side of Cleveland, Ohio

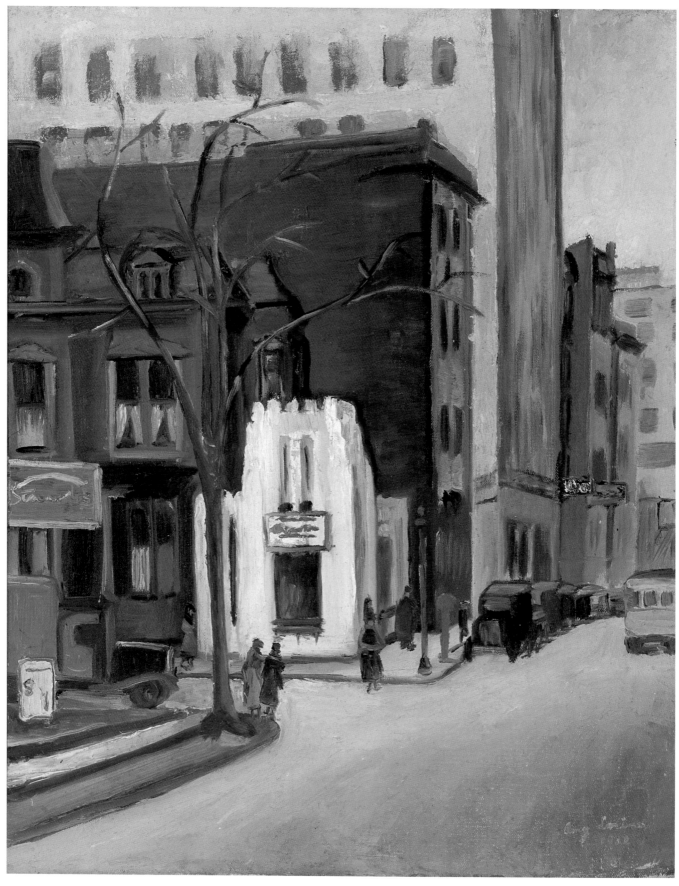

43. *Amy Lorimer* THE WHITE TOWER, 1932 Oil on canvas: 20"x 16"
A street scene in downtown Detroit, Michigan

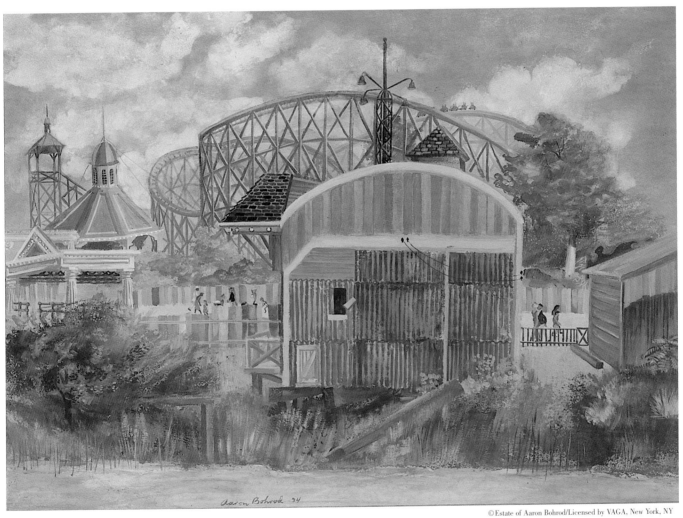

©Estate of Aaron Bohrod/Licensed by VAGA, New York, NY

44. *Aaron Bohrod* RIVERVIEW AMUSEMENT PARK, 1934
Gouache on paper: 13" x 18" (sight)
A popular amusement park located outside the city of Chicago, Illinois

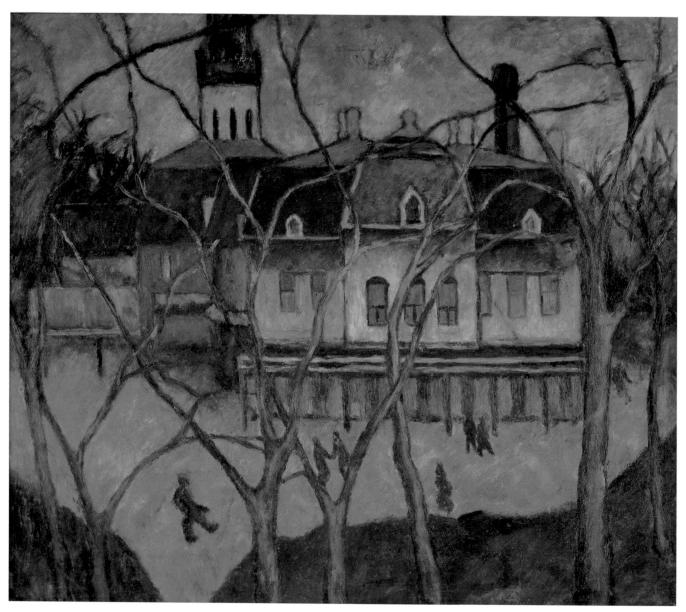

45. *Joseph Friebert* THE WISCONSIN CLUB, 1935 Oil on masonite: 24" x 28"
An early architectural landmark in downtown, Milwaukee, Wisconsin

46. *Charles E. Burchfield* WIRE FENCE IN SNOW, 1936 Watercolor on paper: 26" x 19" (sight)
A view from the backyard of the artist's home in Gardenville (West Seneca), New York

47. *Carlos Lopez* COUNTRY SCHOOLHOUSE, 1937 Oil on canvas: 26 1/4" x 30 1/4"
A typical country school house in rural Michigan

48. *Lawrence McConaha* NIGHT BARNS, ca. 1945. Oil on canvas: 20" x 24"
Farm houses and barns in rural southern Indiana

EVERYDAY ARCHITECTURE

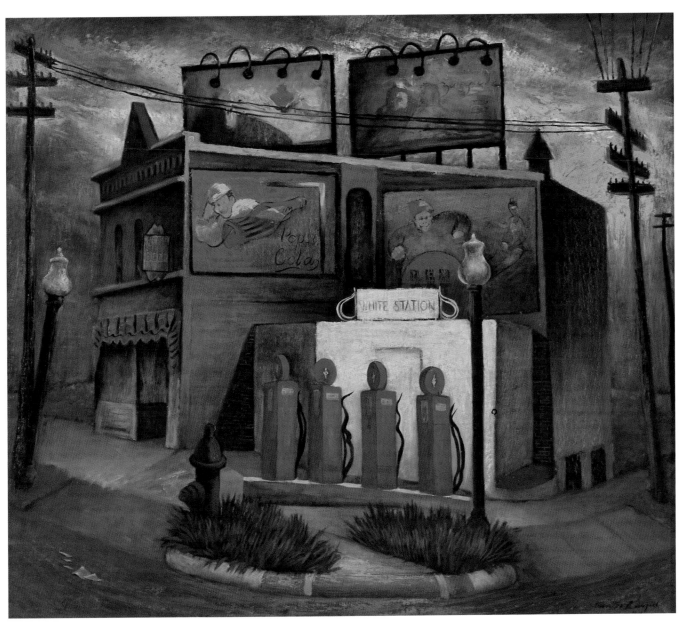

49. *Santos Zingale* THE WHITE STATION—MADISON, 1941 Oil on canvas: 26" x 30"
A well known corner service station in downtown Madison, Wisconsin

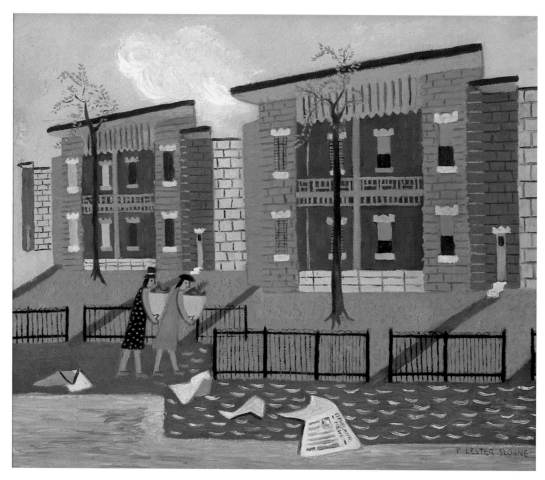

50. *Phyllis Sloane* APARTMENTS, 1945 Oil on board: 22" x 26"
An apartment complex located on the east side of Cleveland, Ohio

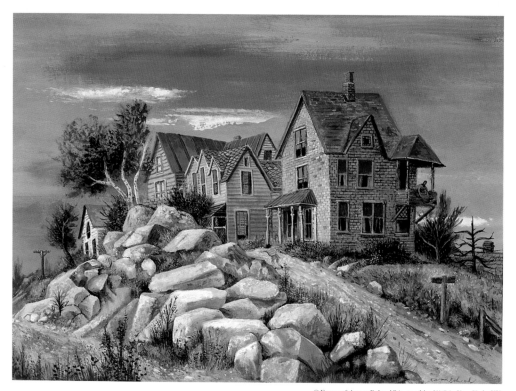

©Estate of Aaron Bohrod/Licensed by VAGA, New York, NY

51. *Aaron Bohrod* HILLY STREET—MARQUETTE, 1953
Gouache on paper: 14 1/2" x 19" (sight)
Houses in the Lake Superior port city of Marquette in northern Michigan

CITIES:

SKYLINES, BOULEVARDS, NEIGHBORHOODS AND DOWNTOWNS

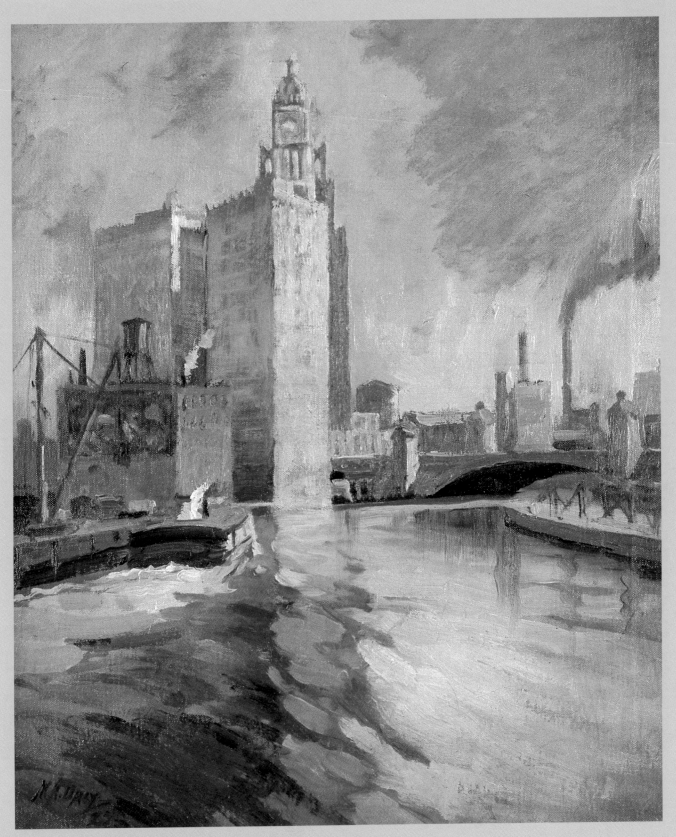

52. *Matt Daly* PORT AND CITY, 1925 Oil on canvas: 24" x 20"
The Wrigley Building and the Tribune Tower viewed from the Chicago River in Chicago, Illinois

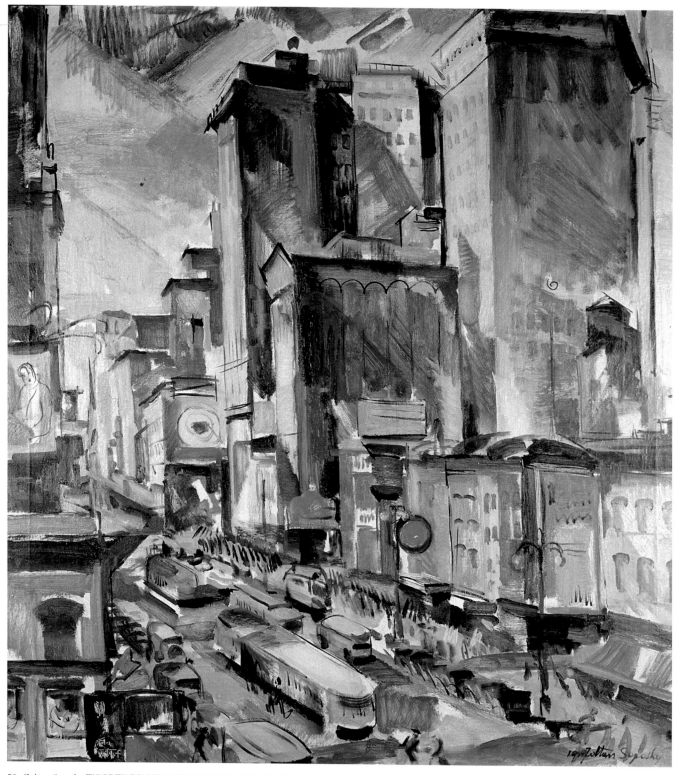

53. *Zoltan Sepeshy* WOODWARD NEAR JEFFERSON, 1929 (WOODWARD AVENUE) Oil on canvas: 36" x 34"
A bird's-eye view of the commercial center of downtown Detroit, Michigan

54. *Louis C. Vogt* THE NEW CINCINNATI GAS AND ELECTRIC, 1929
Watercolor on paper: 9 3/4" x 13 3/4" (sight)
The construction of the main office for the utility company in Cincinnati, Ohio

55. *Amy Lorimer* BOULEVARD—DETROIT, ca. 1932 Oil on canvas: 26 1/4" x 20 1/4"
A tree-lined avenue in a residential neighborhood in Detroit, Michigan

56. *Zoltan Sepeshy* WOODWARD AVENUE NO. II, 1931 Oil on canvas: 25" x 30"
A composite view of the landmarks along the main thoroughfare in the north Detroit suburb of Royal Oak, Michigan

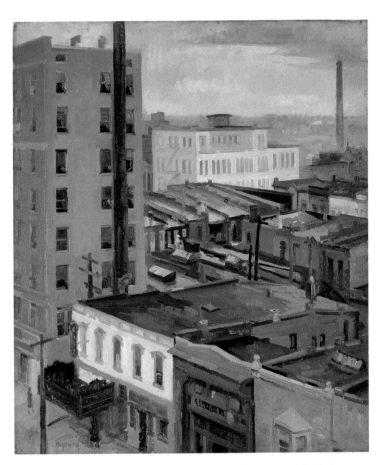

57. *Ruthvan Byrum* ANDERSON ROOFTOPS, 1933 Oil on canvas: 26" x 20"
A bird's-eye view of the city of Anderson, north of Indianapolis, Indiana

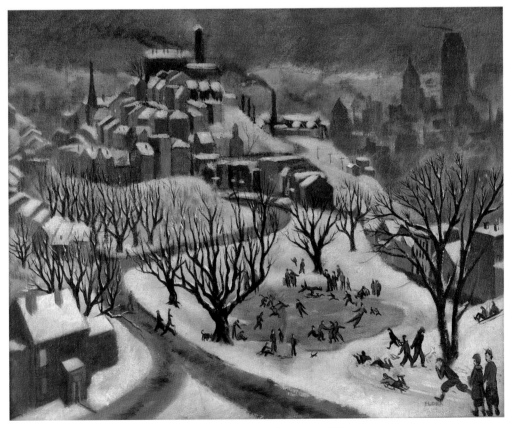

58. *James R. Flora* MOUNT ADAMS WINTER SCENE, 1937 Oil on canvas: 26" x 32"
A winter day in Eden Park on Mt. Adams with a background showing the soot-darkened skyline of Cincinnati, Ohio

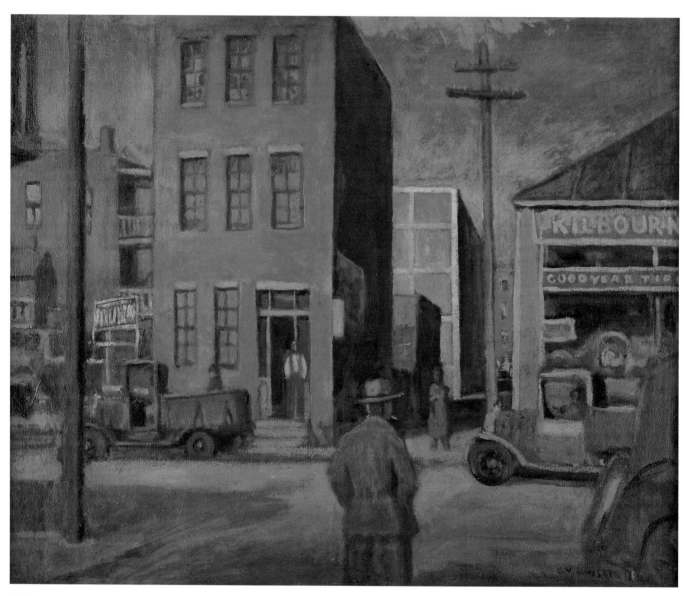

59. *Gerrit V. Sinclair* THIRD WARD RED HOUSE, 1936 Oil on masonite: 20"x 24"
A street scene in a working-class neighborhood on the south side of Milwaukee, Wisconsin

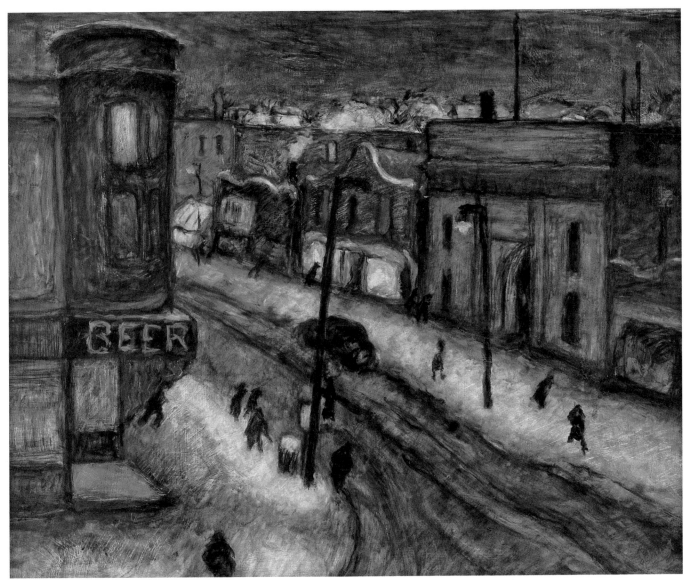

60. *Joseph Friebert* 3RD AND CENTER, 1938 Oil on masonite: 22" x 27"
A winter street scene viewed from the artist's studio in a corner building on the north side of Milwaukee, Wisconsin

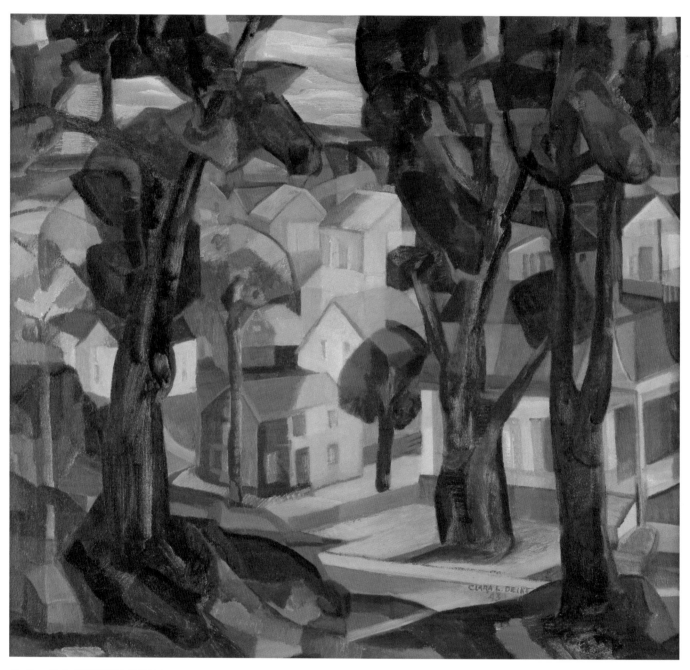

61. *Clara Deike* WESTSIDE CLEVELAND, 1943 Oil on canvas: 24" x 26"
The houses and tree-lined streets in a residential neighborhood on the west side of Cleveland, Ohio

62. *Ethel Johnt* ST. MARY'S OF SORROWS AT DAWN, ca. 1947 Oil on canvas: 25" x 30"
A view of shops and a church along Genesee Street near the artist's studio in Buffalo, New York

63. *Edmund Brucker* THE CAPITOL—INDIANAPOLIS, ca. 1945 Oil on masonite: 22 1/2" x 41 3/4"
A view along the canal near the State Capitol building in Indianapolis, Indiana

64. *Carl Matsuda* HARDYS—LANSING, 1955 Watercolor on paper: 19" x 24" (sight)
A view of the commercial center in downtown Lansing, Michigan

DAILY LIFE:
WORK, PLAY, DOMESTIC ROUTINE AND SOCIAL ACTIVITY

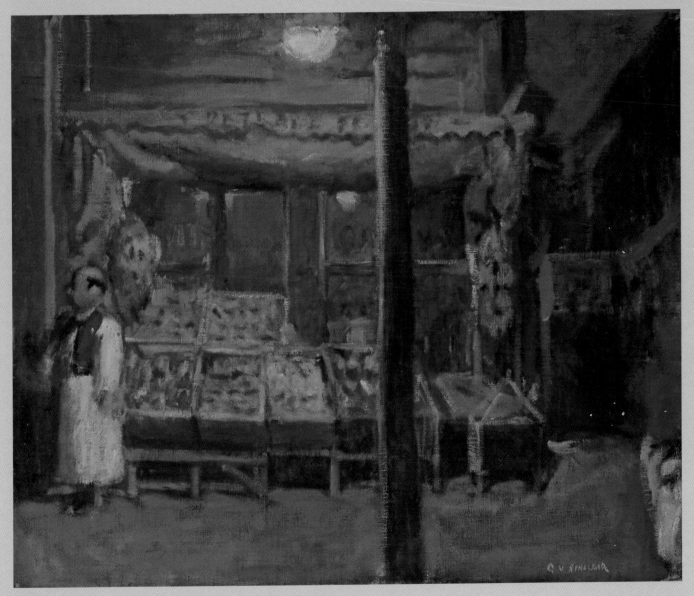

65. *Gerrit V. Sinclair* MILWAUKEE FRUIT STAND, 1916 Oil on canvas: 20" x 24"
A fruit vendor's shop along a street in Milwaukee, Wisconsin

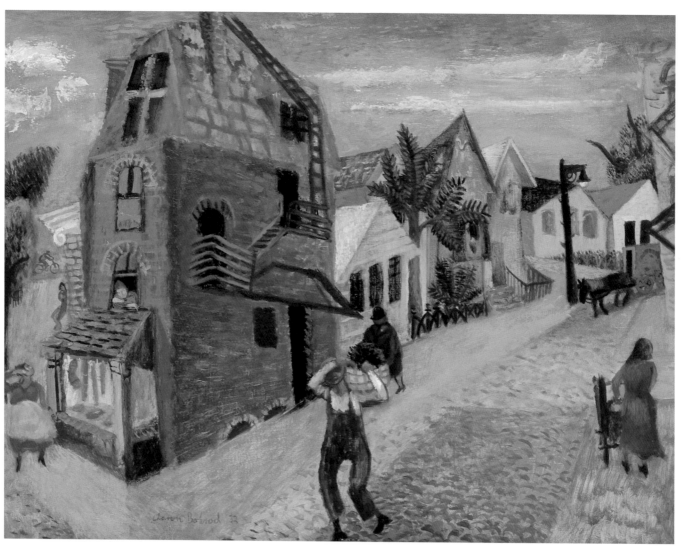

66. *Aaron Bohrod* RED HOUSE CHICAGO, 1932 Oil on masonite: 20"x 26 1/2"

A neighborhood street scene on the north side of Chicago, Illinois

©Estate of Aaron Bohrod/Licensed by VAGA, New York, NY

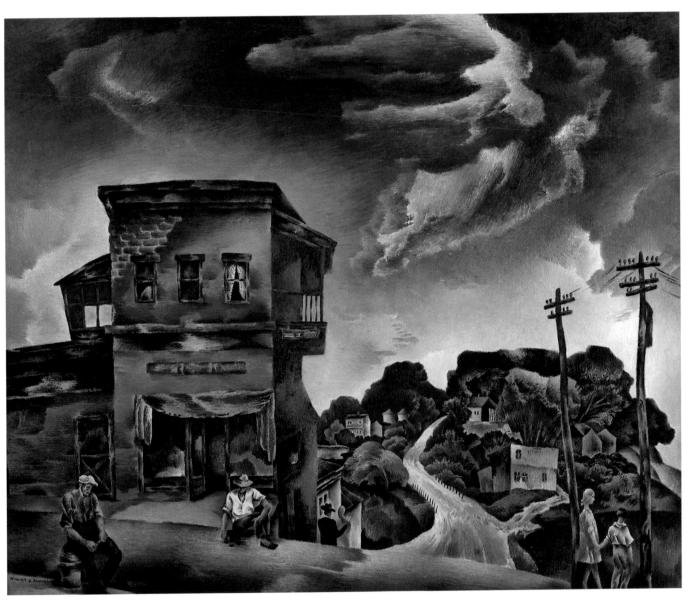

67. *William Schwartz* A VILLAGE CORNER, 1934 Oil on canvas: 30"x 36"
Site unknown: Probably a view of a small town along Lake Michigan in southwest Michigan

68. *William Sommer* FEEDING TIME, ca. 1935 Watercolor on paper: 12" x 16" (sight)
A farmer tending his livestock on a farm in the Brandywine Valley in northeast Ohio

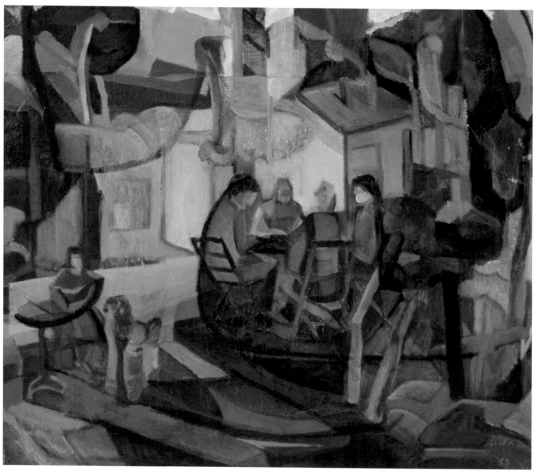

69. *Clara Deike* UNDER THE TREES, 1935, 1941, 1953 Oil on canvas: 20"x 24"
A backyard gathering in a neighborhood on the west side of Cleveland, Ohio

DAILY LIFE

70. *Virginia Cuthbert* MOVIE PALACE, 1936 Oil on canvas: 25" x 30"
A street scene near the Rialto Theater in Pittsburgh, Pennsylvania

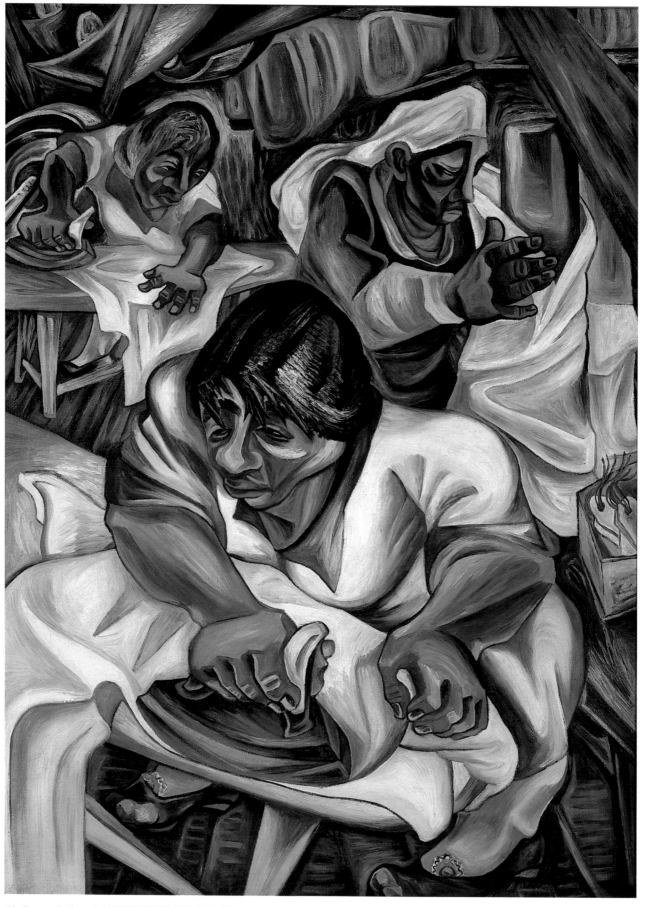

71. *Bernece Berkman* LAUNDRY WORKERS, 1938 Oil on canvas: 40" x 30"
African American women in a commercial laundry in Chicago, Illinois

DAILY LIFE

72. *Bernece Berkman* FLYING ON HUBBARD STREET, 1940
Oil on canvas: 40"x 30"
Two children on a bicycle riding near the Chicago River in Chicago, Illinois

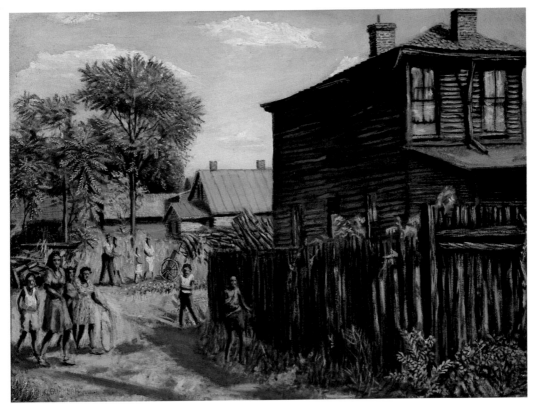

73. *Emerson Burkhart* BACKSTREET PARADE, 1944 Oil on canvas: 22" x 30"
A summertime gathering in an African American neighborhood in Columbus, Ohio

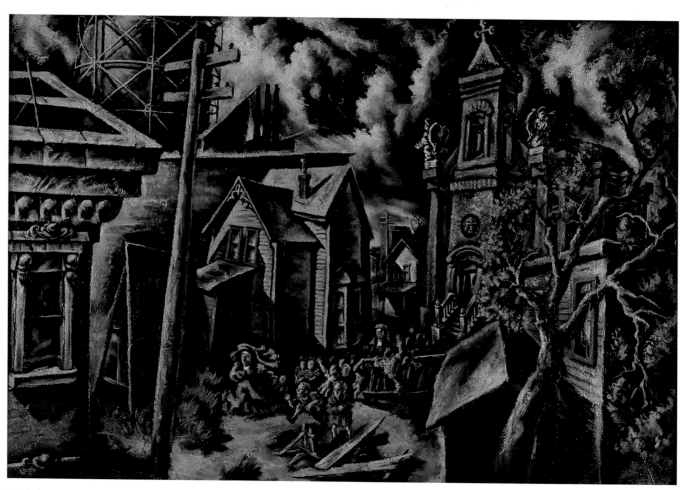

74. *Jack Keijo Steele* RECESS AT ST. BONIFACE SCHOOL, ca. 1947 Oil on masonite: 24" x 35 1/4"
A composite scene with a neighborhood church and school that once stood near the baseball stadium in southwest Detroit, Michigan

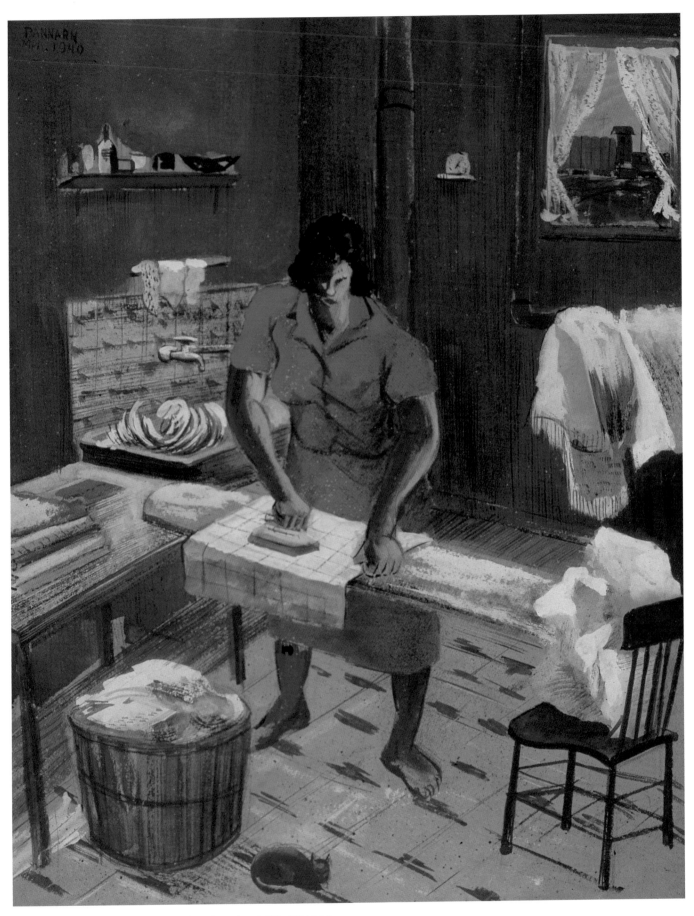

75. *Henry Bannarn* IRONING DAY, 1949 Gouache on board: 20"x 16" (sight)
An interior scene with grain elevators visible through a window in Minneapolis, Minnesota

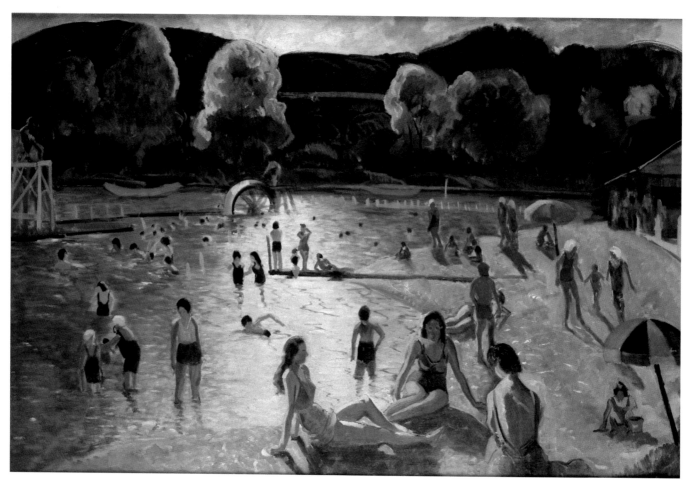

76. *Lawrence McConaha* SPRINGWOOD, ca. 1948 Oil on canvas: 30"x 45"
Bathers at a popular recreational lake near Richmond, Indiana

77. *Floyd Hopper* TEN TILL ELEVEN, 1957–58 Watercolor on paper: 14 1/2" x 21" (sight)
The balloon release at the start of the Memorial Day auto race in Indianapolis, Indiana

INDUSTRY AND COMMERCE:
MINING, SHIPPING, BUILDING AND MANUFACTURING

78. *Aaron Harry Gorson* BARGES PASSING UNDER A BRIDGE, ca. 1910–1915 Oil on canvas: 16" x 19"
A towboat pushing barges up the Monongahela River on the south side of Pittsburgh, Pennsylvania

79. *Charles Biesel* IRONWORKERS ON THE RIVER, 1919 Watercolor on paper: 16" x 20"(sight)
A winter view of heavy construction along the Chicago River in Illinois

80. *Fred Biesel* EVENING—SOUTH CHICAGO, 1925 Oil on canvas: 26" x 30"
Factory buildings and smokestacks near the Calumet River on the south side of Chicago, Illinois

INDUSTRY AND COMMERCE

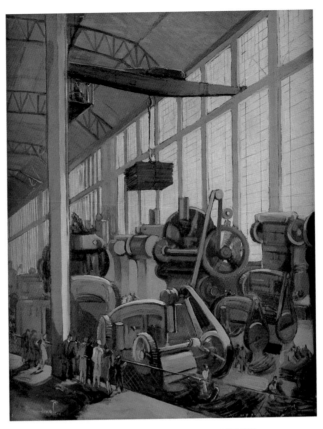

81. *Alexander Levy* STAMPING ROOM—PIERCE ARROW
FACTORY, ca. 1924 Oil on plywood: 20"x 15"
*Car parts being stamped out at the Pierce Arrow automobile factory
in Buffalo, New York*

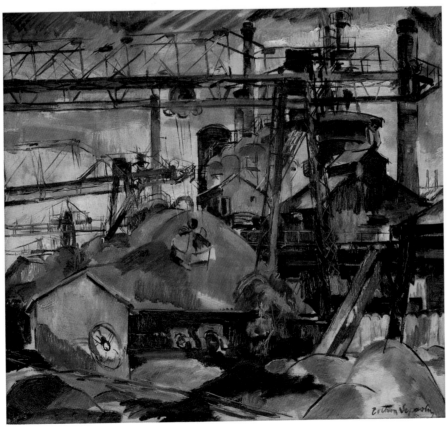

82. *Zoltan Sepeshy* STEEL MILL—ZUG ISLAND, ca. 1928 Oil on canvas: 25" x 28"
Loading cranes, smelting furnaces, and rail tracks at a steel mill on the Rouge River near Detroit, Michigan

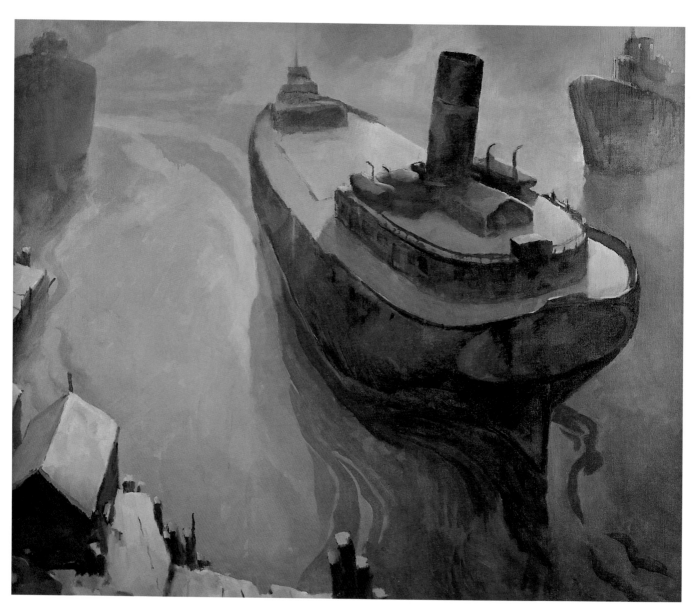

83, *Carl Gaertner* FREIGHTERS, 1931 Oil on canvas: 35" x 41"
Great Lakes ore ships at the mouth of the Cuyahoga River in Cleveland, Ohio

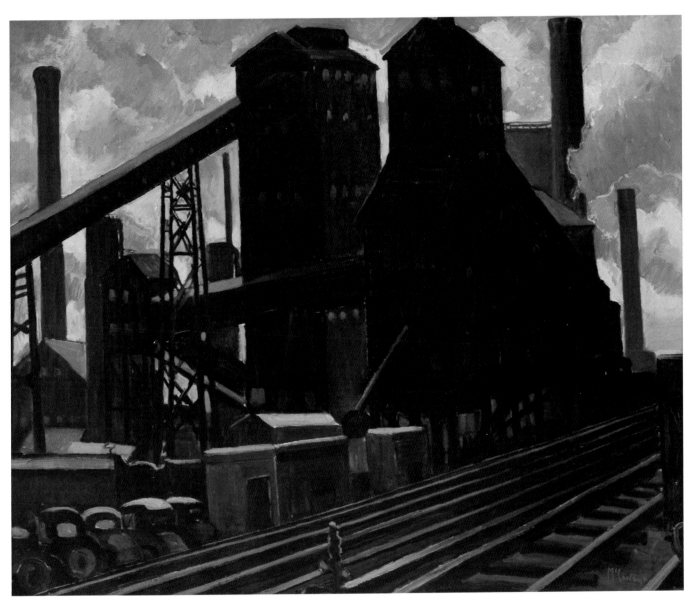

84. *Lawrence McConaha* COKE OTTO, 1933 Oil on canvas: 25" x 30"
An industrial coke processing factory located near the city of Hamilton in southwest Ohio

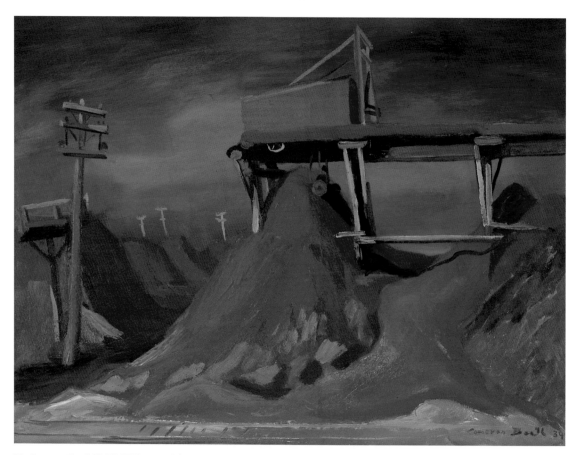

85. *Cameron Booth* IRON ORE, 1934 Oil on canvas: 24" x 32"
A mine in the Iron Range near the town of Hibbing in northern Minnesota

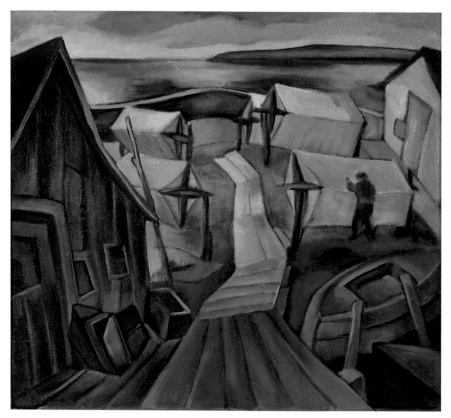

86. *Joseph Sparks* NET MENDING ROW, ca. 1936 Oil on canvas: 18" x 20"
Wooden net winders and storage sheds along Lake Michigan near the town of Frankfort, Michigan

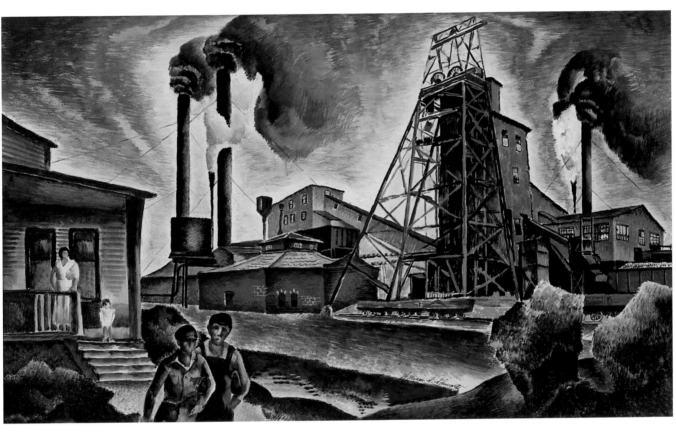

87. *William Schwartz* MINING IN ILLINOIS, ca. 1937 Gouache on paper: 12" x 20"(sight)
A composite view of the mining industry created as a study for a mural in the post office at Eldorado, Illinois.

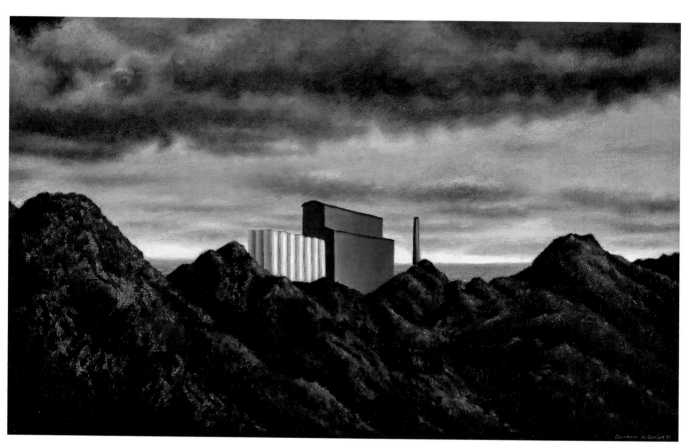

88. *Clarence Holbrook Carter* COAL DOCKS AT SUPERIOR, 1939 Oil on canvas: 18" x 30"
Coal piles and storage structures along Lake Superior near Superior, Wisconsin

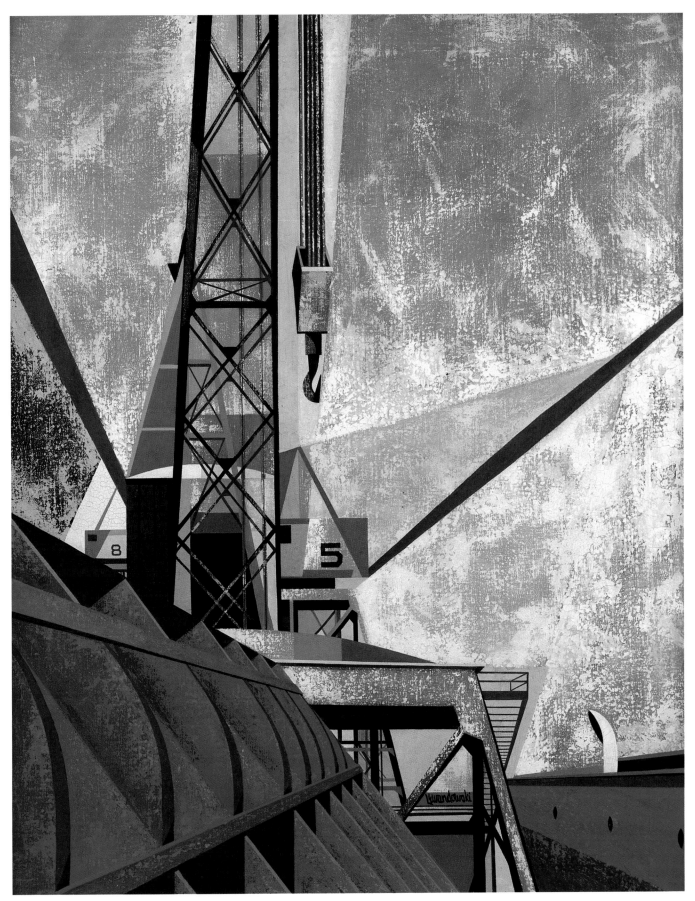

89. *Edmund Lewandowski* GREAT LAKES SHIPBUILDING, 1949 Oil on canvas: 30"x 24"
A composite image of the shipyards at Sturgeon Bay and Manitowoc, Wisconsin

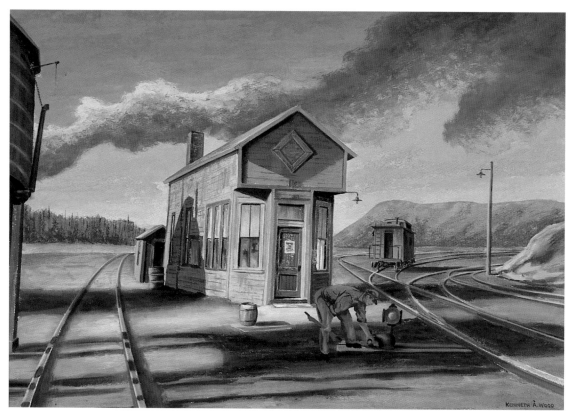

90. *Kenneth Wood* WARM SHADOWS, 1953 Gouache on board: 15" x 22" (sight)
The railyard near Lake Erie northeast of Cleveland in Fairport Harbor, Ohio

91. *Jack Keijo Steele* ASSEMBLY LINE, ca. 1954 Oil on masonite: 20"x 30"
Workers inside the Ford Motor Company assembly plant in Dearborn, Michigan

HISTORY AND IDENTITY:
EVENTS, CUSTOMS, MEMORIES AND MUSINGS

92. *Clyde Singer* THE MEDICINE MAN, 1932 Oil on burlap: 27 1/4" x 34"
A traveling medicine show in the town of Minerva east of Canton, Ohio

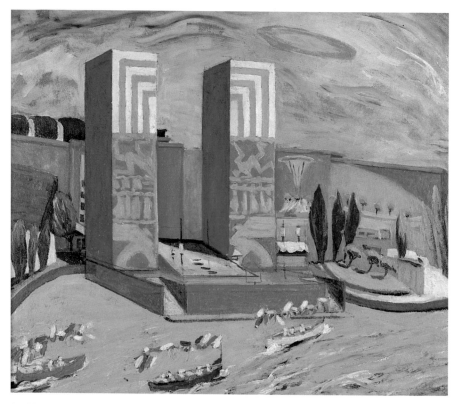

93. *Minnie Harms Neebe* A CENTURY OF PROGRESS, 1933 Oil on masonite: 22" x 26"
The Electric Building erected for the Century of Progress Fair of 1933 and the lagoon now known as
Burnham Park Harbor in Chicago, Illinois

94. *Clara Mairs* HALLOWEEN, 1935 Oil on masonite: 24" x 20"
Children in costumes parading on Halloween in St. Paul, Minnesota

95. *Carlos Lopez* SPRING, 1937 Oil on canvas: 30" x 38"
Sunday worshipers gathering at a country church in rural Michigan

96. *Ethel Spears* FORTH OF JULY, ca. 1938 Tempera on board: 22" x 30 1/2" (sight)
A bird's-eye view of July 4th festivities on the north side of Chicago, Illinois

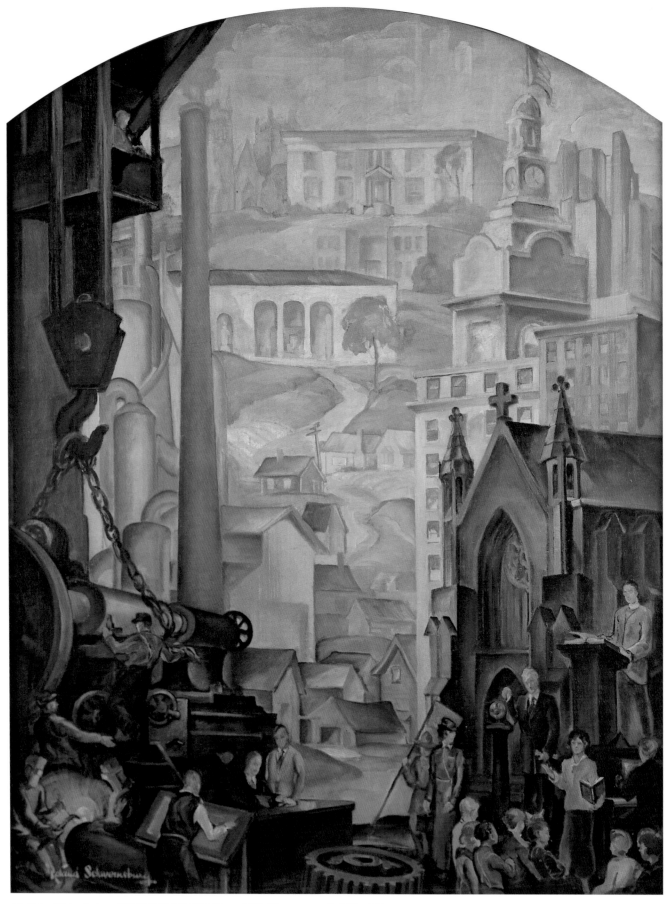

97. Roland Schweinsburg YOUNGSTOWN MURAL, ca. 1938 Oil on canvas: 51 1/2" x 40"
A mural that commemorates industry, civic service, economic prosperity, and cultural growth in Youngstown, Ohio

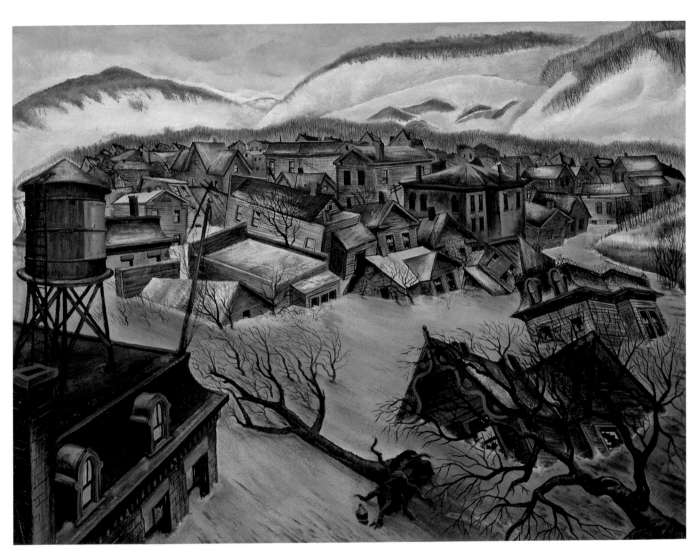

98. *Edward Dobrotka* SARGASSO SEA—OHIO, 1938 Oil on canvas: 30"x 40"
An artist's reconstruction of an historic Ohio River flood in southern Ohio

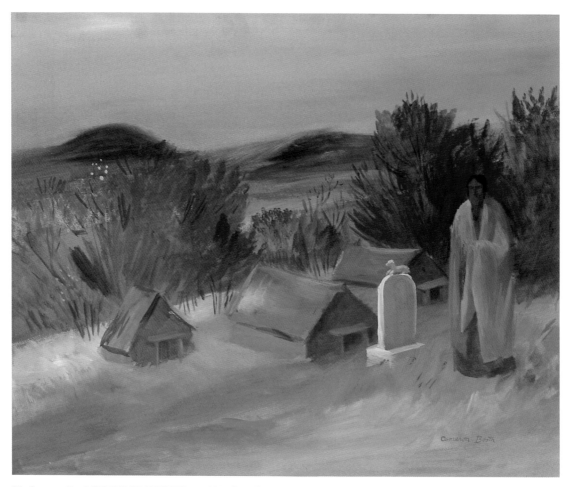

99. *Cameron Booth* INDIAN GRAVEYARD, ca. 1940 Gouache on paper: 18 1/2" x 22 1/2"
A Native American figure amid traditional grave markers in the Chippewa burial ground near Onigum in northern Minnesota

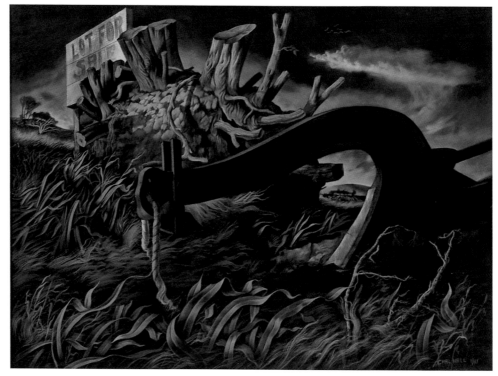

100. *Carl Hall* LOT FOR SALE, 1941 Gouache on board: 13 1/2" x 18" (sight)
A symbolic representation of change and loss in rural Michigan during the Great Depression

HISTORY AND IDENTITY

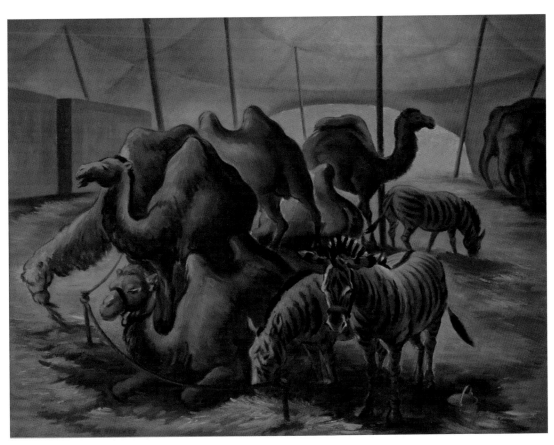

101. *Edmund Brucker* THE MENAGERIE, ca. 1943 Oil on canvas: 19" x 25"
Animals feeding in the menagerie tent of a traveling circus visiting Indianapolis, Indiana

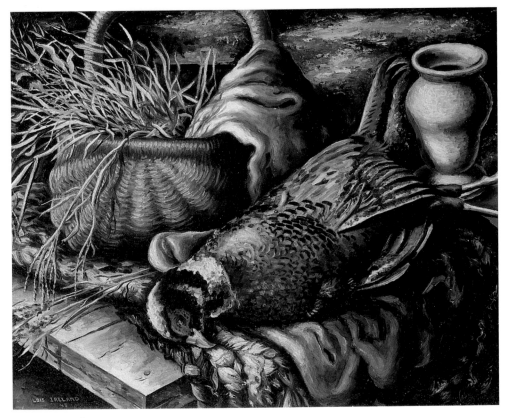

102. *Lois Ireland* A HUNTER'S PRIZE CATCH, 1945 Oil on canvas: 15 1/2" x 19 1/2"
A regional still life celebrating the bounty of the farmland surrounding the artist's hometown of Waunakee just north of Madison, Wisconsin

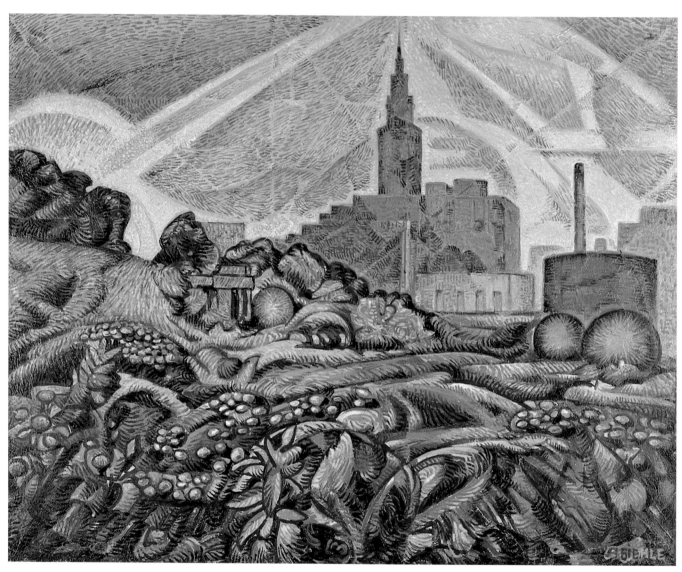

103. *August F. Biehle, Jr.* TERMINAL TOWER—CLEVELAND, ca. 1945 Oil on masonite: 24" x 30"
A artist's vision of prosperity and progress in post-World War II Cleveland, Ohio

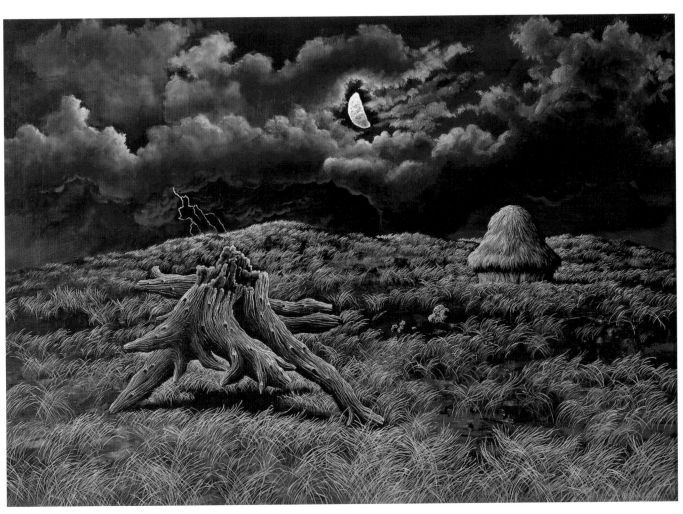

104. *John Rogers Cox* NOCTURNE—SILVER AND GREY, 1952 Oil and tempera on masonite: 17" x 24"
A fantasy night storm passing over a moonlit field of stubble in a composite rural Indiana landscape

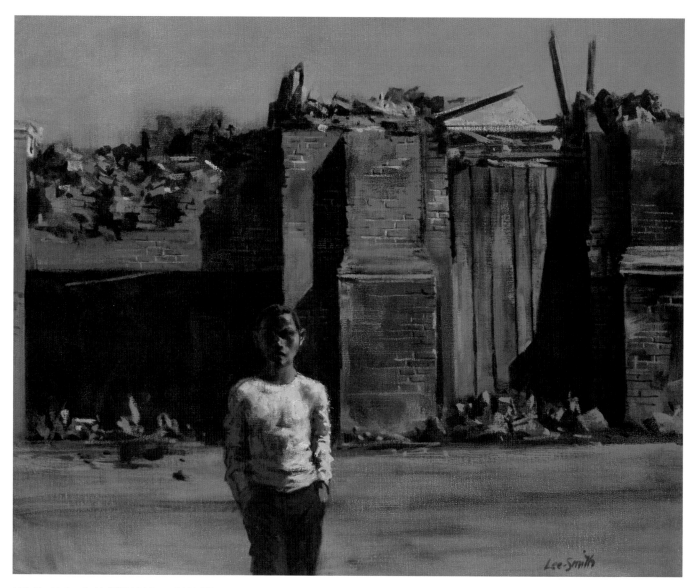

105. *Hughie Lee-Smith* SLUM LAD, ca. 1960 Oil on canvas: 26" x 32"
A composite landscape that transforms a Detroit-based image into a symbol of social change in the urban Midwest.

Artist Biographical Sketches
with Entries on the Paintings

1. JEAN CRAWFORD ADAMS (1884–1972)

Jean Crawford Adams was born in Chicago in 1884. She studied at the School of the Art Institute of Chicago and in Paris. Adams lived and worked in Chicago all of her life, though she did travel frequently both in the United States and abroad. She was a member of the Chicago Society of Artists and another group of Chicago artists known as the Ten. Through her long career, Adams held numerous solo exhibitions and participated regularly in the annual exhibitions of the Chicago No-Jury Society of Artists. Her work was also included in the city of Philadelphia's Sesquicentennial Exposition and in various group exhibitions held at the Art Institute of Chicago, the Carnegie Institute, the Detroit Institute of Arts, and the Pennsylvania Academy of the Fine Arts. Adams was a part of the first generation of Chicago painters to embrace postimpressionism. In the 1920s, her work became bold and graphic, and her colors strong and fauvist. Building her images from patterns of unblended paint strokes, Adams created a personal style of expression that uniquely enriched American Scene painting in the Great Lakes region. The subjects Adams favored in her art reflect her life in the urban Midwest. She is best known for her depictions of Chicago and its distinctive architecture. Her fascination with place, however, also led her to paint numerous landscape views of rural Illinois, Indiana, and Wisconsin. Jean Crawford Adams died in 1971, and is remembered as a pioneer of modern Chicago painting. She once stated that she sought to identify and artistically transform "the currents of power which may be spiritualized and transmuted into art." Her paintings are included in public collections in Baltimore, Maryland; and Springfield, Illinois.

LAKE GENEVA (Plate 3)*
Oil on board, 1929
16" x 20" unsigned.
Period frame: carved and gilded

Exhibited:
The Art Institute of Chicago, (Illinois), 1930, *Jean Crawford Adams.*
Center Galleries, Center for Creative Studies, (Detroit), and Cleveland State University Art Gallery, (Cleveland), 1994, *A Place in Time: The Inlander Collection of Great Lakes Regional Painting*, cat.
Dennos Museum Center, (Traverse City, Michigan), 1996, *Painters of the Great Lakes Scene*, cat.; toured 1997, to Kalamazoo Institute of Arts (Michigan), Flint Institute of Arts (Michigan).

Published:
Dennis Nawrocki and Robert Thurmer, *A Place in Time: The Inlander Collection of Great Lakes Regional Painting* (Cleveland State University: 1994).

ILLINOIS FARM (Plate 20)
Oil on board, ca. 1930
18" x 24" unsigned.
Period frame: painted

Exhibited:
Dennos Museum Center, (Traverse City, Michigan), 1996, *Painters of the Great Lakes Scene*, cat.; toured 1997, to Kalamazoo Institute of Arts (Michigan), Flint Institute of Arts (Michigan).

Published:
Michael D. Hall, *Painters of the Great Lakes Scene* (Dennos Museum Center: 1996).

2. DEWEY ALBINSON (1898–1971)

Born in 1898, Dewey Albinson was the son of a Swedish immigrant who had become a successful upper-middle class businessman in Minneapolis. Around the age of twelve, Albinson was wounded by a gunshot fired by two boys who had stolen his bicycle. During his recuperation he began to sketch and paint. He resolved to study painting seriously and in 1915 he enrolled in the Minneapolis School of Art. In 1919, Albinson moved to New York to continue his studies at the Art Students League. He returned to Minnesota in 1921 and began painting landscapes celebrating the rugged beauty of his native state. The St. Croix River Valley around the town of Taylors Falls became one of his favorite subjects. In 1922 Albinson traveled to Paris, where he studied for two years with the Cubist painters, Andre Lhote and Roger Bissiere. Returning home, he taught briefly at the St. Paul School of Art. Between 1935 and 1937, Albinson served as state director for the WPA. He then moved away from Minnesota, living in Quebec, Miami, and Lambertville, New Jersey, before finally settling in Mexico in 1952. He remained in Mexico for most of the rest of his life. Albinson's early work was presented in numerous solo exhibitions both in the Midwest and in New York. It was also included in *American Art Today* at the 1939 New York World's Fair. During his lifetime, Albinson exhibited his paintings in the Metropolitan Museum of Art, the Whitney Museum of American Art, the Art Institute of Chicago, the Detroit Institute of Arts, the Pennsylvania Academy of the Fine Arts. In addition, he exhibited his work in European museums in Stockholm, Munich, and Copenhagen. Commissioned for several public works, Albinson painted murals for the post offices in Cloquet, Minnesota, and Marquette, Michigan. Dewey Albinson died in 1971. His paintings can be found in the permanent collections of the Minneapolis Art Institute; San Diego Museum of Art, California; the Addison Gallery of American Art, Massachusetts; and the Labor Department in Washington D.C.

TAYLORS FALLS (Plate 18)
Oil on canvas, 1922
26" x 26" s.d.–l.l.
Original frame: gilded and painted

Exhibited:
Center Galleries, Center for Creative Studies, (Detroit), and
Cleveland State University Art Gallery, (Cleveland), 1994, *A Place in
Time: The Inlander Collection of Great Lakes Regional Painting*, cat.

Published:
Dennis Nawrocki and Robert Thurmer, *A Place in Time: The
Inlander Collection of Great Lakes Regional Painting*
(Cleveland State University: 1994).

3. HENRY BANNARN (1910–1965)

Henry Bannarn was born in Wetunka, Oklahoma, in 1910. Early
in his life, his family moved to the Upper Midwest where Henry
grew up in the African American community of Minneapolis,
Minnesota. Bannarn began his study of art at the Minnesota
School of Art in the late 1920s. He completed his art training in
New York in the early 1930s at the Art Students League where he
studied under painters B.J.O. Nordfelt, Carl Mose, and George
Oberteuffer, as well as the sculptor, Ahron Ben-Schumel. Best
known professionally as a sculptor, Bannarn also distinguished
himself as a painter and an educator through his career. Settling in
New York, Bannarn became active in the Harlem Renaissance
movement of the 1930s. The studio/workshop he co-founded with
the painter Charles Alston became an important intellectual and
artistic center of the Harlem art scene between 1934 and 1936.
Bannarn's first important national recognition came in 1939 when
his work was selected for inclusion in the groundbreaking exhibi-
tion of works by African American artists held at the Baltimore
Museum of Art. In 1945, Bannarn won the first prize for landscape
painting in the *4th Annual Exhibition of Art by Contemporary
American Negro Artists* held at Atlanta University. Throughout his
career, Bannarn retained his ties to Minnesota. He exhibited regu-
larly in exhibitions of Minnesota artists and won first prizes in
juried exhibitions held in Minneapolis in 1932 and 1940. In both
his paintings and his sculpture, Bannarn addressed the plight of
African Americans and celebrated historic figures important in his
people's struggle for freedom. Henry Bannarn died in Brooklyn in
1965. His work can be found in the collections of the Howard
University Gallery of Art; Atlanta University; and the National
Archives in Washington D.C.

IRONING DAY (Plate 75)
Gouache on board, 1949
20"x 16" (sight) s.d.–u.l.
Reproduction frame: gilded

Exhibited:
Center Galleries, Center for Creative Studies, (Detroit), and
Cleveland State University Art Gallery, (Cleveland), 1994, *A
Place in Time: The Inlander Collection of Great Lakes Regional
Painting*, cat.

Published:
Dennis Nawrocki and Robert Thurmer, *A Place in Time: The
Inlander Collection of Great Lakes Regional Painting*
(Cleveland State University: 1994).

4. BERNECE BERKMAN (1911–1979)

Bernece Berkman was born in Chicago, Illinois, in 1911. She stud-
ied art at the School of the Art Institute of Chicago and privately
with two of Chicago's important early modernists, Todros Geller
and Rudolph Weisenborn. She also studied briefly in New York at
Hunter College and at the New School for Social Research under
Stuart Davis. It was her Chicago mentors, however, who had the
greatest impact on her. Geller viewed art as a tool for social reform.
Weisenborn was a rebel who involved himself with all art move-
ments that went against academic standards and traditions. Both of
these artists introduced Berkman to cubism and expressionism and
encouraged her to address social issues in her work. Establishing
herself in Chicago, Berkman began exhibiting with the Chicago
Society of Artists and the Chicago Woman's Salon. In 1939 one of
her paintings was included in the *American Art Today* exhibition at
the New York World's Fair. In the spirit of Geller and Weisenborn,
Berkman became a social commentator with a bold, expressionist
style. Her sympathies for the plight of workers and the poor gave
her paintings a political tone not unlike that found in works by her
New York contemporaries Ben Shahn and William Gropper. By the
mid-1940s, Berkman turned to making highly abstract paintings
that were no longer focused on social and regional issues. In the
years before World War II, however, Bernece Berkman transformed
her vision of the urban Chicago world around her into some of the
most original and politically charged paintings created by any
American Scene artist. Bernece Berkman died in 1979. Her paint-
ings are included in the collections of the Art Institute of Chicago;
University of Omaha, Nebraska; the Evansville Illinois State
Hospital; Carnegie Museum of Art; Seattle Art Museum; University
of Iowa; and the University of Michigan.

LAUNDRY WORKERS (Plate 71)
Oil on canvas, 1938
40"x 30" s.d.–l.r.
Period frame: painted

Exhibited:
Columbus Museum of Art, (Ohio), 2000, *Illusions of Eden: Visions
of the American Heartland* cat.; toured 2000–2001, to Museum of
Modern Art (Vienna), Ludwig Museum (Budapest), Madison Art
Center (Wisconsin), Washington Pavilion (South Dakota).
Columbus Museum of Art, (Ohio), 2003, *American Expressionism*
cat.; toured 2003, to The Kennedy Gallery (New York), Portland
Museum of Art (Oregon).

Published:
Robert Stearns, ed., *Illusions of Eden: Visions of the American
Heartland* (Arts Midwest: 2000).
Bram Dijkstra, *American Expressionism: Art and Social Change
1920–1950* (Abrams: 2003).

FLYING ON HUBBARD STREET (Plate 72)
Oil on canvas, 1940
40"x 30" s.d.–l.r.
Original frame: painted

Exhibited:
Center Galleries, Center for Creative Studies, (Detroit), and
Cleveland State University Art Gallery, (Cleveland), 1994, *A
Place in Time: The Inlander Collection of Great Lakes Regional
Painting*, cat.

Dennos Museum Center, (Traverse City, Michigan), 1996, *Painters of the Great Lakes Scene*, cat.; toured 1997, to Kalamazoo Institute of Arts (Michigan), Flint Institute of Arts (Michigan).
Columbus Museum of Art, (Ohio), 2000, *Illusions of Eden: Visions of the American Heartland* cat.; toured 2000–2001, to Museum of Modern Art (Vienna), Ludwig Museum (Budapest), Madison Art Center (Wisconsin), Washington Pavilion (South Dakota).

Published:

Dennis Nawrocki and Robert Thurmer, *A Place in Time: The Inlander Collection of Great Lakes Regional Painting* (Cleveland State University: 1994).
Robert Stearns, ed., *Illusions of Eden: Visions of the American Heartland* (Arts Midwest: 2000).

LAKE SHORE (Plate 8)
Gouache on paper, 1940
18" x 24" (sight) s.d.–l.r.
Period frame: painted

Exhibited:

Dennos Museum Center, (Traverse City, Michigan), 1996, *Painters of the Great Lakes Scene*, cat.; toured 1997, to Kalamazoo Institute of Arts (Michigan), Flint Institute of Arts (Michigan).

Published:

Michael D. Hall, *Painters of the Great Lakes Scene* (Dennos Museum Center: 1996).

5. AUGUST F. BIEHLE, JR. (1885–1979)

August F. Biehle, Jr., was born in Cleveland, Ohio, in 1885. At an early age he learned painting from his father who had been trained in Germany as a painter of decorative murals. In 1903, young Biehle went to Europe and studied for two years at the Kunstgewerbeschule in Munich. He returned to Cleveland and attended evening classes at the Cleveland School of Art. In 1910 he again went to Munich and came in contact with the Blue Rider group. Excited by the new art emerging in Europe, Biehle became a modernist. Returning to Cleveland in 1912, he joined the city's progressive art society, the Kakoon Klub. He also began to paint in the company of William Sommer and other Cleveland painters identified with the city's avant-garde movement. Between 1919 and 1921 Biehle spent his summers studying with Henry Keller and learning new approaches to color and design. From 1920 on, Biehle became a regular exhibitor in the annual May Show held at the Cleveland Museum of Art. He also mounted a number of successful solo exhibitions in the Cleveland area. Design and composition were important to Biehle's style, and his earliest mature works exhibit a decorativeness that reflects the artist's strong interest in stylized organic form and the art of the German *Jugendstil*. Despite their reference to actual sites, Biehle's regional landscapes are inherently abstract. In spirit, they reflect the northern European modernist tradition that Biehle himself had brought to the Cleveland art scene. After a long and active life as an artist, August F. Biehle, Jr. died in 1979. His works are in the Cleveland Museum of Art; the Butler Institute of American Art; as well as numerous private collections throughout the state of Ohio.

ZOAR OHIO, ROAD TO THE SCHOOLHOUSE (Plate 15)
Watercolor, pencil and gouache on paper, 1917
18 3/4" x 24" (sight) s.d.–l.r.
Period frame: carved and gilded

Exhibited:

Center Galleries, Center for Creative Studies, (Detroit), and Cleveland State University Art Gallery, (Cleveland), 1994, *A Place in Time: The Inlander Collection of Great Lakes Regional Painting*, cat.
Columbus Museum of Art (Ohio), 1997, *The Paintings of Charles Burchfield: North by Midwest*, cat.; toured 1997–98, to Burchfield-Penney Art Center (Buffalo), National Museum of American Art (Washington D.C.).
The Beck Center (Cleveland), 2000, *The Poetics of Place: Charles Burchfield and the Cleveland Connection*.

Published:

Dennis Nawrocki and Robert Thurmer, *A Place in Time: The Inlander Collection of Great Lakes Regional Painting* (Cleveland State University: 1994).
Nannette Maciejunes and Michael D. Hall, *The Paintings of Charles Burchfield: North by Midwest* (Abrams: 1997).

HOLLYHOCKS (Plate 16)*
Gouache on paper, ca. 1919
11" x 15" (sight) s.d.–l.r.
Period frame: carved and gilded

Exhibited:

Dennos Museum Center, (Traverse City, Michigan), 1996, *Painters of the Great Lakes Scene*, cat.; toured 1997, to Kalamazoo Institute of Arts (Michigan), Flint Institute of Arts (Michigan).

Published:

Michael D. Hall, *Painters of the Great Lakes Scene* (Dennos Museum Center: 1996).

TERMINAL TOWER (Plate 103)
Oil on masonite, ca. 1945
24" x 30" s.–l.r.
Period frame: painted

Exhibited:

Center Galleries, Center for Creative Studies, (Detroit), and Cleveland State University Art Gallery, (Cleveland), 1994, *A Place in Time: The Inlander Collection of Great Lakes Regional Painting*, cat.

Published:

Dennis Nawrocki and Robert Thurmer, *A Place in Time: The Inlander Collection of Great Lakes Regional Painting* (Cleveland State University: 1994).

6. CHARLES BIESEL (1865–1945)

Charles Biesel was born in New York City in 1865. He studied art in New York and spent his early years painting landscape scenes along the New England coast. Proficient in both oil and water media, Biesel identified his work as "decidedly American" and claimed that his realist style had been greatly influenced by Winslow Homer and John Sloan. Sometime in the second decade

of the twentieth century, Biesel moved to Chicago, where he became a member of the Arts Club of Chicago and the Chicago Society of Artists. In 1922, Biesel helped found the Chicago No-Jury Society of Artists and served as the Society's first secretary. His early experience as a member of the Society of Independent Artists in New York served him well as he sought to help the No-Jury Society gain recognition for the vanguard artists of Chicago. Biesel held numerous solo exhibitions in galleries throughout the Midwest and the East. He was also a regular participant in group exhibitions sponsored by the various art organizations to which he belonged. Additionally, Biesel was a frequent exhibitor in the annual exhibitions of Chicago painters held at the Art Institute of Chicago. His views of industrial Chicago anticipate the urban scenes that would be produced by the Chicago regionalists of the 1930s. Charles Biesel died in Chicago in 1945. His landscapes and marine paintings are found in private collections in New York; New England; Pennsylvania; and throughout the Chicago area.

IRONWORKERS ON THE RIVER (Plate 79)
Watercolor on paper, 1919
16" x 20" (sight) s.d.–l.r.
Period frame: painted

Exhibited:
Center Galleries, Center for Creative Studies, (Detroit), and Cleveland State University Art Gallery, (Cleveland), 1994, *A Place in Time: The Inlander Collection of Great Lakes Regional Painting*, cat.

Published:
Dennis Nawrocki and Robert Thurmer, *A Place in Time: The Inlander Collection of Great Lakes Regional Painting* (Cleveland State University: 1994.

7. FRED BIESEL (1893–1962)

Born in Philadelphia in 1893, Fred Biesel began his study of art at the Rhode Island School of Design. Sometime around 1924, Biesel moved to Chicago following the path of his father, the painter Charles Biesel, who had become a resident of the city a few years earlier. The younger Biesel completed his art studies at the Art Institute of Chicago. His important teachers were Robert Henri, George Bellows, Randall Davey, and John Sloan. Once out of school, Biesel quickly became identified with the growing community of young Chicago artists working in various avant-garde styles. His immediate circle included V.M.S. Hannell, Emil Armin, and the painter Frances Strain, who ultimately became his wife. Experimenting with various postimpressionist styles, these artists frequently painted colorful and expressionistic views of the industrial and rural landscapes they found south of Chicago along the Indiana shore of Lake Michigan. Biesel exhibited with the Chicago No-Jury Society of Artists and with another Chicago group known as the Ten. He also participated in museum exhibitions as far away as Rhode Island, New York, New Mexico, and New Jersey. At mid-career he was awarded a solo exhibition at the Art Institute of Chicago. During the 1930s Biesel served as assistant supervisor for the Illinois State WPA arts project. Fred Biesel died in Chicago in 1962. His paintings are included in private collections throughout the Upper Midwest.

EVENING—SOUTH CHICAGO (Plate 80)
Oil on canvas, 1925
26" x 30" s.d.–l.l.
Period frame: carved and gilded

Exhibited:
Robert Henry Adams Fine Art, (Chicago), 1990, *Chicago: The Modernist Vision*, cat.
Center Galleries, Center for Creative Studies, (Detroit), and Cleveland State University Art Gallery, (Cleveland), 1994, *A Place in Time: The Inlander Collection of Great Lakes Regional Painting*, cat.

Published:
Dennis Nawrocki and Robert Thurmer, *A Place in Time: The Inlander Collection of Great Lakes Regional Painting* (Cleveland State University: 1994.

8. AARON BOHROD (1907–1992)
Aaron Bohrod was born in Chicago in 1907. Between 1926 and 1930, he studied art, first at the School of the Art Institute of Chicago, and then at the Art Students League in New York, where he was taught by John Sloan, Kenneth Hays Miller, and several other well-known American painters. Heeding Sloan's admonition that artists should "paint what they know," Bohrod left New York in 1930 and returned to his native Chicago to paint views of the city's north side streets and the life of the working class in the Great Lakes region. Through the 1930s, Bohrod exhibited his work in most of the important exhibitions surveying contemporary trends in American art. During the Second World War he served as an artist-correspondent for *Life* magazine. Following the unexpected death of John Steuart Curry in 1946, Bohrod was invited to assume the position of Artist in Residence at the University of Wisconsin in Madison. His primary responsibility at the University involved traveling throughout the state of Wisconsin and providing encouragement to amateur artists who had become part of the University's Rural Arts outreach program. Resettling in Madison, Bohrod began documenting rural Wisconsin much as he had chronicled urban Chicago in the 1930s. He remained at the University of Wisconsin from 1948 to his retirement in 1973. Through the thirties and forties, Bohrod gained fame as one of America's most original and prolific regionalists. His depictions of city life in the industrial Great Lakes have an expressive quality unique in the art of the American Scene. From 1954 on, Bohrod focused on trompe-l'oeil paintings and gained further recognition as a still life painter. Active as an artist into the 1990s, Aaron Bohrod died in Madison, Wisconsin in 1992. Bohrod's work can be found in scores of public collections including those of the Whitney Museum of American Art; the Metropolitan Museum of Art; Library of Congress; Phoenix Art Museum; the Detroit Institute of Arts; Hirshhorn Museum and Sculpture Garden; and the Museum of Fine Arts, Boston.

RED HOUSE CHICAGO (Plate 66)
Oil on masonite, 1932
20"x 26" s.d.–l.c.
Original frame: combed and painted
©Estate of Aaron Bohrod/Licensed by VAGA, New York, NY

Exhibited:
Robert Henry Adams Fine Art, (Chicago), 1990, *Chicago: The Modernist Vision*, cat.
Block Gallery Northwestern University, (Illinois), 1992, *Thinking Modern: Painting in Chicago 1910 – 1940*.
Center Galleries, Center for Creative Studies, (Detroit), and Cleveland State University Art Gallery, (Cleveland), 1994, *A Place in Time: The Inlander Collection of Great Lakes Regional Painting*, cat.
Columbus Museum of Art, (Ohio), and Museo de Arte Moderno (Mexico City), 1996, *Visions of America: Urban Realism 1900–1945*, cat.; toured 1997, to Butler Institute of American Art (Ohio).

Published:
Robert Henry Adams, Chicago: *The Modernist Vision* (Adams Fine Art: 1990).
Dennis Nawrocki and Robert Thurmer, *A Place in Time: The Inlander Collection of Great Lakes Regional Painting* (Cleveland State University: 1994).
Teresa del Conde, Austin Artega, et. al., *Visions of America: Urban Realism 1900–1945* (Instituto Nacional de Bellas Artes: 1996).

RIVERVIEW AMUSEMENT PARK (Plate 44)
Gouache on paper, 1934
13" x 18" (sight) s.d.–l.c.
Period frame: silver leaf
©Estate of Aaron Bohrod/Licensed by VAGA, New York, NY

Exhibited:
Witherspoon Art Gallery, (North Carolina), 1981, *Witherspoon Annual Exhibition: Art on Paper*.
F.B. Horowitz Fine Art, (Minnesota), 1991, *American Artists Rediscovered*, cat.
Dennos Museum Center, (Traverse City, Michigan), 1996, *Painters of the Great Lakes Scene*, cat.; toured 1997, to Kalamazoo Institute of Arts (Michigan), Flint Institute of Arts (Michigan).

Published:
F.B. Horowitz, *American Artists Rediscovered* (Horowitz Fine Art: 1991).
Michael D. Hall, *Painters of the Great Lakes Scene* (Dennos Museum Center: 1996).

HOUSE BOATS—CHICAGO RIVER (Plate 7)
Oil on masonite, ca. 1938
29" x 40" s.–l.l.
Reproduction period frame: combed and painted
©Estate of Aaron Bohrod/Licnesed by VAGA, New York, NY

Exhibited:
The Art Institute of Chicago, (Illinois), 1940, *Annual Exhibition of American Paintings and Sculpture*, cat.
Columbus Museum of Art, (Ohio), 2000, *Illusions of Eden: Visions of the American Heartland* cat.; toured 2000–2001, to Museum of Modern Art (Vienna), Ludwig Museum (Budapest), Madison Art Center (Wisconsin), Washington Pavilion (South Dakota).

Published:
Stearns, Robert ed. *Illusions of Eden: Visions of the American Heartland* Minneapolis: Arts Midwest, 2000

HILLY STREET—MARQUETTE (Plate 51)
Gouache on cardboard, 1953
14" x 19" (sight) s.–l.r.
Period frame: painted
©Estate of Aaron Bohrod/Licensed by VAGA, New York, NY

Exhibited:
River Edge Galleries, (Mishicot, Wisconsin), 1991, *Aaron Bohrod: Recent Oils, Decoratives, Early Works*.
Center Galleries, Center for Creative Studies, (Detroit), and Cleveland State University Art Gallery, (Cleveland), 1994, *A Place in Time: The Inlander Collection of Great Lakes Regional Painting*, cat.

Published:
Dennis Nawrocki and Robert Thurmer, *A Place in Time: The Inlander Collection of Great Lakes Regional Painting* (Cleveland State University: 1994).

9. CAMERON BOOTH (1892–1980)

Cameron Booth was born in 1892 in Erie, Pennsylvania. Between 1912 and 1917 he studied art at the School of the Art Institute of Chicago. During World War I he served with the U.S. Army and remained in Paris after the armistice for a brief period of further art study. In 1921 Booth accepted a teaching position at the Minneapolis School of Art. In 1927 he returned to Europe to study for a year with Andre Lhote in Paris and Hans Hofmann in Munich. In 1929 he joined the teaching faculty at the St. Paul School of Art and became the school's president in 1931. During the period of the American Scene, Booth became known for his depictions of houses, barns, industrial sites and, particularly, for his paintings of horses. Stylistically, his work was a blend of realism and the Parisian modernism he had learned from Lhote. Booth was particularly bold and original in his use of color, notably certain strong reds and blues. He actively exhibited his work nationally and was included in numerous group exhibitions held at the Art Institute of Chicago, the Carnegie Institute, and the Pennsylvania Academy of the Fine Arts. Booth traveled regularly between Minnesota and New York and in 1944 accepted a teaching position at the Art Students League that would keep him in New York for the next four years. In 1948 he joined the faculty of the University of Minnesota and returned to the Upper Midwest. By 1955 he had had changed the direction of his work and had become an abstract expressionist. Cameron Booth died in Minneapolis in 1980. His American Scene paintings can be found in the collections of the Newark Museum; the Phillips Collection; the Minneapolis Institute of Arts; Denver Art Museum; M. H. De Young Memorial Museum; and the Art Institute of Chicago.

LEECH LAKE (Plate 1)
Oil on canvas, 1923
26" x 34" s.d.–l.l.
Artist made copy of original frame: carved and gilded

IRON ORE (Plate 85)
Oil on canvas, 1934
24" x 32" s.d.–l.r.
Period frame: gilded and painted

Exhibited:
Dennos Museum Center, (Traverse City, Michigan), 1996, *Painters of the Great Lakes Scene*, cat.; toured 1997, to Kalamazoo Institute of Arts (Michigan), Flint Institute of Arts (Michigan).

Published:
Michael D. Hall, *Painters of the Great Lakes Scene* (Dennos Museum Center: 1996).

INDIAN GRAVEYARD (Plate 99)
Gouache on paper, ca. 1940
18" x 22" (sight) s.–l.r.
Period frame: painted

Exhibited:
The Art Institute of Chicago, (Illinois), 1942, *Annual Exhibition of Watercolors by American Artists.*

10. EDMUND BRUCKER (1912–1999)

Edmund Brucker was born in 1912 in Cleveland, Ohio. He studied art at the Cleveland School of Art, graduating in 1934. His teachers included Henry Keller, Rolf Stoll, and Paul Travis. In 1938, Brucker joined the faculty of the John Herron Art Institute in Indianapolis, where he taught until his retirement in the early 1980s. During the 1940s Brucker was recognized as an important member of the generation of young Indianapolis regionalists who successfully challenged the entrenched impressionist tradition that had dominated Indiana painting since the late nineteenth century. Brucker exhibited widely through the Great Lakes region. His work was shown at the Cleveland Museum of Art, the Butler Institute of American Art, the Milwaukee Art Institute, the Carnegie Institute and regularly at the Hoosier Salon Annuals in Chicago and at the Indiana State Fair. Though he was best known as a portrait painter, Brucker also chronicled the Great Lakes regional scene. Adept in both oil and watercolor, he produced a number of works depicting industrial and urban subjects as well as landscapes portraying rural Ohio and Indiana. His paintings were awarded top honors in Hoosier Salon exhibitions on three different occasions. Many of his works are actually composite scenes formulated from sketches and detailed drawings made at different sites and times. Brucker's stylized realism emphasized design, composition, and line, and his palette is rich in its use of gray tones. Edmund Brucker died in Indianapolis in 1999. His work is represented in the collections of Indiana University; DePauw University; Purdue University; and Dartmouth College.

BILL (Plate 30)
(PORTRAIT OF THE ARTIST'S BROTHER)
Oil on canvas, ca. 1938
32" x 26" unsigned
Original frame: painted and stained

Exhibited:
John Herron Museum, (Indianapolis, Indiana), 1939, *Annual Exhibition of Indiana Artists*, (prize).

THE MENAGERIE (Plate 101)
Oil on canvas, ca. 1943
19" x 25" s.–l.l.
Period frame: painted

BAG EARS (Plate 37)
Oil on canvas, 1944
40"x 24" s.–l.r.
Period frame: painted

Exhibited:
Indiana State Fair, (Indianapolis, Indiana), ca. 1945, *Indiana Artists Exhibition*, (prize).
Center Galleries, Center for Creative Studies, (Detroit), and Cleveland State University Art Gallery, (Cleveland), 1994, *A Place in Time: The Inlander Collection of Great Lakes Regional Painting*, cat.
Dennos Museum Center, (Traverse City, Michigan), 1996, *Painters of the Great Lakes Scene*, cat.; toured 1997, to Kalamazoo Institute of Arts (Michigan), Flint Institute of Arts (Michigan).
Columbus Museum of Art, (Ohio), 2000, *Illusions of Eden: Visions of the American Heartland* cat.; toured 2000–2001, to Museum of Modern Art (Vienna), Ludwig Museum (Budapest), Madison Art Center (Wisconsin), Washington Pavilion (South Dakota).
The Riffe Gallery, (Columbus, Ohio), 2003, *Ohio: The State of the Arts*; toured 2003–2004, to Fitton Center (Hamilton, Ohio), Springfield Museum of Art (Ohio), Southern Ohio Museum (Portsmouth), Butler Institute of American Art (Youngstown, Ohio).

Published:
Dennis Nawrocki and Robert Thurmer, *A Place in Time: The Inlander Collection of Great Lakes Regional Painting* (Cleveland State University: 1994).
Michael D. Hall, *Painters of the Great Lakes Scene* (Dennos Museum Center: 1996).
Robert Stearns, ed., *Illusions of Eden: Visions of the American Heartland* (Arts Midwest: 2000).
Nanette Maciejunes and E. Jane Connell, "Epilogue," *Timeline* 20 (March–June 2003), p. 88.

THE CAPITOL—INDIANAPOLIS (Plate 63)*
Oil on masonite, ca. 1945
22" x 42" s.–l.l.
Reproduction period frame: painted

11. CHARLES E. BURCHFIELD (1893–1967)

Charles Ephraim Burchfield was born in Ashtabula Harbor, Ohio, in 1893. After the death of his father in 1898, he moved with his family to Salem, Ohio, where he completed high school. He next attended the Cleveland School of Art, graduating in 1916. His teachers there included Henry Keller, Frank Wilcox, and William Eastman. In 1921 he married and moved to Buffalo, New York, where he supported himself for the next eight years as a designer for a firm that produced decorative wallpaper. Burchfield's career as a painter advanced rapidly from the start. He found a market for his work in New York the year after he graduated from art school and was awarded a solo exhibition at the Museum of Modern Art before he turned forty. In the history of American watercolor, Burchfield shares center stage with Winslow Homer, Charles Demuth, and John Marin.

Initially, Burchfield became famous as a pioneer in the American Scene movement. His moody, realist views of life in the Upper Midwest are among the most skillful and ambitious regionalist works produced in the United States during the twenties and thirties. From the mid-1940s on, Burchfield turned to nature for his inspiration and evolved a style that is a blend of regional, mystical and modernist elements. By the late 1950s, Charles Burchfield had gained international recognition as an important and highly individualistic figure in American art. In 1967, Burchfield died near his Gardenville home, outside Buffalo. Examples of his watercolors can be found in almost all major American art museums as well as in important private collections both in the United States and in Europe. Important bodies of the artist's work are held by the Museum of Modern Art; the Whitney Museum of American Art; the Burchfield-Penny Art Center; Buffalo State University; and the Cleveland Museum of Art.

BRICK KILN IN AUTUMN (Plate 40)
(BUILDING WITH DOMED TOP)
Watercolor on paper: 1917
17" x 21" (sight) estate stamp–l.l.
Reproduction period frame: carved and gilded

Exhibited:
Kennedy Galleries, (New York), 1990, *Charles Burchfield Watercolors 1915–1920*, cat.
Center Galleries, Center for Creative Studies, (Detroit), and Cleveland State University Art Gallery, (Cleveland), 1994, *A Place in Time: The Inlander Collection of Great Lakes Regional Painting*, cat.
Dennos Museum Center, (Traverse City, Michigan), 1996, *Painters of the Great Lakes Scene*, cat.; toured 1997, to Kalamazoo Institute of Arts (Michigan), Flint Institute of Arts (Michigan).
Columbus Museum of Art (Ohio), 1997, *The Paintings of Charles Burchfield: North by Midwest*, cat.; toured 1997–98, to Burchfield-Penney Art Center (Buffalo), National Museum of American Art (Washington D.C.).

Published:
Nannette Maciejunes, *Charles Burchfield: Watercolors 1915–1920* (Kennedy Galleries: 1990).
Dennis Nawrocki and Robert Thurmer, *A Place in Time: The Inlander Collection of Great Lakes Regional Painting* (Cleveland State University: 1994).
Michael D. Hall, *Painters of the Great Lakes Scene* (Dennos Museum Center: 1996).
Nannette Maciejunes and Michael D. Hall, *The Paintings of Charles Burchfield: North by Midwest* (Abrams: 1997).

Catalogued:
Joseph S. Trovato, *Charles Burchfield: Catalogue of Paintings in Public and Private Collections*, (Munson-Williams-Proctor Institute: 1970).

WIRE FENCE IN SNOW (Plate 46)
Watercolor on paper, 1936
26" x 19" (sight) s.d.–l.l.
Period frame: painted

Exhibited:
Frank Rehn Galleries, (New York), 1937, *Charles Burchfield*.
Dennos Museum Center, (Traverse City, Michigan), 1996, *Painters of the Great Lakes Scene*, cat.; toured 1997, to

Kalamazoo Institute of Arts (Michigan), Flint Institute of Arts (Michigan).
Columbus Museum of Art (Ohio), 1997, *The Paintings of Charles Burchfield: North by Midwest*, cat.; toured 1997–98, to Burchfield-Penney Art Center (Buffalo), National Museum of American Art (Washington D.C.).

Published:
"Burchfield's America," *Life 1* (December 28, 1936).
Michael D. Hall, *Painters of the Great Lakes Scene* (Dennos Museum Center: 1996).
Nannette Maciejunes and Michael D. Hall, *The Paintings of Charles Burchfield: North by Midwest* (Abrams: 1997).

Catalogued:
Joseph S. Trovato, *Charles Burchfield: Catalogue of Paintings in Public and Private Collections*, (Munson-Williams-Proctor Institute: 1970).

12. EMERSON BURKHART (1905–1969)

Emerson Burkhart was born on a farm near Kalida, Ohio, in 1905. He attended college at Ohio Wesleyan University, graduating in 1926. After college he went to New York to study painting at the Art Students League. A year later, he moved to Provincetown, Massachusetts, to study further with the well-known New England painter, Charles Hawthorne. Returning to the Midwest in 1931, he took a position teaching at the Columbus Art School in Columbus, Ohio. Early in his professional life, Burkhart painted in a range of impressionist and postimpressionist styles. He was, however, a realist at heart and came into his artistic maturity as an American Scene painter in the 1940s. His best-known regionalist works document life in the African American neighborhoods of Columbus. The heavily worked and highly textured surfaces of Burkhart's canvases recall those found in the paintings of his Chicago contemporary, Ivan Albright. During his career, Burkhart exhibited at such institutions as the Pennsylvania Academy of the Fine Arts, the Carnegie Institute, the Art Institute of Chicago and the Butler Institute of American Art. He received two WPA mural commissions and is notable for the many self-portraits he produced during his lifetime. After the death of his wife in 1955, Burkhart changed the focus of his work. Traveling the world as Artist in Residence for the American International School, he began painting scenes that interested him at every port of call. Emerson Burkhart died in 1969 in Columbus. His paintings can be found in the collections of the Columbus Museum of Art, Ohio; the Schumacher Gallery; Capital University, Ohio; and the Ohio Historical Society.

BACKSTREET PARADE (Plate 73)
Oil on canvas: 1944
22" x 30" s.–l.l.
Reproduction frame: copy of original artist-made frame

13. RUTHVEN BYRUM (1896–1958)

Ruthven Holmes Byrum was born in 1896 in the town of Grand Junction, Michigan. He is remembered, however, as an Indiana American Scene painter who lived most of his life in the small

city of Anderson, Indiana. As a young man, Byrum first studied art at Indiana University. Subsequently, he traveled abroad to study with Andre Lhote in Paris and with Hans Hofmann in Munich. Returning to the U.S., Byrum became an art instructor at Anderson College in 1936. In time, he was promoted to head of the Anderson College art department. As a painter, Byrum produced a range of portraits, still life compositions and landscapes. Best known for his Indiana rural scenes and his city views of Anderson, Byrum also painted canvases recording his travels through the Blue Ridge Mountains of the South and across the American West. Byrum's paintings were selected for exhibition in over twenty Hoosier Salons between 1929 and 1957. The artist was also a frequent participant in the art exhibitions held at the Indiana State Fair where he won numerous prizes and awards. An important selection of Byrum's early paintings depicting Anderson street scenes was assembled by the First Savings Bank of Anderson where it was on public display until 1990. Ruthven Byrum remained active as a working artist up until the time of his death in 1958. His work is included in the permanent collections of the Richmond Art Association, Indiana; Sheldon Swope Art Museum, Indiana; and Anderson College, Indiana.

ANDERSON ROOFTOPS (Plate 57)
Oil on canvas, 1933
16" x 20" s.–l.l.
Period frame: painted

Exhibited:
Center Galleries, Center for Creative Studies, (Detroit), and Cleveland State University Art Gallery, (Cleveland), 1994, *A Place in Time: The Inlander Collection of Great Lakes Regional Painting*, cat.

Published:
Dennis Nawrocki and Robert Thurmer, *A Place in Time: The Inlander Collection of Great Lakes Regional Painting* (Cleveland State University: 1994).

14. CLARENCE HOLBROOK CARTER (1904–1999)

Clarence Holbrook Carter was born in Portsmouth, Ohio, in 1904. He studied art at the Cleveland School of Art from 1923 to 1927. His teachers there included Henry Keller and Paul Travis. In 1927 Carter went to Europe and studied briefly in Capri under Hans Hofmann. He then traveled on to Taormina, Italy, and to Paris. Returning home in 1928, he married and took up residence in Cleveland, supporting himself teaching and working at the Cleveland Museum of Art. From 1938 to 1944 Carter lived in Pittsburgh, Pennsylvania and taught at the Carnegie Institute. In 1944 he resigned his teaching post and moved east to Bucks County, Pennsylvania. Four years later he moved again, this time to Milford, New Jersey where he would remain. Carter is recognized as a landscape and portrait painter accomplished in both oil and watercolor. His crisp style has been called magic realism. Many of his best-known American Scene paintings depict specific regional subjects he observed as a boy growing up in southeastern Ohio or as a young adult living in the industrial centers of the Great Lakes region. From 1937 to 1938, Carter served as the northeastern Ohio district supervisor of the Federal Art Project. In 1938 he completed a series of monumental murals for the Portsmouth, Ohio post office. On the occasion of his ninetieth birthday in 1994, Carter was given a retrospective exhibition at the Southern Ohio Museum in

Portsmouth. In 1999, Clarence Carter died in New Jersey. Though his late work became increasingly surrealist in character, Carter is remembered as a major realist painter from the American Scene era. His work is represented in the Brooklyn Museum; the Butler Institute of American Art, Ohio; the Nelson-Atkins Museum of Art; the Whitney Museum of American Art; the Museum of Modern Art; Sheldon Swope Art Museum, Indiana; Carnegie Museum of Art; the Columbus Museum of Art, Ohio; and many other important public institutions.

THE ELYSIUM (Plate 42)
Watercolor on paper: 1928
14 3/4" x 19 3/4" (sight) s.d.–l.l.
Period frame: gilded and painted

Exhibited:
Beck Center for the Arts, (Cleveland, Ohio), and The Burchfield-Penney Art Center, (Buffalo, New York), 2000, *The Poetics of Place: Charles Burchfield and the Cleveland Connection*.

UNTITLED (Plate 21)
Oil on canvas, 1932
24" x 32" s.d.–l.c.
Period frame: stained and varnished

COAL DOCKS AT SUPERIOR (Plate 88)
Oil on canvas, 1939
18" x 30" s.d.–l.r.
Original frame: painted

Exhibited:
Gimpel and Weitzenhoffer Gallery, (New York), 1976, *Clarence Carter: A Retrospective View*; toured 1976, to Twenty Four Collection, (Miami, Florida), Philbrook Art Center, (Tulsa, Oklahoma), The University of Texas Art Museum, (Austin).
Hirschl and Adler Galleries, (New York), 1982, *Clarence Carter*.
Harmon-Meek Gallery, (Naples, Florida), 1984, *Clarence Carter*.
Center Galleries, Center for Creative Studies, (Detroit), and Cleveland State University Art Gallery, (Cleveland), 1994, *A Place in Time: The Inlander Collection of Great Lakes Regional Painting*, cat.
Dennos Museum Center, (Traverse City, Michigan), 1996, *Painters of the Great Lakes Scene*, cat.; toured 1997, to Kalamazoo Institute of Arts (Michigan), Flint Institute of Arts (Michigan).
Columbus Museum of Art, (Ohio), 2000, *Illusions of Eden: Visions of the American Heartland* cat.; toured 2000–2001, to Museum of Modern Art (Vienna), Ludwig Museum (Budapest), Madison Art Center (Wisconsin), Washington Pavilion (South Dakota).

Published:
Frank Anderson Trapp, et. al., *Clarence Holbrook Carter* (Rizzoli: 1989).
Dennis Nawrocki and Robert Thurmer, *A Place in Time: The Inlander Collection of Great Lakes Regional Painting* (Cleveland State University: 1994).
Robert Stearns, ed., *Illusions of Eden: Visions of the American Heartland* (Arts Midwest: 2000).

NIGHT CARNIVAL (Plate 34)
Watercolor on paper, 1941
22" x 15" (sight) s.d.–l.r.
Period frame: painted

Exhibited:
Hirschl and Adler Galleries, (New York), 1982, *Clarence Carter*.
Harmon-Meek Gallery, (Naples, Florida), 1984, *Clarence Carter*.
Dennos Museum Center, (Traverse City, Michigan), 1996,
Painters of the Great Lakes Scene, cat.; toured 1997, to
Kalamazoo Institute of Arts (Michigan), Flint Institute of
Arts (Michigan).

Published:
Frank Anderson Trapp, et. al., *Clarence Holbrook Carter*
(Rizzoli: 1989).
Michael D. Hall, *Painters of the Great Lakes Scene* (Dennos
Museum Center: 1996).

15. JOHN ROGERS COX (1915–1990)

Born in Terre Haute, Indiana, in 1915, John Rogers Cox was
raised in the city of his birth. He began to draw at the age of five.
Though he was a poor student through high school, Cox exhibited
a strong interest in art through his school years. After graduation,
he enrolled in a B.F.A. program conducted jointly by the
University of Pennsylvania and the Pennsylvania Academy of the
Fine Arts. He received his degree in 1938. He returned to Terre
Haute to work as a bank teller but was soon appointed the first
director of the Sheldon Swope Art Gallery, a position he held
from 1941 to 1943. Under Cox's direction, the Gallery assembled
one of the premier public collections of American Scene painting.
In 1942, Cox's picture, *Grey and Gold*, won the Second Medal in
the *Artists for Victory* exhibition at the Metropolitan Museum of
Art in New York. Two years later the same painting received the
Popular Prize in the exhibition *Painting in the United States, 1944*
held at the Carnegie Institute in Pittsburgh. Shortly thereafter, it
was purchased for the permanent collection of the Cleveland
Museum of Art. In 1948 Cox joined the faculty of the School of
the Art Institute of Chicago. He taught and painted in Chicago for
almost two decades thereafter. Although Cox was an artist of
modest production, his works were included in many of the
nation's most important annual survey exhibitions during the
1940s and 50s, including those at the Whitney Museum of
American Art, the Art Institute of Chicago, and the Pennsylvania
Academy of the Fine Arts. Remembered as one of America's most
original magic realist landscape painters, John Rogers Cox died
in 1990. His major works are in the collections of the Cleveland
Museum of Art; the Sheldon Swope Art Museum, Indiana; the
Butler Institute of American Art, Ohio; and the Museum of Fine
Art, Springfield, Massachusetts.

NOCTURNE—SILVER AND GREY (Plate 104)*
Oil on board, 1952
17" x 24" s.d.–l.r.
Period frame: painted

Exhibited:
Center Galleries, Center for Creative Studies, (Detroit), and
Cleveland State University Art Gallery, (Cleveland), 1994, *A
Place in Time: The Inlander Collection of Great Lakes Regional
Painting*, cat.

Published:
Dennis Nawrocki and Robert Thurmer, *A Place in Time: The
Inlander Collection of Great Lakes Regional Painting* (Cleveland
State University: 1994).

16. JOHN STEUART CURRY (1897–1946)

John Steuart Curry was born on a farm near Dunavant, Kansas,
in 1897. He enrolled in the Kansas City Art Institute in 1916
but soon transferred to the School of the Art Institute of
Chicago. After graduation, he moved east to study illustration
with Harvey Dunn and then traveled to Paris to complete his art
studies. From 1921 to 1926 he worked as an illustrator and
lived in Westport, Connecticut. There, he began producing can-
vases depicting scenes of farm life on the Kansas prairie. In
1928 he painted a work entitled *Baptism in Kansas*, which
earned him almost immediate fame as a painter of rural
America. Within three years the painting became one of the
first acquisitions made by the newly established Whitney
Museum of American Art in New York. Curry suddenly found
himself a leader in the emerging American Scene and his name
became inseparably linked with those of the movement's other
pioneers, Grant Wood and Thomas Hart Benton. In 1936 Curry
was appointed Artist in Residence at the University of
Wisconsin in Madison, Wisconsin. His most famous Great
Lakes regionalist picture, *Wisconsin Landscape*, was painted in
Madison and subsequently purchased by the Metropolitan
Museum of Art in 1942. Curry is recognized as a realist; his
style is figurative and, at times, narrative. His compositions are
carefully developed to present a rhythmic and dramatic interac-
tion between figure and landscape elements. John Steuart Curry
died in Madison, Wisconsin, in 1946. His murals can be found
in the Kansas State House; the United States Department of the
Interior and the Justice Department in Washington D.C., and in
the law library of the University of Wisconsin. His easel paint-
ings are included in the collections of the Muskegon Museum of
Art, Michigan; the Whitney Museum of American Art; the
Metropolitan Museum of Art; the Butler Institute of American
Art, Ohio; the St. Louis Art Museum; the National Gallery of
Art; and the Nelson-Atkins Museum of Art.

A WISCONSIN LANDSCAPE (Plate 24)
Watercolor on paper, ca. 1936–40
12" x 12" (sight) s.–l.r.
Period frame: painted

Exhibited:
Mongerson-Wunderlich, (Chicago), 1992, *Works From the
Estate of John Steuart Curry*.
Emporia State University, (Kansas), 1993, *John Steuart Curry's
America*, cat.; toured 1993–1994, to various Midwestern uni-
versity art galleries.
Dennos Museum Center, (Traverse City, Michigan), 1996,
Painters of the Great Lakes Scene, cat.; toured 1997, to
Kalamazoo Institute of Arts (Michigan), Flint Institute of
Arts (Michigan).

Published:
Charles C. Eldridge, *John Steuart Curry's America* (Exhibits
USA, Washington D.C.: 1992).
Michael D. Hall, *Painters of the Great Lakes Scene* (Dennos
Museum Center: 1996)

DUCK HUNTERS AND DECOYS (Plate 10)
Watercolor on paper, ca. 1943
22" x 30" (sight) unsigned, (authenticated by artist's widow)
Period frame: painted and patinated

Exhibited:
Mongerson-Wunderlich, (Chicago), 1992, *Works From the Estate of John Steuart Curry.*
Center Galleries, Center for Creative Studies, (Detroit), and Cleveland State University Art Gallery, (Cleveland), 1994, *A Place in Time: The Inlander Collection of Great Lakes Regional Painting*, cat.
Dennos Museum Center, (Traverse City, Michigan), 1996, *Painters of the Great Lakes Scene*, cat.; toured 1997, to Kalamazoo Institute of Arts (Michigan), Flint Institute of Arts (Michigan).

Published:
Dennis Nawrocki and Robert Thurmer, *A Place in Time: The Inlander Collection of Great Lakes Regional Painting* (Cleveland State University: 1994).

17. VIRGINIA CUTHBERT (1908–2001)

Virginia Cuthbert was born in West Newton, Pennsylvania, in 1908. She began her formal art study at Syracuse University, where she graduated with a Bachelor of Fine Arts degree in 1926. Between 1930 and 1931 she studied with Charles Hawthorne in Provincetown and then with various European instructors in France, Italy, and England, where she traveled on a fellowship. She returned to the United States to work with George Luks in New York. Between 1933 and 1935 she pursued graduate study at the University of Pittsburgh and at the Carnegie Institute. Establishing her studio in Pittsburgh, Cuthbert became well known as a western Pennsylvania regionalist. The Victorian houses and other buildings of the area held a particular fascination for her. In 1941, she moved to Buffalo, New York, where her husband had accepted the directorship of the Albright Art School. She became a member of Buffalo's Patteran Society of Artists and in 1956 joined the prestigious Frank Rehn Gallery in New York City where her Buffalo colleague, Charles E. Burchfield, also exhibited. Beginning in the mid-1940s, Cuthbert's style shifted away from traditional realism and toward a personal form of magic realism. Increasingly, fantasy and dream images began to suffuse the scenes in her pictures. In the course of her career, Cuthbert exhibited her work nationally at such institutions as the Pennsylvania Academy of the Fine Arts; the Metropolitan Museum of Art; and the Virginia Museum of Fine Arts. Virginia Cuthbert died in Buffalo in 2001. Her work is included in the collections of Princeton University; Albright-Knox Art Gallery; and the Philadelphia Museum of Art.

MOVIE PALACE (Plate 70)
Oil on canvas, 1936
25" x 30" s.–l.l.
Period frame: painted

Exhibited:
Nina Freudenheim Gallery, (Buffalo, New York), 1990, *Virginia Cuthbert: A Retrospective*, cat.
Columbus Museum of Art, (Ohio), 2000, *Illusions of Eden: Visions of the American Heartland* cat.; toured 2000–2001, to Museum of Modern Art (Vienna), Ludwig Museum (Budapest), Madison Art Center (Wisconsin), Washington Pavilion (South Dakota).

Published:
Robert Stearns, ed., *Illusions of Eden: Visions of the American Heartland* (Arts Midwest: 2000).

18. MATT DALY (1860–1937)

Best known for the glaze-painted scenes he created on vessels produced by the Rookwood Pottery in Cincinnati, Ohio, Matt Daly is also recognized for his oil paintings. Born near Cincinnati in 1859, Daly was raised by parents who had immigrated to Ohio from Ireland. Artistic by nature, Daly entered the McMicken School of Art at the age of seventeen. There he was given instruction not only in drawing and painting but in such applied arts as wood carving and china decorating. Continuing his study at the newly formed Cincinnati Art Academy, Daly completed his art training under the noted realists, Frank Duveneck, Thomas Noble, and Lewis C. Lutz. In 1883 Daly joined the art staff at Rookwood where he remained employed until 1903. The floral, landscape, and portrait designs he created there earned him a reputation as one of the foremost artists in the American art pottery movement. In the years after he left Rookwood, Daly increasingly spent time painting landscapes depicting subjects he found throughout the Midwest as well as along the Eastern seaboard and even in the Canadian Rockies. His painting style, like that of many in his generation, blended aspects of realism and impressionism. Also successful as a portrait artist, Daly painted likenesses of many of Cincinnati's most prominent citizens. During the 1930s he completed a number of Federal Art Project commissions, one of which involved painting a series of works for the Cincinnati Public Schools illustrating the pottery and weaving of the American Indians. At the time of his death in 1937, Matt Daly was remembered as a talented, versatile artist who had enriched the cultural life his home city for over fifty years. Daly's paintings can be found in the permanent collections of the University of Cincinnati; the Cincinnati Art Museum; the Cincinnati Art Club; and the Cincinnati Historical Society.

PORT AND CITY (Plate 52)
Oil on canvas, 1925
24" x 20" s.d.–l.r.
Period frame: carved and gilded

Exhibited:
Center Galleries, Center for Creative Studies, (Detroit), and Cleveland State University Art Gallery, (Cleveland), 1994, *A Place in Time: The Inlander Collection of Great Lakes Regional Painting*, cat.

Published:
Dennis Nawrocki and Robert Thurmer, *A Place in Time: The Inlander Collection of Great Lakes Regional Painting* (Cleveland State University: 1994).

19. ADOLF DEHN (1895–1968)

Adolf Dehn was born in Waterville, Minnesota, in 1895. He studied art at the Minneapolis School of Art between 1914 and 1917. He then moved to New York to continue his studies at the Art Students League. In New York, Dehn threw himself

into liberal politics. Declaring himself a conscientious objector, he was forced to spend the last year of World War I in a camp for pacifists in South Carolina. Returning to New York, he completed his studies. His most important teachers at the Art Students League were Boardman Robinson and Kenneth Hayes Miller. It was Robinson who first introduced him to lithography. In the early 1920s Dehn moved to Europe where he was employed by *The Dial* magazine to document continental life and culture. Once abroad, he began producing a steady stream of satirical lithographs that he sold both in Europe and New York. In 1929 he returned to the U.S. and began exhibiting his prints to considerable critical acclaim. In 1937, Dehn turned another important corner in his career when he began to paint in watercolor. During his summer visits to Minnesota, he created a large body of watercolors depicting the lakes and farms of his home state. His American Scene landscapes are typically naturalistic in style. Well known for both his prints and his watercolors, Dehn was elected to the National Academy of Design in 1961. Adolf Dehn died in New York in 1968. His work has been exhibited at the Whitney Museum of American Art; the Museum of Modern Art; the Metropolitan Museum of Art, and the Dayton Art Institute. His lithograph, *Central Park at Night* was included in the *American Art Today* exhibition at the 1939 New York World's Fair. Dehn's prints and paintings can be found in many public collections including the Art Institute of Chicago; the Cleveland Museum of Art; and the Museum of Fine Arts, Boston.

WHEAT FIELDS (Plate 25)
Watercolor on Paper, 1940
14" x 21" (sight) s.d.–l.r.
Period frame: painted

Exhibited:
Dennos Museum Center, (Traverse City, Michigan), 1996, *Painters of the Great Lakes Scene*, cat.; toured 1997, to Kalamazoo Institute of Arts (Michigan), Flint Institute of Arts (Michigan).

Published:
Michael D. Hall, *Painters of the Great Lakes Scene* (Dennos Museum Center: 1996).

20. CLARA L. DEIKE (1881–1964)

The pioneer Cleveland modernist, Clara L. Deike was born in Detroit in 1881. Moving with her family to Ohio at a young age, Deike attended high school in Cleveland and went on to earn a degree in education from the Cleveland Normal School. After briefly teaching elementary school, Deike decided to pursue her interest in art and enrolled at the School of the Art Institute of Chicago. She returned to Cleveland to continue her art training with Henry Keller and Frederick Gottwald at the Cleveland School of Art. After graduating in 1912, Deike began teaching art in Cleveland's public schools where she remained a teacher until her retirement in 1945. Deike's first mature paintings clearly owed a stylistic debt to the colorful, German-influenced decorative style favored by many of the early Cleveland modernists. In the 1920s, however, Deike traveled abroad to study with both Hans Hofmann and Diego Rivera. As a result, her style became much more structural and architectural in appearance. Through the thirties and forties Clara Deike produced a large body of still life pictures and

American Scene landscapes notable for their cubist composition and expressive color. Deike exhibited for forty years in the annual May Shows held at the Cleveland Museum of Art, winning prizes in six different years. Her work was also selected for inclusion in the landmark *Great Lakes Exhibition 1938–1939* as well as for various other exhibitions in Washington D.C., New York, and Gloucester, Massachusetts. Clara Deike died in 1964 and is remembered as an important Cleveland painter who was also a strong voice for women in the arts. Her work can be found in the Cleveland Museum of Art; Baldwin-Wallace College, Ohio; and numerous private collections throughout the Great Lakes region.

UNDER THE TREES (Plate 69)
Oil on canvas, 1935, 1941, 1953
20"x 24" s.d.–l.r.
Period frame: silver leaf

WESTSIDE CLEVELAND (Plate 61)
Oil on canvas, 1943
24" x 26" s.d.–l.r.
Original frame: gilded and painted

Exhibited:
Vixseboxse Art Galleries, (Cleveland, Ohio), 1992, *Clara L Deike: A Retrospective*.
Center Galleries, Center for Creative Studies, (Detroit), and Cleveland State University Art Gallery, (Cleveland), 1994, *A Place in Time: The Inlander Collection of Great Lakes Regional Painting*, cat.

Published:
Dennis Nawrocki and Robert Thurmer, *A Place in Time: The Inlander Collection of Great Lakes Regional Painting* (Cleveland State University: 1994).

21. EDWARD DOBROTKA (1918–1977)

Born in 1918 and raised by his Czechoslovakian parents on the west side of Cleveland, Ohio, Edward Dobrotka exhibited a talent for drawing when he was still a child. As a high school honor student, Dobrotka served as a reporter and artist for his school newspaper. In 1936, his drawing skills won him a four-year scholarship to the Cleveland School of Art. While still a senior, Dobrotka painted a self-portrait that captured a first prize at the 1939 May Show at the Cleveland Museum of Art. Immediately heralded as one of the city's most promising painters, Dobrotka launched himself into the professional art arena at the age of twenty-one. Following graduation, he moved to New York where he took employment as a comic book artist, married, and then joined the Army Air Force, serving in the military until the end of World War II. Back in New York in 1945, Dobrotka returned to his job "ghost drawing" the character Super Boy for Superman Comics Inc. Despite the war, the 1940s marked the high point of Dobrotka's career as a painter. Throughout the decade his works toured to major museums in both the East and the Midwest including the Pennsylvania Academy of the Fine Arts, the Art Institute of Chicago, and the Butler Institute of American Art. In 1942, his painting *Sargasso Sea, Ohio* was exhibited in the *Artists for Victory* exhibition held at New York's Metropolitan Museum of Art. Little is known of Dobrotka's life from 1950 until his death in 1977. He continued to support himself as a commercial artist but he ceased exhibiting his oil paintings as the Cold War era began.

Edward Dobrotka's paintings are in the collections of the Cleveland Museum of Art and the families of a few of the artist's early Cleveland patrons.

SARGASSO SEA—OHIO (Plate 98)
Oil on canvas: 1938
30"x 40" s.–l.r.
Original Frame: painted

Exhibited:
Cleveland Museum of Art, (Ohio), 1939, *Annual Exhibition of Works by Cleveland Artists*, (prize) cat.
Minneapolis Art Institute, (Minnesota), 1939, *Cleveland Oils.*
Art Institute of Chicago, (Illinois), 1940, *Annual Exhibition of American Paintings and Sculpture*, cat.
Milwaukee Art Museum, (Wisconsin), 1941, *Kearney Memorial Regional Exhibit.*
Butler Institute of American Art, (Youngstown, Ohio), 1942, *New Year Show.*
The Metropolitan Museum of Art, (New York), 1942, *Artists For Victory*, cat.
Columbus Museum of Art (Ohio), 1997, *The Paintings of Charles Burchfield: North by Midwest*, cat.; toured 1997–98, to Burchfield-Penney Art Center (Buffalo), National Museum of American Art (Washington D.C.).

Published:
Nannette Maciejunes and Michael D. Hall, *The Paintings of Charles Burchfield: North by Midwest* (Abrams: 1997).

22. JAMES ROYER FLORA (1914–1999)

James Flora was born in Bellefontaine, Ohio, in 1914. As a teenager in a small Midwestern town he worked at the local movie theater and at his father's barber shop. He entered nearby Urbana University in 1931, and transferred to the Art Academy of Cincinnati two years later. During his five years at the Academy, he studied painting with John Weiss and Carl Zimmerman. Both of these artists left their mark on Flora's early regionalist style. After graduation, Flora worked for a while as an assistant to Zimmerman, helping his former teacher complete several large public murals. In the early 1940s, Flora took a position as an art director for Columbia Records and resettled in Connecticut. By the mid-1940s, the inventive record album covers he was designing for Columbia began to reshape the way records were marketed. Turning his back on the world of commercial design, Flora left Columbia in 1950 and moved his family to Mexico where he set up a painting studio outside the village of Taxco. Two years later he returned to the U.S. to build another career writing and illustrating children's books in New York. In the 1980s, Flora began painting an extended series of works addressed to maritime subjects. Exhibiting these works in galleries and museums around New England, he gained some popular acclaim for his graphic, highly stylized depictions of ocean liners. In 1999, James Royer Flora died at his waterside home in Rowayton, Connecticut. Limited edition serigraph prints produced from some of his ship and ocean liner paintings were published and distributed during his lifetime.

MOUNT ADAMS WINTER SCENE (Plate 58)*
Oil on canvas, 1937

26" x 32" s.–l.r.
Period frame: gilded and painted

23. JOSEPH FRIEBERT (1908–2002)

Joseph Friebert was born in Buffalo, New York in 1908. When he was three years old, his family moved to Milwaukee, Wisconsin. In 1927 he began studying pharmacy and became a fully registered pharmacist in 1930. His passion, however, was art. Friebert began to exhibit his work in 1935. He won his first award two years later and in 1938 he was selected as one of nineteen Milwaukee artists to be included in the *Great Lakes Exhibition 1938–39*. In 1945 Friebert graduated from Milwaukee State Teachers College, left the field of pharmacy and began teaching art at the University of Wisconsin, Milwaukee, where he remained employed from 1946 until his retirement in 1976. Friebert exhibited extensively during his lifetime. His work was presented nationally at the Whitney Museum of American Art, the Worcester Art Museum, Massachusetts, the University of Chicago, Birmingham Museum of Art, Alabama, the Walker Art Center, the Pennsylvania Academy of the Fine Arts, and the Denver Art Museum. In 1956, his work was included in the American pavilion at the Venice Biennale. Friebert's art reflected the Depression era's concern for the modern human condition. The figures in his dimly lit compositions seem stoic and even melancholy. To enhance the pensive mood expressed in his work, Friebert developed a form of "indirect painting" in which images are built up in successive layers of thin underpaint used in combination with glaze and varnish applications. During his long career Friebert made paintings, prints, sculptures, and murals. Joseph Friebert died in Milwaukee, Wisconsin, in 2002. His work is included in the collections of the University of Wisconsin; the Milwaukee Art Museum; University of Kansas; University of Northern Michigan; and the J.B. Speed Art Museum in Louisville, Kentucky.

THE WISCONSIN CLUB (Plate 45)
Oil on masonite, 1935
24" x 28" s.d.–verso
Reproduction period frame: silver leaf

Exhibited:
Fine Arts Galleries University of Wisconsin–Milwaukee, (Wisconsin), 1969, *Four Decades of the Work of Joseph Friebert.*

Published:
Howard Schroedter, *Joseph Friebert* (University of Wisconsin: 1968).

3RD AND CENTER (Plate 60)
Oil on masonite, 1938
22" x 27" s.d.–verso
Period frame: painted

Exhibited:
Fine Arts Galleries University of Wisconsin, Milwaukee, (Wisconsin), 1969, *Four Decades of the Work of Joseph Friebert.*
Dennos Museum Center, (Traverse City, Michigan), 1996, *Painters of the Great Lakes Scene*, cat.; toured 1997, to Kalamazoo Institute of Arts (Michigan), Flint Institute of Arts (Michigan).

Published:
Howard Schroedter, *Joseph Friebert*, (University of
Wisconsin: 1968).
Michael D. Hall, *Painters of the Great Lakes Scene* (Dennos
Museum Center: 1996).

24. CARL GAERTNER (1898–1952)

Born in Cleveland in 1898, Carl Gaertner lived the greater part of
his life in his native city. At the age of twenty he entered Western
Reserve University in Cleveland and supported himself by teach-
ing art at a nearby high school. Two years later he entered the
Cleveland School of Art where his most important teacher was
Henry Keller. He completed his studies there in 1923. Through
his entire adult life, Gaertner was both a painter and a teacher.
He became a member of the Cleveland School of Art faculty in
1927 and remained employed at the School until the year of his
death. From 1935 through 1938, Gaertner served as president of
the Cleveland Society of Artists. From 1945 on, his work was rep-
resented by the Macbeth Gallery in New York. Through the
course of his career, Gaertner was awarded over thirty prizes in
competitive exhibitions. Like many Cleveland painters, Gaertner
worked in both oil and watercolor. His dramatic scenes of indus-
trial Cleveland and Pittsburgh are executed in a realist style that
recalls the earlier paintings of George Bellows and the Ashcan
school painters in New York. In spirit, however, Gaertner belongs
to the generation of Midwestern American Scene painters who
recorded and interpreted an era of great change in their country's
history. In 1952, Carl Gaertner died suddenly in his home in the
Chagrin Valley on the outskirts of Cleveland. Today, his work is
included in more than twenty-five public collections including
those of the American Academy of Arts and Letters; the Art
Institute of Chicago; the Cleveland Museum of Art; Dallas
Museum of Fine Arts; Mills College; Sheldon Swope Art
Museum, Indiana; and the Whitney Museum of American Art.

FREIGHTERS (Plate 83)*
Oil on canvas, 1931
35" x 41" s.d.–l.r.
Reproduction period frame: gilded

Exhibited:
Cleveland Museum of Art, (Ohio), 1931, *Thirteenth Annual
Exhibition of Cleveland Artists*, cat.
Cleveland Museum of Art, (Ohio), 1931, *Traveling Exhibition of
Oils by Cleveland Artists*; toured 1931–1932, to various
Ohio Museums.
Dennos Museum Center, (Traverse City, Michigan), 1996,
Painters of the Great Lakes Scene, cat.; toured 1997, to
Kalamazoo Institute of Arts (Michigan), Flint Institute of
Arts (Michigan).
Columbus Museum of Art, (Ohio), 2000, *Illusions of Eden:
Visions of the American Heartland* cat.; toured 2000–2001, to
Museum of Modern Art (Vienna), Ludwig Museum (Budapest),
Madison Art Center (Wisconsin), Washington Pavilion
(South Dakota).

Published:
Michael D. Hall, *Painters of the Great Lakes Scene* (Dennos
Museum Center: 1996).
Robert Stearns, ed., *Illusions of Eden: Visions of the American
Heartland* (Arts Midwest: 2000).

25. AARON HARRY GORSON (1872–1933)

Born in Kovno, Lithuania, in 1872, Aaron Harry Gorson immi-
grated to the United States in 1888 to join an older brother in
Philadelphia. In 1894 he began taking art classes at the
Pennsylvania Academy of the Fine Arts where he studied
under Thomas Anshutz, who had replaced Thomas Eakins as
head of the Academy. Steeped in the Eakins realist tradition,
Gorson left Philadelphia in 1899 to study abroad at the
Academie Julian in Paris. There, he seems to have found a
direction for his own art in the tonalist paintings of James
Whistler. Returning to Philadelphia after a year, Gorson
uprooted himself again in 1903 to resettle in Pittsburgh where
he soon attracted the patronage of the Mellon family and their
circle. A steady market soon developed for Gorson's moody,
tonal depictions of the steel mills and rivers of Pittsburgh. His
dramatic night scenes, illuminated by the fires of blast fur-
naces and forges, were particularly admired by his industrial-
ist patrons. Eventually, however, Gorson exhausted his
Pittsburgh market and moved on to New York in 1921, where
he began painting scenes of the Hudson River and the com-
mercial landscape of the city. Still, his reputation remained
based on his depictions of Pittsburgh. Between 1908 and 1921
Gorson's paintings were shown at seven different *Annual
International Exhibitions* held at the Carnegie Institute. His
Pittsburgh work was also exhibited at the Corcoran Gallery in
Washington D.C., the Art Institute of Chicago, and the St.
Louis Art Museum. Gorson died unexpectedly in 1933 at the
age of sixty-one. A memorial exhibition to help his family was
held in Pittsburgh in 1934. His work can be found today in
the collections of the Carnegie Museum of Art; the Newark
Museum; the Worcester Art Museum, Massachusetts;
Pennsylvania State College; and New York University.

BARGES PASSING UNDER A BRIDGE (Plate 78)
Oil on canvas, ca. 1910–1915
16" x 19" unsigned
Period frame: gilded

Exhibited:
Carnegie Museum of Art, (Pittsburgh), 1967, *A.H. Gorson*.
Spanierman Gallery, (New York), 1989, *The Power and the Glory:
Pittsburgh Industrial Landscapes by Aaron Harry Gorson*, cat.
Center Galleries, Center for Creative Studies, (Detroit), and
Cleveland State University Art Gallery, (Cleveland), 1994, *A
Place in Time: The Inlander Collection of Great Lakes Regional
Painting*, cat.

Published:
Rina Youngner, *The Power and the Glory: Pittsburgh Industrial
Landscapes by Aaron Harry Gorson* (Spanierman Gallery, New
York: 1989).
Dennis Nawrocki and Robert Thurmer, *A Place in Time: The
Inlander Collection of Great Lakes Regional Painting* (Cleveland
State University: 1994).

26. CARL HALL (1921–1996)

Best known as a painter of Oregon's Willamette Valley, Carl
Hall was born in Washington D.C. in 1921. In the early 1920s
Hall's father moved his family to Detroit where he found
employment in the Packard automobile factory. Encouraged by

his high school art teacher, Hall began attending the Meinzinger School of Art in Detroit after class during his senior year. While still in high school, Hall had one of his paintings accepted into the prestigious *Annual Exhibition for Michigan Artists* at the Detroit Institute of Arts. Following his graduation in 1939, Hall entered the Meinzinger school full time. There he studied painting under Carlos Lopez, a Cuban American regionalist painter who had settled in Detroit. Lopez encouraged and supported the professional ambitions of his talented young student. By 1941, Hall was already gaining national recognition for the distinctive magic realism he brought to the American Scene landscapes he was painting and exhibiting. As World War II broke out, Hall was drafted and sent to Oregon for Army training. In 1944, while Hall was in the South Pacific, the New York dealer Julian Levy arranged to present several of the artist's pictures in his gallery alongside works by some of the best known surrealists and magic realists of the day. A year after his discharge Hall moved west to Oregon and began painting new canvases inspired by the mist-shrouded landscape of the Pacific Northwest. He held his first solo exhibition with Levy in 1947. A year later, *Life* ran a feature on Hall and his Oregon pictures. After 1950, Hall turned away from his early realism and toward a more abstract style better suited to expressing his mystical sense of the ambiguous relationship between man and nature. Recognized as one of Oregon's most important artists and teachers, Carl Hall died in Salem, Oregon, in 1996. His paintings can be found in the collections of the Whitney Museum of American Art; Wichita Art Museum, Kansas; the Detroit Institute of Arts; the Boston Museum of Fine Arts; Sheldon Swope Art Museum; the University of Oregon; and the Hallie Ford Museum of Art in Salem, Oregon.

LOT FOR SALE (Plate 100)*
Gouache on paper, 1941
13" x 18" (sight) s.d.–l.r.
Period frame: painted and patinated

Exhibited:
Center Galleries, Center for Creative Studies, (Detroit), and Cleveland State University Art Gallery, (Cleveland), 1994, *A Place in Time: The Inlander Collection of Great Lakes Regional Painting*, cat.
Halie Ford Museum of Art, (Salem, Oregon), 2000, *Eden Again: The Art of Carl Hall*, cat.

Published:
Dennis Nawrocki and Robert Thurmer, *A Place in Time: The Inlander Collection of Great Lakes Regional Painting* (Cleveland State University: 1994).
Roger Hull, *Eden Again: The Art of Carl Hall* (University of Washington: 2000)

27. LEO HENKORA (1893–1954)

Leo Henkora was born in 1893 in Vienna, Austria. As a teenager, Henkora studied art in both Vienna and Munich before immigrating to the United States in 1914. He landed in New York and was overwhelmed by the size of the city. Heading west, he settled briefly in Pipestone, Minnesota, and then moved south to Chicago. His first years in America were difficult and disappointing. In 1920 he found his way to Minneapolis where a local doctor engaged him to make

anatomical drawings. Employed and finally able to converse in English, Henkora put down roots in Minneapolis. Sometime in the early 1920s he enrolled at the Minneapolis School of Art. There, he studied painting and composition under Cameron Booth and Anthony Angarola, an early Chicago modernist who taught briefly at the School around 1922. By 1925, Henkora had become an instructor at the School and was also serving as the director of the Minneapolis Municipal Sketching Club. In 1927 Henkora took a summer teaching job in Missouri and then returned to Minneapolis to open the Henkora School of Art. Actively exhibiting his work through the 1920s, Henkora was a regular participant in the annual exhibitions at the Minnesota State Fair, the annual painting and watercolor exhibitions held at the Art Institute of Chicago, and the national watercolor exhibitions at the Pennsylvania Academy of the Fine Arts. Little is known about Henkora after 1930. At some point, he left Minnesota and resettled in Oregon, where he died in 1954. His early, cubist-inspired landscapes, however, solidly connect the modernist legacy American landscape painters inherited from Cézanne to the art of the American Scene in the Great Lakes region.

FALL AT THE EDGE OF TOWN (Plate 19)
Oil on canvas, 1927
28" x 34" s.d.–l.l.
Original frame: gilded

Exhibited:
Center Galleries, Center for Creative Studies, (Detroit), and Cleveland State University Art Gallery, (Cleveland), 1994, *A Place in Time: The Inlander Collection of Great Lakes Regional Painting*, cat.

Published:
Dennis Nawrocki and Robert Thurmer, *A Place in Time: The Inlander Collection of Great Lakes Regional Painting* (Cleveland State University: 1994).

28. FLOYD D. HOPPER (1909–1984)

Floyd Hopper was born in southern Indiana's Martin County in 1909. As a teenager, he moved with his family to West Baden, Indiana, where he went to high school. Between 1929 and 1933, Hopper attended the John Herron School of Art in Indianapolis, earning a certificate upon the completion of his studies. In 1933, he attended a summer school program sponsored by the Pennsylvania Academy of the Fine Arts to study painting with Eliot O'Hara. Returning to Indianapolis, he continued his studies for several more years working with a number of well-known Indiana painters including William Forsyth, Clifton Wheeler, Donald Mattison, and Henrik Mayer. By the late 1930s, Hopper had become one of the leading American Scene painters in the state of Indiana. Working in oil, egg tempera, and water media, Hopper was especially esteemed by his peers for his watercolors. His regionalist views of workers, farmers, city scenes and barnyards won numerous prizes and awards in competitive regional exhibitions including the annual exhibitions of Indiana artists held at the John Herron Art Museum, the annual Hoosier Salons held in Chicago, the Indiana State Fair, and the juried shows sponsored by the Indianapolis Artists Association and the Fort Wayne Women's Club. When World War II began, Hopper put aside his art to work full time as a

patternmaker in a defense plant. At the conclusion of the war he founded a casting company of his own in the town of Noblesville, Indiana. Running a business full time, the artist found little time to paint through the forties and fifties. Closing his company in 1958, Hopper returned to his art and picked up his career where he had left off, painting and entering exhibitions. He supported himself teaching out of his Noblesville studio until the time of his death in 1984. Floyd Hopper's oils and watercolors are represented in the collections of the Fort Wayne Museum of Art; the Indianapolis Museum of Art; Indiana University; DePauw University; Ball State University; and several other public institutions.

TEN TILL ELEVEN (Plate 77)
Watercolor on paper, 1957–58
14" x 21" (sight) s.–l.r.
Original frame: stained

Exhibited:
Center Galleries, Center for Creative Studies, (Detroit), and Cleveland State University Art Gallery, (Cleveland), 1994, *A Place in Time: The Inlander Collection of Great Lakes Regional Painting*, cat.

Published:
Dennis Nawrocki and Robert Thurmer, *A Place in Time: The Inlander Collection of Great Lakes Regional Painting* (Cleveland State University: 1994).

29. LOIS IRELAND (BORN 1928)

Lois Ireland was born in 1928 in the small town of Waunakee, Wisconsin. In 1940, she began taking watercolor and drawing lessons from a young university art student from Waunakee. As a teenager, Ireland traveled to Madison to meet John Steuart Curry in his studio on the campus of the University of Wisconsin. At Curry's urging, she took up oil painting and began participating in the annual *Rural Art Exhibit* held at the campus Union. Curry, as Artist in Residence at the University, had been charged with managing the Rural Art Project as an outreach designed to connect the campus with amateur artists throughout rural Wisconsin. Under Curry's mentorship, Ireland became one of the program's great success stories. Inspired by reproductions of paintings by Grant Wood, Peter Hurd, Curry, and other regionalists that she found in books and magazines, Ireland became a painter of the American Scene herself. In her own self-taught style, she began creating works that expressed her first hand experience of life in the rich farm country where she grew up. Between 1944 and 1948, Ireland exhibited her paintings at the Milwaukee Art Institute, the Carnegie Museum of Art, and the Madison Art Association. She also won numerous prizes for her work including an award in a national high school art competition sponsored by the Ingersol Watch Company. Although she later enrolled in the art program at the University of Wisconsin and went on to attend the Art Students League in New York, Ireland created many of her best-known works before she reached the age of twenty. Ultimately, Ireland chose a life as a homemaker and painted only sporadically through her mature years. Today, Lois Ireland lives in Hastings, Minnesota, and still draws and paints portraits for friends and neighbors. Her paintings may be found in several important private collections as well as in the collections of the Madison Art Center and the University of Wisconsin.

A HUNTER'S PRIZE CATCH (Plate 102)
Oil on canvas, 1945
15 1/2" x 19 1/2" (s.–l.l.)
Period frame: patinated

Exhibited:
Memorial Union, University of Wisconsin (Madison, Wisconsin), 1945, *Rural Art Exhibit*.

Catalogued:
John Rector Barton, *Rural Artists of Wisconsin*, (University of Wisconsin, Madison: 1948).

30. ROMAN JOHNSON (BORN 1917)

Roman Johnson was born in Columbus, Ohio, in 1917 and has spent most of his life in the city of his birth. Through his early years, Johnson was encouraged to draw by his mother, who often gave him window shades to use as paper. Growing up in the African American community in Columbus, Johnson had little formal training in art. While still in his early twenties, he did study informally with the African American painter, Cletus Butler who was himself studying at Ohio State University. It was a white painter named Emerson Burkhart, however, who ultimately inspired Johnson to become an artist. In 1941, Johnson encountered Burkhart painting *en plein air* along a neighborhood street in Columbus. Declaring his interest in painting, Johnson persuaded Burkhart to let him set up an adjacent easel. They painted side by side for the next six years. Through this period, the two friends completed scores of canvases depicting neighborhood life in Columbus. Encouraged by Burkhart to undertake more formal art training, Johnson left for New York in 1946 to attend classes at the Art Students League, where he was greatly influenced by the teaching of Edwin Dickinson and Ernest Fiene. While in New York, Johnson exhibited his paintings at the Whitney Museum of American Art and at the National Academy of Design. In the late 1950s, Johnson returned to Columbus and set up the studio he maintains today. Abandoning the American Scene style of his early period, Johnson is now working in a neo-expressionist style in which he records his personal understandings of the African American experience. Articulating the populism that has shaped his art, Johnson says: "I want everybody to be able to read what I paint...I am not interested in what is in vogue, but in communicating images." Roman Johnson's paintings can be found in the collections of the Columbus Museum of Art; the South Side Settlement House, Columbus; the Schumacher Gallery, Capital University, Columbus; and several private collections in the Upper Midwest.

DAD (Plate 33)
Oil on canvas, 1939–1943
35" x 24" s.d.–l.r.
Original frame: varnish and silver leaf

Exhibited:
Columbus Museum of Art, (Ohio), 1993, *Friends and Mentors: Emerson Burkhart and Roman Johnson*, cat.
Center Galleries, Center for Creative Studies, (Detroit), and Cleveland State University Art Gallery, (Cleveland), 1994, *A Place in Time: The Inlander Collection of Great Lakes Regional Painting*, cat.

Published:
Dennis Nawrocki and Robert Thurmer, *A Place in Time: The Inlander Collection of Great Lakes Regional Painting* (Cleveland State University: 1994).

31. ETHEL JOHNT (1904–1970)

Ethel Johnt was born in Hamburg, New York, in 1904. She received her art training at the Buffalo School of Fine Arts, where she studied between 1924 and 1926. She completed her studies at the National Academy of Design in New York with teachers including Leon Kroll and Arthur Covey. Returning to Buffalo, Johnt became an active member of the city's art community. Establishing a residence and studio in downtown Buffalo, Johnt painted and exhibited actively through the late 1930s and into the 1950s. She was a member of the progressive Patteran Society in Buffalo and won several prizes in competitive exhibitions held at the Albright Art Gallery. Johnt became best known for her paintings of city and rural scenes in and around Buffalo. Her style blends a sophisticated appropriation of naïve and folk art with a traditional American Scene naturalism. In 1938, Johnt exhibited a painting in the landmark *Great Lakes Exhibition 1938–1939* sponsored by the Patteran Society and toured to seven museums throughout the Great Lakes region. Johnt also exhibited in the traveling survey exhibition of American art sponsored by the Pepsi Cola Company in the 1940s. Throughout her career, Ethel Johnt supported herself as a teacher at Elmwood Franklin School in Buffalo. Professionally, she distinguished herself as a painter in a local company of very talented women artists that included Virginia Cuthbert and Martha Visser't Hooft. Ethel Johnt died in Buffalo in 1970. Her work is included in the collection of the Albright-Knox Art Gallery in Buffalo.

SAINT MARY'S OF SORROWS AT DAWN (Plate 62)
Oil on canvas, ca. 1947
25" x 30" s.–l.r.
Original frame: painted

Exhibited:
Pepsi-Cola Company, 1947, *Fourth Annual Art Competition and Exhibition.*

32. HENRY KELLER (1869–1949)

Henry Keller was born aboard a ship in the Atlantic Ocean in 1869. His German immigrant parents settled in northeastern Ohio. At the age of 21, Henry entered the School of Design for Women in Cleveland, an institution later to be known as the Cleveland School of Art. In 1890, Keller traveled to Germany to study art in Munich and a year later returned to the United States where he worked for the next eight years as a commercial lithographer designing circus posters. In 1899 he again traveled to Germany to study, first in Dusseldorf and then at the Royal Academy in Munich. Keller returned to Cleveland in 1902 where he assumed a teaching position at the Cleveland School of Art. He would remain on the Cleveland faculty until his retirement in 1945. Well trained and experimental in his approach to painting, Keller was invited to exhibit in the 1913 Armory Show in New York by his friend Walt Kuhn. Excited by the array of modernist works presented at the Armory Show, Keller became a leading advocate for "new art" in Cleveland. His enthusiasm for modernism inspired generations of art students at the Cleveland School of Art. The list of Keller's prominent students includes the names of Carl Gaertner, Charles Burchfield, Clara Deike, August F. Biehle, Jr., and Clarence Carter. In the 1920s Keller traveled and painted extensively through the United States, Canada, and Puerto Rico. He became recognized as a master of watercolor and his influence established Cleveland as one of the great centers of American watercolor painting. Keller was elected to the National Academy of Design in 1939. Throughout his long and distinguished career, Keller exhibited regularly at the Cleveland Museum of Art, the Carnegie Museum of Art, the Pennsylvania Academy of the Fine Arts, and the Whitney Museum of American Art in New York. Henry Keller died in San Diego, California, in 1949 and was buried near Cleveland in Berlin Heights, Ohio. His works can be found in the Art Institute of Chicago; the Cleveland Museum of Art; the Whitney Museum of American Art; the Boston Museum of Fine Arts; the Brooklyn Museum; the Metropolitan Museum of Art; and in numerous other important public and private collections.

DEEP WOODS (Plate 14)
Gouache on cardboard, ca. 1916
19" x 29" (sight) s.–l.r.
period frame: stained and varnished

Exhibited:
Beck Center for the Arts, (Cleveland, Ohio), and Burchfield-Penney Art Center, (Buffalo, New York), 2000, *The Poetics of Place: Charles Burchfield and the Cleveland Connection.*

33. HUGHIE LEE-SMITH (1915–1999)

Born in Eustis, Florida, in 1915, Hughie Lee-Smith spent most of his early childhood living with his grandmother in the African American community of Atlanta, Georgia. In 1925, Lee-Smith was sent to join his mother in Cleveland, Ohio. Recognizing her son's artistic talent, Lee-Smith's mother enrolled him in the Saturday youth art classes at the Cleveland Museum of Art, where he was taught by the painter Clarence Carter. In his last year of high school, Lee-Smith won a *Scholastic Magazine* scholarship to the Detroit Society of Arts and Crafts in Michigan. Returning to Cleveland, he enrolled at the Cleveland School of Art where his teachers included Henry Keller and Carl Gaertner. Following his graduation in 1938, Lee-Smith moved to Detroit where he worked in an automotive factory. After serving in the Navy during W.W. II, he returned to Detroit and earned an education degree at Wayne State University. During the early and mid-1950s, Lee-Smith exhibited regularly at the Detroit Institute of Arts and the Detroit Artists Market. In 1953, one of his paintings won the prestigious Founders Society Prize at the *Annual Exhibition for Michigan Artists*. It was in Detroit that Lee-Smith developed his mature painting style. Creating dreamlike landscapes populated with enigmatic, solitary figures, he explored what he once described as "a shifting back and forth between that which is patently artificial and the real." Like John Rogers Cox and Carl Hall, Lee-Smith turned his regional experience inward and became a magic realist. In 1957, Lee-Smith left Detroit and moved to New York, where over the next thirty years he became recognized as one of the most important African

American painters of his generation. His paintings were included in exhibitions at the Butler Institute of American Art, Howard University, the Boston Museum of Fine Arts, the Museum of Modern Art, and the Dallas Museum of Art. In 1988, an important retrospective of Lee-Smith's work was assembled by the New Jersey State Museum and toured nationally. In 1997 Hughie Lee-Smith moved to New Mexico, where he died in Albuquerque in 1999. His paintings are included in over thirty major public collections including the Metropolitan Museum of Art; the National Academy of Design; Howard University; the Detroit Institute of Arts; and the Flint Institute of Arts, Michigan.

BEACH SCENE (Plate 11)
Oil on masonite, 1953
23" x 35" s.d.–l.l.
Original frame: varnished

Exhibited:
New Jersey State Museum, (Trenton), and The Cultural Center, (Chicago, Illinois), *Hughie Lee-Smith Retrospective Exhibition*, 1989, cat.; toured to The Studio Museum (Harlem, New York). Center Galleries, Center for Creative Studies, (Detroit), and Cleveland State University Art Gallery, (Cleveland), 1994, *A Place in Time: The Inlander Collection of Great Lakes Regional Painting*, cat.

Published:
Dennis Nawrocki and Robert Thurmer, *A Place in Time: The Inlander Collection of Great Lakes Regional Painting*, (Cleveland State University: 1994).

SLUM LAD (Plate 105)
Oil on canvas, ca. 1960
26" x 32" s.–l.r.
Period frame: painted

Exhibited:
Forsythe Gallery, (Ann Arbor, Michigan), 1966, *Recent Works by Hughie Lee-Smith*.
Dennos Museum Center, (Traverse City, Michigan), 1996, *Painters of the Great Lakes Scene*, cat.; toured 1997, to Kalamazoo Institute of Arts (Michigan), Flint Institute of Arts (Michigan).

Published:
Michael D. Hall, *Painters of the Great Lakes Scene* (Dennos Museum Center: 1996).
Nannette Maciejunes and E. Jane Connell, "Epilogue," *Timeline* 20 (March–June 2003), p. 94.

34. ALEXANDER LEVY (1881–1947)

Alexander Levy was born in Bonn, Germany, in 1881. Sometime later, his family immigrated to the United States and settled in Cincinnati. There, Levy enrolled in the Cincinnati Art Academy and studied painting under Frank Duveneck. He continued his studies at the New York School of Art, where he was taught by William Merritt Chase and Robert Henri. Once out of school, he began exhibiting his paintings and supporting himself as a commercial illustrator in New York. In 1909 he moved to Buffalo, New York, and two years later became the art director at the Larkin Soap Company. Submitting his paintings to local exhibitions and competitions, Levy soon established himself as one of

the city's outstanding artists. In the 1930s, however, he became embroiled in a bitter power struggle that pitted Buffalo's more traditional artists against the city's modernists and their allies on the curatorial staff of the Albright Art Gallery. Levy became the champion of the traditionalists. As the modernists gained recognition, he became increasingly alienated from the Buffalo art community. Despite his personal disappointments, Levy did achieve national recognition as an artist. A realist who painted with great skill and stylistic flourish, his work encompassed a variety of themes from portraits and rural landscapes to urban and industrial scenes. His early 1920s views of the Pierce-Arrow factory in Buffalo anticipate the regional industrial scenes that many Great Lakes artists would produce in the 1930s and 40s. Alexander Levy died in 1947. His work is included in the collections of the Delaware Art Museum; Denver Art Museum; the Peabody Institute, Massachusetts; the Detroit Institute of Arts; and the Art Institute of Chicago.

STAMPING ROOM—PIERCE ARROW FACTORY (Plate 81)*
Oil on plywood, ca. 1924
20"x 15" s.–l.r.
Period frame: gilded

Exhibited:
Dennos Museum Center, (Traverse City, Michigan), 1996, *Painters of the Great Lakes Scene*, cat.; toured 1997, to Kalamazoo Institute of Arts (Michigan), Flint Institute of Arts (Michigan).

Published:
Michael D. Hall, *Painters of the Great Lakes Scene* (Dennos Museum Center: 1996).

35. EDMUND LEWANDOWSKI (1914–1998)

Edmund Lewandowski was born to Polish parents in Milwaukee, Wisconsin, in 1914. Between 1931 and 1935 he studied art at the Layton School of Art in Milwaukee where he was strongly influenced by the formalist art theories presented to him by the Wisconsin regionalist Gerrit Sinclair. In 1937 Lewandowski joined the Downtown Gallery in New York where his works were exhibited alongside those of Charles Sheeler, William Zorach, and other prominent early twentieth century American modernists. He soon became a part of the WPA and was awarded commissions to paint murals for several public buildings. His art career was interrupted by a period of service in the United States Army Air Force during World War II. After his discharge, Lewandowski accepted a teaching post at the Layton School of Art. Through the 1940s, his paintings were exhibited in many important museums including the Museum of Modern Art, the Art Institute of Chicago, California Palace of the Legion of Honor, the Whitney Museum of American Art, and the Corcoran Gallery of Art in Washington D.C. In the early 1950s Lewandowski served as head of the department of art at Florida State University in Tallahassee. In 1954 he returned to Milwaukee to become president of his alma mater, the Layton School of Art. He served as Layton's president until 1972 when he became chairman of the art department at Winthrop University in South Carolina. Throughout his career, Lewandowski was recognized stylistically as a precisionist. He created paintings in which the industrial world of the Great Lakes region was transformed into hard-edged shapes arranged in flat, often monochromatic compositions. As one of the few

precisionists associated with the American Scene movement, Lewandowski made a unique contribution to the history of Great Lakes regional painting. Edmund Lewandowski died in 1998 in Rock Hill, South Carolina. His works are in the collections of the Sheldon Memorial Art Gallery, Nebraska; the Milwaukee Art Museum; the Flint Institute of Arts, Michigan; the Museum of Modern Art; and the Brooklyn Museum.

GREAT LAKES SHIPBUILDING (Plate 89)
Oil on canvas, 1949
30"x 24" s.–l.c.
Original frame: paint wash patina

Exhibited:
Allen Gallery (New York), 1951, *Edmund Lewandowski.*
Corcoran Gallery of Art, (Washington D.C.), 1953, *23rd Biennial Exhibition of American Oil Painting*, cat.
Museum of Fine Arts, (Houston, Texas), 1955, *Fortune.*
Columbus Museum of Art (Ohio), 2000, *Illusions of Eden: Visions of the American Heartland* cat.; toured 2000–2001, to Museum of Modern Art (Vienna), Ludwig Museum (Budapest), Madison Art Center (Wisconsin), Washington Pavilion (South Dakota).

Published:
"Shipyard Painting," *Fortune Magazine* (August 1951—cover).
Nathaniel Pousette-Dart, *American Painting Today* (Hastings House: 1956).
Robert Stearns, ed., *Illusions of Eden: Visions of the American Heartland* (Arts Midwest: 2000).

36. CARLOS LOPEZ (1908–1953)

Carlos Lopez was born in Havana, Cuba, in 1908. His family immigrated to the United States in 1919. He began his art studies at the School of the Art Institute of Chicago in 1927. He moved to Detroit in 1930 and continued his training at the Detroit Art Academy from 1930 to 1933. Lopez was professionally active in the Michigan art scene from the mid-1930s to the early 1950s. During the Great Depression, he completed four post office mural projects under the auspices of the United States Treasury Department. In 1937 his regionalist landscape painting *Spring* won the Friends of Modern Art Prize at the *Annual Exhibition for Michigan Artists* at the Detroit Institute of Arts. A year later, this same painting was selected for inclusion in the historic *Great Lakes Exhibition 1938–39*. Through the course of his career, Lopez exhibited nationally at the Corcoran Gallery in Washington D.C., the Art Institute of Chicago, the Pennsylvania Academy of the Fine Arts, Carnegie Institute, and the Whitney Museum of American Art. The American Scene paintings that Lopez created in the late 1930s are characterized by strong colors and broad paint strokes that make them appear expressionist in style. In addition to landscapes, Lopez also painted allegorical works featuring harlequins, matadors and musicians. In 1945 Lopez became a member of the art faculty at the University of Michigan and moved his studio from Detroit to Ann Arbor, Michigan, where he died in 1953. His work is included in the collections of the Cranbrook Art Museum, Michigan; the Henry Ford Museum, Michigan; Standard Oil Company of New Jersey; the Detroit Institute of Arts; and the Whitney Museum of American Art.

COUNTRY SCHOOL (Plate 47)
Oil on canvas, 1937
26 1/4" x 32 1/4" s.d.–u.r.
Period frame: painted

SPRING (Plate 95)
Oil on canvas, 1937
30"x 38" s.–l.l.
Original frame: painted

Exhibited:
Detroit Institute of Arts, (Michigan), 1937, *Annual Exhibition for Michigan Artists*, (first prize—modern art), cat.
Albright Art Gallery, (Buffalo, New York), 1938, *Great Lakes Exhibition: 1938-1939* cat.; toured 1938-1939, to Art Gallery of Toronto, (Canada), Cleveland Museum of Art, (Ohio), Detroit Institute of Arts, (Michigan), Memorial Art Gallery, (Rochester, New York), Milwaukee Art Institute, (Wisconsin), Toledo Museum of Art, (Ohio).
Dennos Museum Center, (Traverse City, Michigan), 1996, *Painters of the Great Lakes Scene*, cat.; toured 1997, to Kalamazoo Institute of Arts (Michigan), Flint Institute of Arts (Michigan).

Published:
Florence Davies, "More Michigan Art," *The Detroit News* (November 21, 1937).
Michael D. Hall, *Painters of the Great Lakes Scene* (Dennos Museum Center: 1996).

LIFTING FOG (Plate 9)
Watercolor on paper, ca. 1945
24" x 37" (sight) s.–u.l. and verso
Original frame: combed gesso painted

Exhibited:
Dennos Museum Center, (Traverse City, Michigan), 1996, *Painters of the Great Lakes Scene*, cat.; toured 1997, to Kalamazoo Institute of Arts (Michigan), Flint Institute of Arts (Michigan).

Published:
Michael D. Hall, *Painters of the Great Lakes Scene* (Dennos Museum Center: 1996).

37. AMY McCLELLAN LORIMER (1893–1950)

Amy McClellan Lorimer was born in Toronto, Canada, in 1893. As a young woman she studied art at the Collegiate Institute in Winnipeg, Canada. She then moved to the United States and settled in Detroit, where she continued her studies at the School of the Detroit Society of Arts and Crafts. There, she studied painting with the Paris trained American modernist, Samuel Halpert, who had been appointed head of the painting department at the School in 1927. After Halpert's untimely death in 1930, Lorimer finished her studies under his successor, John Carroll. Through the 1930s and the early 1940s, Lorimer was a very active member of the Detroit art scene. She joined the Detroit Society of Women Painters and Sculptors and exhibited annually at the exhibitions sponsored by the Society at the Detroit Scarab Club. She also showed regularly in the *Annual Exhibition for Michigan Artists* held at the Detroit Institute of Arts, winning a prize in the

1936 Annual. In 1937 Lorimer presented a solo exhibition at the Detroit Artists Market and two years later her work was selected for inclusion in the exhibition *American Art Today* at the New York World's Fair. Other national exhibitions followed. In 1940, Lorimer exhibited paintings at both the Art Institute of Chicago and the Pennsylvania Academy of the Fine Arts. Lorimer was best known for her oil paintings of Detroit street scenes, especially her views of busy downtown boulevards and commercial buildings. A Detroit critic wrote that Lorimer had: "a genius for finding paintable spots in a prosy town." In spirit, Lorimer's pictures belong to the American Scene movement, but in style, they consistently reflect the Parisian modernism she learned from her mentor, Samuel Halpert. Through most of her career, Amy Lorimer taught art at Detroit's Central YWCA. Amy McClellan Lorimer died in Detroit in 1950. Her paintings can be found in the Detroit Historical Society as well as in numerous private collections in Michigan.

THE WHITE TOWER (Plate 43)*
Oil on canvas, 1932
20"x 16" s.d.–l.r.
Period frame: silver leaf

Exhibited:
Kresge Art Museum Michigan State University, (East Lansing, Michigan), 1986, *The Michigan Experience*, cat.; toured 1986, to Bressler Museum, (Alpena, Michigan), Grand Rapids Art Museum, (Michigan), Midland Center for the Arts, (Michigan), Kalamazoo Institute of Arts, (Michigan), Museum of Arts and History, (Port Huron, Michigan), Saginaw Art Museum, (Michigan), Lee Hall Gallery, (Marquette, Michigan), Depree Art Center, (Holland, Michigan).
Center Galleries, Center for Creative Studies, (Detroit), and Cleveland State University Art Gallery, (Cleveland), 1994, *A Place in Time: The Inlander Collection of Great Lakes Regional Painting*, cat.

Published:
Sadayoshi Omoto and Eldon Van Liere, *The Michigan Experience* (Michigan State University: 1986).
Dennis Nawrocki and Robert Thurmer, *A Place in Time: The Inlander Collection of Great Lakes Regional Painting* (Cleveland State University: 1994).

BOULEVARD—DETROIT (Plate 55)
Oil on canvas: ca. 1932
26" x 20" s.–l.l.
Period frame: silver leaf

38. CLARA MAIRS (1878–1963)

Born in Hastings, Minnesota in 1878, Clara Mairs is best remembered as a highly original printmaker. Her paintings, however, strongly complement her prints and have earned Mairs an important place in the history of Great Lakes regional art. Mairs received her first training at the St. Paul Art Institute sometime near the turn of the century. Around 1910 she left Minnesota to study at the Pennsylvania Academy of the Fine Arts under Daniel Garber. By 1918, Mairs had returned to St. Paul where she met the painter Clement Haupers who, though twenty-two years her junior, became her life-long companion. Enthusiastic about the new art being produced in Europe, Mairs and Haupers went to

Paris in 1923 to study painting with the French cubist Andre Lhote at the Academie Montparnassee. The two artists also traveled to Italy and Algiers before returning to the United States in 1925. Resettled in Minnesota, Mairs became interested in printmaking and in 1928 she and Haupers returned to Paris where Clara mastered the technique of etching. By 1930, Mairs was back in St. Paul painting and making prints. By the late 1940s, her etchings had been published in several important collections of American prints. The subjects Mairs preferred for her paintings and etchings were animals, the circus, children at play, stories from the Bible, and the domestic lives of her friends and neighbors. A bohemian by nature, Mairs developed a personal and highly idiosyncratic artistic style. Her witty, sometimes satirical, work recounts specific moments in the lives of the people living near her St. Paul studio. During the 1950s Mairs spent many winters working in Mexico. Through her lifetime, she exhibited her work at the Library of Congress, Philadelphia Print Club, Brooklyn Society of Etchers, the La Jolla Art Center in California and the 1939 New York World's Fair. Clara Mairs continued making art up until a few weeks before her death in St. Paul in 1963. Her paintings and prints are in the collections of the Minnesota Museum of Art; the Philadelphia Museum of Art; High Museum of Art, Atlanta; San Diego Museum of Art; Walker Art Center; and the United States Department of State.

HALLOWEEN (Plate 94)
Oil on masonite, 1935
24" x 20" s.–l.r.
Original frame: painted

Exhibited:
St. Paul Gallery and School of Art, (Minnesota), 1961, *Work by Clara Mairs*, cat.

Catalogued:
Malcolm E. Lein, *Work by Clara Mairs*. St. Paul Gallery and School of Art (Minnesota, 1961).

TWO CHILDREN (Plate 36)
Oil on canvas, ca. 1940
40"x 32" unsigned
Period frame: carved and painted

39. CARL MATSUDA (1911–1981)

Born in the state of Washington in 1911, Carl Matsuda grew up in the Midwest. His Japanese father was studying agriculture at Michigan State University when he met and married Carl's mother. Moving to the Northwest, the couple had just started a family when Carl's father suddenly died, forcing his wife to take her two sons back to Michigan to live with her parents. By the time Carl was a teenager, his family had relocated to the city of Lansing, Michigan, where Carl attended high school. After graduation, Matsuda worked for a local window cleaning company until the outbreak of World War II, when he went to work at a General Motors defense plant. After the war, he bought the window cleaning business he had worked for earlier and operated it successfully until his retirement. By the 1950s, Matsuda had discovered his talent for drawing and painting. He began working in watercolor, painting in a distinctive calligraphic

style. His many watercolors from this period document life in urban Lansing. Though Matsuda was largely self-taught as an artist, he did take a class from the well-known American Scene painter, John DeMartelly, who had joined the art faculty at Michigan State in 1946. The two became friends. By the 1960s, Matsuda had become a member of the Lansing Art Guild and was a regular participant in the Guild's annual exhibitions. On several occasions he won awards and prizes for his work, including a first prize in the Guild's 1968 spring exhibit. Matsuda is also known to have exhibited his paintings in the Lansing Public Library, the Oldsmobile plant cafeteria and in various local stores and businesses including one popular Lansing nightclub. By the 1970s, he had begun making wood-block prints and was teaching classes at the Lansing Art Guild studio. In 1981, Carl Matsuda died in Lansing. He is remembered as a man who liked art, classical music, fly-fishing, and golf. His paintings are in private collections in both Lansing and Detroit, Michigan.

HARDYS—LANSING (Plate 64)
Watercolor on paper, 1955
19" x 24" (sight) s.d.–l.r.
Period frame: natural wood

40. LAWRENCE McCONAHA (1894–1962)

Lawrence McConaha was born in Centerville, Indiana, in 1894. He studied art briefly with the Indiana Impressionists, John Elwood Bundy and George Baker, and spent two summers at the Guy Wiggins School in Connecticut. As a teenager, McConaha learned telegraphy and subsequently served in the United States Army as a telegraph operator during World War I. On his return to civilian life, he took a position as a telegrapher in a brokerage firm in Richmond, Indiana. He worked full-time in the brokerage business thereafter until his retirement in the 1950s, painting in whatever time he had in the evening and on his weekends. Inspired by Paul Gauguin's paintings in the collection of the Art Institute of Chicago, McConaha traveled to Tahiti in 1933 to discover the source of Gauguin's vision for himself. During his three-week stay in Tahiti, he painted furiously, completing over forty canvases before returning home. Over the course of his pilgrimage, McConaha became a serious artist. For the next twenty years, he traveled the state of Indiana painting colorful, postimpressionist views of the rural and industrial landscape of his region. Though McConaha's style exhibits something of the "primitive" quality associated with naïve art, the artist himself was fully aware of the American Scene movement of which he was a part. Ambitious and hard working, he exhibited his paintings at the National Academy of Design, the Corcoran Gallery in Washington, D.C., the Salmagundi Club, New York, the Los Angeles County Museum of Art, the Art Institute of Chicago, and several other important institutions. In the course of his career, McConaha received over fifty awards for his work. In 1934, his industrial scene, *Coke Otto*, was awarded a first prize in a regional exhibition juried by the artist, Charles E. Burchfield. Lawrence McConaha died in Richmond, Indiana, in 1962. His works can be found in the collections of the Tipton, Indiana, Library; and the Richmond Art Association in Richmond, Indiana.

COKE OTTO (Plate 84)
Oil on Canvas, 1933
25" x 30" s.–l.r.
Original frame: gilded and painted

Exhibited:
Pennsylvania Academy of the Fine Arts, (Philadelphia, Pennsylvania), 1933, *Annual Exhibition*, cat.
Herron Art Museum, (Indianapolis, Indiana), 1934, *Annual Exhibition of Indiana Artists* (first prize).
Marshall Field Galleries, (Chicago, Illinois), 1935, *The Hoosier Salon Exhibition* (prize).
Cincinnati Art Galleries, (Ohio), 1990, *Gallery Selections*, cat.
Columbus Museum of Art (Ohio), 1997, *The Paintings of Charles Burchfield: North by Midwest*, cat.; toured 1997–98, to Burchfield-Penney Art Center (Buffalo), National Museum of American Art (Washington D.C.).

Published:
Lucille Morehouse, "In the World of Art," *The Indianapolis Sunday Star* (March 4, 1934).
Nannette Maciejunes and Michael D. Hall, *The Paintings of Charles Burchfield: North by Midwest* (Abrams: 1997).

INDIANA PASTORAL (Plate 23)
Oil on canvas, ca. 1936
30"x 36" s.–l.r.
Period frame: painted

Exhibited:
Dennos Museum Center, (Traverse City, Michigan), 1996, *Painters of the Great Lakes Scene*, cat.; toured 1997, to Kalamazoo Institute of Arts (Michigan), Flint Institute of Arts (Michigan).

Published:
Michael D. Hall, *Painters of the Great Lakes Scene* (Dennos Museum Center: 1996).

NIGHT BARNS (Plate 48)
Oil on canvas, ca. 1945
20"x 24" s.–l.r.
Original frame: painted

Exhibited:
Dennos Museum Center, (Traverse City, Michigan), 1996, *Painters of the Great Lakes Scene*, cat.; toured 1997, to Kalamazoo Institute of Arts (Michigan), Flint Institute of Arts (Michigan).

Published:
Michael D. Hall, *Painters of the Great Lakes Scene* (Dennos Museum Center: 1996).

SPRINGWOOD (Plate 76)
Oil on canvas: ca. 1948
30"x 45" s.–l.r.
Original frame: gilded

Exhibited:
Center Galleries, Center for Creative Studies, (Detroit), and Cleveland State University Art Gallery, (Cleveland), 1994, *A Place in Time: The Inlander Collection of Great Lakes Regional Painting*, cat.

Published:
Dennis Nawrocki and Robert Thurmer, *A Place in Time: The Inlander Collection of Great Lakes Regional Painting* (Cleveland State University: 1994.

41. FRANCES McVEY (1903–1984)

Frances Haines McVey was born in Muncie, Indiana, in 1903. She graduated from the School of the Art Institute of Chicago in 1925 and lived and worked in the Upper Midwest all of her life. At the age of thirty she married Richard C. McVey, assistant superintendent of the Chicago Public Schools. She completed her art training in Chicago by studying with the painter Boris Anisfeld between 1935 and 1936. Thereafter, she established a studio in the Chicago area, where she became known primarily for her portrait and figure compositions in oil and pastel. McVey was a member of the United Scenic Artist's Association and the Chicago Society of Artists. From 1939 on she was a regular contributor to the annual calendars published by the Society. McVey exhibited her work at the Art Institute of Chicago, the Riverside Museum in New York and at the Library of Congress in Washington, D.C. In the later years of her career, McVey devoted herself to painting religious subjects. She became a "psychic" artist producing works in which she believed she collaborated with the spirits of visionary artists from the past such as William Blake. Ten such canvases entitled *The Saint Series*, honor important figures of the Piscean Age. At the end of her life, McVey gave this series of paintings to Camp Chesterfield, a Spiritualist center located near Anderson, Indiana. From the mid-1950s until the time of her death, McVey maintained a studio just outside the grounds of Camp Chesterfield where she painted, taught art, and participated in the activities of her spiritual community. Frances McVey died in 1984. Her works can be found at the Hett Gallery at Camp Chesterfield in Chesterfield, Indiana; and in a few private collections in Illinois, Indiana, and Michigan.

THE SCHOOL TEACHER (Plate 35)
Oil on canvas, ca. 1942
24" x 30" s.–l.r.
Period frame: combed and painted

42. GEORGE JO MESS (1898–1962)

George Jo Mess was born in Cincinnati, Ohio in 1898. In 1899, his family moved to Indianapolis, Indiana, where George would live for most of his life. At the age of thirteen George began attending Saturday art classes at the John Herron Art Institute taught by Marie C. Todd, Otto Stark, and William Forsyth. His art studies were interrupted by a brief stint in the army near the end of World War I. Following his discharge, he enrolled in the teacher's college at Columbia University where he took art classes with Arthur C. Dow, the respected art educator and art theorist. Completing his studies, Mess returned to Indianapolis and married the artist, Evelynne Bernloehr. In 1929 the two traveled to France to study landscape and mural painting. In the mid-1930s, George learned printmaking and began experimenting with aquatint. His studied, craftsman-like approach to art was well suited to the printmaking process. Ultimately, he became a member of the print societies of four different states; Illinois, Ohio, Indiana and Pennsylvania. In the winter of 1941, Mess and his wife bought a farm in the southern Indiana town of Nashville and became a part of the lively colony of artists living and working in the picturesque countryside of rural Brown County. Thereafter, the couple divided their time between two studios, one in Indianapolis and the other in Nashville. Throughout his career, Mess produced oil paintings and aquatints depicting rural and urban life in Indiana. His work is distinctive for its tight linear composition and its controlled decorativeness. George Jo Mess died in Indianapolis in 1962. His prints are housed in several important public collections including those of the Philadelphia Art Museum; the Metropolitan Museum of Art; the Library of Congress; the Cleveland Museum of Art; and the Princeton University Art Museum.

DRY DOCK—GEIST LAKE (Plate 13)*
Oil on masonite, 1956
25" x 36" s.–l.r.
Original frame: gilded and painted

Exhibited:
Dennos Museum Center, (Traverse City, Michigan), 1996, *Painters of the Great Lakes Scene*, cat.; toured 1997, to Kalamazoo Institute of Arts (Michigan), Flint Institute of Arts (Michigan).

Published:
Michael D. Hall, *Painters of the Great Lakes Scene* (Dennos Museum Center: 1996).

Catalogued:
June DuBois and Martin F. Krause, *Indiana Artists George Jo and Evelynne Bernloeher Mess* (Indiana Historical Society: 1985).

43. LISELOTTE MOSER (1906–1983)

Liselotte Moser was born in Switzerland in 1906. She studied in Vienna and in Berne before coming to Detroit in 1927. She completed her art training at the Art School of the Detroit Society of Arts and Crafts under John P. Wicker and Samuel Halpert. It was Halpert who most shaped Moser's art. As one of the first twentieth century American painters to study in Paris, Halpert brought firsthand knowledge of postimpressionist painting to Detroit. Moser responded to Halpert's teaching and began painting landscape and figure compositions that reflected a modernist ideology. A bold simplification of form and a flattened postimpressionist space distinguishes Moser's landscape pictures from the late 1920s and the 1930s. Moser exhibited frequently in the Detroit area from 1928 until the early 1960s. She was a regular participant in the *Annual Exhibition for Michigan Artists* held at the Detroit Institute of Arts. She was awarded the prestigious Kamperman purchase prize for a painting that she submitted to the Annual in 1938. Another of her paintings was selected for inclusion in *The Great Lakes Exhibition 1938–39*. In addition to her painting, Moser also became known for her textile work. In 1964, Liselotte Moser left Detroit and returned to her native Switzerland, where she died in 1983. She is remembered as a vibrant, cosmopolitan force in the Detroit art scene of her time. Her work is in the col-

lection of the Detroit Institute of Arts as well as in numerous private collections throughout Michigan.

FACTORIES BY THE RIVER (Plate 2)
Oil on canvas, 1929
23" x 32" s.–l.r.
Period frame: carved and gilded

Exhibited:
Dennos Museum Center, (Traverse City, Michigan), 1996, *Painters of the Great Lakes Scene*, cat.; toured 1997, to Kalamazoo Institute of Arts (Michigan), Flint Institute of Arts (Michigan).
Creative Arts Center, (Pontiac, Michigan), 2000, *Women in the Arts: Representing Michigan 1900–1960*.

Published:
Michael D. Hall, *Painters of the Great Lakes Scene* (Dennos Museum Center: 1996).

44. MINNIE HARMS NEEBE (1873–1958)

Minnie Harms Neebe was born in Chicago in 1873. She studied art at the School of the Art Institute of Chicago and at the Fine Arts Academy in Provincetown, Massachusetts. Her most important teachers were Charles Hawthorne, Walter Ufer, E. Ambrose Webster, W.J. Reynolds and Louis A. Neebe, who became her husband. Minnie Harms Neebe was active in Chicago during the era when an awareness of modern art first began to shape the work of painters there. Through the twenties and thirties, Neebe became a member of several progressive Chicago artist's organizations including the Chicago Society of Artists, the Neo-Arlimusc (an advocacy for art, literature, music and science) and the Chicago No-Jury Society of Artists. When the first book surveying Chicago's emerging generation of modern painters was published in 1933, Neebe was included in it. Her brightly colored fauvist landscape pictures blended representational and abstract elements into compositions reflecting the rebellious spirit of Chicago's vanguard artists. In her statement for the book, Neebe wrote; "The purely abstract in art occupies a most important place, although I always fuse it with the more realistic phases of my canvases." Cosmopolitan in her lifestyle, Neebe traveled extensively all through her life. Her paintings depict subjects from New England, the American Southwest, and the Pacific coast as well as from the Great Lakes region. Throughout the 1930s, women became important contributors in all areas of American art. The city of Chicago, in particular, produced a highly creative generation of women artists in this era. Experimenting with a broad range of new approaches to painting, ambitious and talented women such as Minnie Harms Neebe, Jean Crawford Adams, Francis Strain, and Bernece Berkman all greatly enriched the arts in Chicago through the period of the American Scene. Minnie Harms Neebe died in 1958. Her works can be found in the Illinois State Museum as well as in many private collections.

A CENTURY OF PROGRESS (Plate 93)
Oil on masonite, 1933
22" x 26" unsigned
Reproduction of artist-made frame: carved with silver leaf

Exhibited:
Robert Henry Adams Fine Art, (Chicago, Illinois). 1990, *Chicago Modern*.
Center Galleries, Center for Creative Studies, (Detroit), and Cleveland State University Art Gallery, (Cleveland), 1994, *A Place in Time: The Inlander Collection of Great Lakes Regional Painting*, cat.

Published:
Dennis Nawrocki and Robert Thurmer, *A Place in Time: The Inlander Collection of Great Lakes Regional Painting* (Cleveland State University: 1994).

45. GLIDDEN PARKER (1913–1980)

Glidden McLelland Parker, Jr. was born in Phillips, Maine, in 1913. As a child he went to a one-room country school. Parker attended Bates College in Lewiston, Maine, where he studied writing and received a B.A. degree in literature in 1935. After graduation, Parker traveled to Europe. He enrolled at the University of Vienna and learned to speak and read German, studied comparative literature, and began writing a novel. Returning to Maine, he next traveled to Alfred, New York, where he became intensely interested in ceramics. Pursuing this interest, he entered Alfred University as a graduate student in ceramics. In the course of his studies, he took up painting under the tutelage of the American Cubist, Katherine Nelson. By 1940, Parker had exhibited his paintings in a number of competitive regional art exhibitions at the Albright Art Gallery in Buffalo and the Memorial Art Gallery in Rochester, New York. He had also established Glidden Pottery in Alfred. After graduation, Parker was offered a teaching job in Philadelphia but he declined in order to continue designing and marketing his successful line of ceramic ware. He also pursued his other creative interests, holding several exhibitions of his oil paintings at the Wakefield Gallery in New York and in 1947, writing and publishing a short story that received some critical acclaim. In 1950, one of his most innovative pottery pieces was accessioned into the permanent collection of the Museum of Modern Art. By the late 1950s, however, Parker found his ceramic market challenged by low-priced wares imported from Japan and elsewhere. He closed Glidden Pottery in 1957 and moved to Arizona. In 1962 Raymond Loewy hired him to teach pottery in his ceramic studio in Puerto Rico. A few years later, Parker left Puerto Rico to take a job as a stained-glass designer in Scottsdale, Arizona, where he remained into the mid-1970s. He then moved to Santa Fe, New Mexico, to begin yet another career designing ceramic sculpture. He died in Santa Fe in 1980 as he was completing the construction of his new studio. As a painter, ceramic artist, writer, and designer, Glidden Parker is remembered for his many creative achievements and artistic successes.

BRIDGE IN WINTER—ALFRED (Plate 26)
Oil on canvas, 1946
36" x 25" s.d.–l.r.
Original frame: painted and patinated

Exhibited:
Center Galleries, Center for Creative Studies, (Detroit), and Cleveland State University Art Gallery, (Cleveland), 1994, *A Place in Time: The Inlander Collection of Great Lakes Regional Painting*, cat.

Published:
Dennis Nawrocki and Robert Thurmer, *A Place in Time: The Inlander Collection of Great Lakes Regional Painting* (Cleveland State University: 1994).

46. CONSTANCE RICHARDSON (1905–2002)

Constance Coleman Richardson was born in Indianapolis, Indiana, in 1905. She attended Vassar College and studied art at the Pennsylvania Academy of the Fine Arts between 1925 and 1928. She moved in 1930 to Detroit, where her husband, Edgar P. Richardson, had taken a position as an administrator at the Detroit Institute of Arts. Primarily interested in landscape painting, Richardson produced a large body of work depicting the Great Lakes region. She also painted numerous vistas of landscape sites she discovered in her travels to the American West. A realist throughout her career, Richardson created technically expert paintings notable for their detail. Her many panoramic views of Deluth Harbor comprise a unique site-specific genre of American Scene painting. Richardson exhibited her work widely through her long career. During the thirties and forties her paintings were included in group exhibitions in such institutions as the Museum of Modern Art, the Whitney Museum of American Art, the Saint Louis Art Museum, and the Detroit Institute of Arts. Richardson also held numerous solo exhibitions in New York. There, she was originally represented at the Schaffer Gallery and later at the Macbeth Gallery and the Kennedy Galleries. Her work was selected for inclusion in both the 1939 *Golden Gate Exposition* in San Francisco and the *Great Lakes Exhibition 1938–39* which toured to seven different American and Canadian museums. Constance Richardson died in Philadelphia in 2002. Her paintings can be found in the permanent collections of the Columbus Museum of Art, Ohio; Indianapolis Museum of Art; the Flint Institute of Arts, Michigan; the Detroit Institute of Arts; Pennsylvania Academy of the Fine Arts; the Muskegon Museum of Art, Michigan; and the University of Michigan in Ann Arbor, Michigan.

ORE DOCKS, DULUTH (Plate 12)
Oil on masonite, 1953
16" x 31" s.d.–l.l.
Period frame: painted and patinated

Exhibited:
Detroit Institute of Arts, (Michigan), 1954, *Forty-Fifth Annual Exhibition for Michigan Artists*, cat.

47. PAUL SARGENT (1880–1946)

Paul Turner Sargent was born in 1880 and was raised on his family's farm near the town of Charleston in central Illinois. In 1899 he began his formal education at Westfield College in Illinois but soon transferred to Eastern Illinois Normal School where he graduated in 1906. At the urging of his college drawing teacher, Sargent enrolled at the School of the Art Institute of Chicago in 1906. There, he pursued a traditional course in painting under a faculty that included John Vanderpoel, Henry Wood Stevens, and Charles Francis Browne. Completing his studies in 1912, Sargent soon returned to his farm in Charleston where he built a studio and lived for the rest of his life. In 1920, Sargent began traveling to rural Brown County in southern Indiana to paint the rustic vistas he found in the countryside around the town of Nashville. A painter of place as well as of light and shadow, Sargent found himself at home among the Indiana Impressionists who had already established Nashville as the best-known art colony in the Midwest. In 1926, Sargent helped found the Brown County Artist Association and, as a result, became historically identified with Indiana and its landscape painters. Eschewing the urban subjects and the modernist styles that fascinated so many painters in the American Scene, Sargent painted his views of hay fields, creeks, and farmsteads in a traditional regional style that blended realism and impressionism. Through the course of his career, Sargent enjoyed considerable professional success. He participated in Hoosier Salon exhibitions for over twenty years. His paintings were also included in exhibitions at the Sheldon Swope Art Gallery in Terre Haute, Indiana, the Art Institute of Chicago, Indiana University, the University of Illinois and several other notable Midwestern institutions. Paul Sargent died in 1946 on the Illinois farm where he was born. His paintings can be found in the Brown County Art Association; Charleston Public Library, Illinois; Tarble Arts Center, Charleston, Illinois; and numerous private collections.

HAY STACKS (Plate 17)
Oil on canvas: 1921
20" x 28 1/4" s.d.–l.l.
Period frame: gilded

48. WILLIAM S. SCHWARTZ (1896–1977)

William S. Schwartz was born in 1896 in Smorgen, Russia. Between 1908 and 1912 he studied at the Vilna Art School in Poland. At the age of seventeen, he immigrated to the United States, and in 1915 entered the School of the Art Institute of Chicago. There, he studied with Ivan Trutnev and Karl A. Buehr. During this period he supported himself as a singer. Well known for his tenor voice, Schwartz sang with the Chicago Symphony and could have pursued a career in music. He chose painting instead, and completed his course at the Art Institute in 1917 with honors in life study and portraiture. Once out of school, Schwartz associated himself with a small circle of artists including Aaron Bohrod, Ivan Albright, Archibald Motley, Jr., and Anthony Angarola, another important Chicago modernist with whom he shared a studio for several years. By the mid-1920s, Schwartz had evolved a style of his own strongly influenced by various European modernists and by the poetic allegories of the American painter, Arthur B. Davies. In 1925 one of Schwartz's early allegorical works won the prestigious Albert Kahn Prize in a competition in Detroit, Michigan. By the early 1930s, Schwartz had become an American Scene painter working in a style that was his own blend of naturalism and cubism. His ambitious paintings of the urban and rural landscape around Lake Michigan became his signature works. The Chicago street scene he entitled *Dancing the Blues Away* was selected for presentation at the 1939 New York World's Fair. Schwartz was also awarded several mural commissions by the WPA. He completed murals for Illinois post offices in Fairfield, Eldorado, and Pittsfield. Throughout his long career, Schwartz produced oil paintings, watercolors,

lithographs and sculpture. William Schwartz died in 1977 having distinguished himself as one of the most important painters of his era. His work can be found in many public collections including those of the San Francisco Museum of Modern Art; Dallas Museum of Fine Art; Pennsylvania Academy of the Fine Arts; the Art Institute of Chicago; Denver Art Museum; the Detroit Institute of Arts; the Tel Aviv Museum in Israel; and the Biro-Bidjan Museum in Russia.

THE OLD CANDY STORE (Plate 41)
Oil on canvas, 1926
18" x 21" s.d.–l.r. and verso
Period frame: gilded and patinated

Exhibited:
Center Galleries, Center for Creative Studies, (Detroit), and Cleveland State University Art Gallery, (Cleveland), 1994, *A Place in Time: The Inlander Collection of Great Lakes Regional Painting*, cat.

Published:
Dennis Nawrocki and Robert Thurmer, *A Place in Time: The Inlander Collection of Great Lakes Regional Painting* (Cleveland State University: 1994).

A VILLAGE CORNER (Plate 67)
Oil on canvas, 1934
30"x 36" s.–l.l. and s.d.–verso
Period frame: patinated

Exhibited:
Art Institute of Chicago, (Illinois), 1944, *Annual Exhibition of Works by Artists of Chicago and Vicinity*, cat.
Columbus Museum of Art, (Ohio), 2000, *Illusions of Eden: Visions of the American Heartland* cat.; toured 2000–2001, to Museum of Modern Art (Vienna), Ludwig Museum (Budapest), Madison Art Center (Wisconsin), Washington Pavilion (South Dakota).

Published:
Robert Stearns, ed., *Illusions of Eden: Visions of the American Heartland* (Arts Midwest: 2000).

BOAT HOUSE (Plate 4)
Gouache on paper, ca. 1936
20"x 28" s.–u.l.
Period frame: painted

Exhibited:
Dennos Museum Center, (Traverse City, Michigan), 1996, *Painters of the Great Lakes Scene*, cat.; toured 1997, to Kalamazoo Institute of Arts (Michigan), Flint Institute of Arts (Michigan).

Published:
Michael D. Hall, *Painters of the Great Lakes Scene* (Dennos Museum Center: 1996).

MINING IN ILLINOIS (Plate 87)
(Study for the post office mural in Eldorado, Illinois)
Gouache on paper, ca. 1937
11 3/4" x 19 3/4" (sight) s.–l.c.
Period frame: painted

Referenced:
Marlene Park and Gerald E. Markowitz, *Democratic Vistas: Post Offices and Public Art in the New Deal* (Temple University: 1984).

49. ROLAND A. SCHWEINSBURG (1898–1963)

Roland Schweinsburg was born in Ellwood City, Pennsylvania, in 1898. The son of a steel mill worker, Schweinsburg was raised in the blue-collar, working class world of the Great Lakes region. Determined to become an artist, Schweinsburg left home to enroll at the Cleveland School of Art where he was taught by Henry Keller, Paul Travis, Frank Wilcox, William Eastman and others. After graduation, he remained in Cleveland and supported himself as a freelance interior designer. He also worked as an advertising and newspaper artist. Sometime in the late 1920s or early 1930s, Schweinsburg moved to Youngstown, Ohio, where he began painting for the WPA mural project. His public commissions included a mural for the children's room of the McMillan Library in Youngstown and another for the post office in East Liverpool, Ohio. Schweinsburg is also known to have painted American Scene murals for the post office in Alexandria, Indiana, the high school at Struthers, Ohio, and for the Carnegie Library in East Liverpool, Ohio. Adept in oil, watercolor, and encaustic, Schweinsburg taught art and illustration at the Butler Institute of American Art in Youngstown for many years. He exhibited regularly throughout northeast Ohio and won a prize for one of his paintings of industrial Cleveland in the 1926 May Show at the Cleveland Museum of Art. He also exhibited nationally at the Corcoran Gallery in Washington D.C., the Art Institute of Chicago, the Detroit Institute of Arts, Indianapolis Art Museum, and the San Diego Art Museum. Between 1932 and 1935, Schweinsburg served as president of the Mahoning Society of Painters in Youngstown. He was given a solo exhibition of his work at the Butler Institute of American Art in 1939. Schweinsburg was an active member of his local art community. He died in Youngstown in 1963. Roland Schweinsburg's murals survive in a number of public buildings including the post office in Eaton, Ohio; the Masonic Temple in Youngstown; and the two East Liverpool sites previously noted.

YOUNGSTOWN MURAL (Plate 97)
Oil on canvas, ca. 1938
51" x 40" s.–l.l.
Contemporary frame

Exhibited:
Vixseboxse Art Galleries (Cleveland, Ohio), 1992, *Ohio Painters*.
Center Galleries, Center for Creative Studies (Detroit), and Cleveland State University Art Gallery (Cleveland), 1994, *A Place in Time: The Inlander Collection of Great Lakes Regional Painting*, cat.
The Butler Institute of American Art (Youngstown, Ohio), 1999, *Regionalist Visions*.

Published:
Dennis Nawrocki and Robert Thurmer, *A Place in Time: The Inlander Collection of Great Lakes Regional Painting* (Cleveland State University: 1994).

50. ZOLTAN SEPESHY (1898–1974)

Zoltan Sepeshy was born in Kassa, Hungary, in 1898. He attended the Royal Academy of Art in Budapest and received degrees in art and art education. He also studied briefly in Vienna and Paris before coming to the United States in 1921. In 1922 he settled in Detroit, Michigan and took employment as an architectural draftsman. He was appointed an instructor at the School of the Detroit Society of Arts and Crafts in 1926. In 1930 he became head of the painting department at the Cranbrook Academy of Art in Bloomfield Hills, Michigan. He later served as the Academy's president from 1947 until his retirement in 1966. Throughout his career, Sepeshy exhibited widely and won numerous prizes in national competitive exhibitions. His work was shown at the Carnegie Museum of Art, the Metropolitan Museum of Art, the Whitney Museum of American Art, the Butler Institute of American Art, the Art Institute of Chicago and the Detroit Institute of Arts. Sepeshy's paintings were routinely included in most of the important American art survey exhibitions in the 1930s, including: *American Art of Today* at the 1939 New York World's Fair, the 1939 *Golden Gate Exposition* in San Francisco, and the *Great Lakes Exhibition 1938–39*. Sepeshy's depictions of urban Detroit from the late 1920s exhibit a strong modernist influence. They are composed in a flat, cubist space and are painted with a bold, expressionist brush stroke. Through the 1930s and into the 1940s, Sepeshy's style became more realistic. An increasing concern with the particulars of his landscape and figure compositions prompted him to turn away from his early modernist style. During the high period of the American Scene, he became best known for his luminous egg tempera paintings depicting the small towns and harbors along the eastern shore of Lake Michigan. Zoltan Sepeshy died in Royal Oak, Michigan in 1974. His work is included in many important collections including those of the National Academy of Design, New York; the Metropolitan Museum of Art; the Saint Louis Art Museum; Sheldon Swope Art Museum, Terre Haute; the Wichita Art Museum, Kansas; the Detroit Institute of Arts; the Toledo Museum of Art, Ohio; and the Dallas Museum of Fine Art.

STEEL MILL—ZUG ISLAND (Plate 82)
Oil on canvas, ca. 1928
25" x 28" s.–l.r.
Period frame: gilded and painted

Exhibited:
Kresge Art Museum Michigan State University, (East Lansing, Michigan), 1986, *The Michigan Experience*, cat.: toured 1986–1987, to Bressler Museum, (Alpena, Michigan), Grand Rapids Art Museum, (Michigan), Midland Center for the Arts, (Michigan), Kalamazoo Institute of Arts, (Michigan), Museum of Arts and History, (Port Huron, Michigan), Saginaw Art Museum, (Michigan), Lee Hall Gallery, (Marquette, Michigan), Depree Art Center, (Holland, Michigan).
Dennos Museum Center, (Traverse City, Michigan), 1996, *Painters of the Great Lakes Scene*, cat.; toured 1997, to Kalamazoo Institute of Arts (Michigan), Flint Institute of Arts (Michigan).
Columbus Museum of Art, (Ohio), 2000, *Illusions of Eden: Visions of the American Heartland* cat.; toured 2000–2001, to Museum of Modern Art (Vienna), Ludwig Museum (Budapest), Madison Art Center (Wisconsin), Washington Pavilion South Dakota).

Published:
Sadayoshi Omoto and Eldon Van Liere. *The Michigan Experience* (Michigan State University: 1986).

Michael D. Hall, *Painters of the Great Lakes Scene* (Dennos Museum Center: 1996).
Robert Stearns, ed., *Illusions of Eden: Visions of the American Heartland* (Arts Midwest: 2000).

WOODWARD NEAR JEFFERSON (Plate 53)
(WOODWARD AVENUE)
Oil on canvas, 1929
36" x 34" s.d.–l.r.
Reproduction period frame: gilded and painted

Exhibited:
Detroit Institute of Arts, (Michigan), 1930, *Annual Exhibition for Michigan Artists* (first prize), cat.
Lowe Art Center Syracuse University, (New York), and Cranbrook Academy of Art Museum, (Bloomfield Hills, Michigan), 1966, *Zoltan Sepeshy: Forty Years of his Work*, cat.
Center Galleries, Center for Creative Studies, (Detroit), and Cleveland State University Art Gallery, (Cleveland), 1994, *A Place in Time: The Inlander Collection of Great Lakes Regional Painting*, cat.
Muskegon Museum of Art, (Michigan), 2002, *Zoltan Sepeshy Remembered*, cat.

Published:
Lawrence Schmeckebier, *Zoltan Sepeshy: Forty Years of his Work* (Syracuse University: 1966).
Dennis Nawrocki and Robert Thurmer, *A Place in Time: The Inlander Collection of Great Lakes Regional Painting* (Cleveland State University: 1994).
James Houghton, *Zoltan Sepeshy Remembered* (Muskegon Museum of Art: 2002).

WOODWARD AVENUE No. II (Plate 56)*
Oil on canvas, 1931
25" x 30" s.–l.r.
Original frame: combed and painted

Exhibited:
Cranbrook Pavilion, (Bloomfield Hills, Michigan), 1936, *Zoltan Sepeshy*.
Cranbrook Academy of Art Museum, (Bloomfield Hills, Michigan), 1950, *Zoltan Sepeshy*.
Lowe Art Center Syracuse University, (New York), and Cranbrook Academy of Art Museum, (Bloomfield Hills, Michigan), 1966, *Zoltan Sepeshy: Forty Years of his Work*, cat.
Kresge Art Museum Michigan State University, (East Lansing, Michigan), 1986, *The Michigan Experience*, cat.: toured 1986–1987, to Bressler Museum, (Alpena, Michigan), Grand Rapids Art Museum, (Michigan), Midland Center for the Arts, (Michigan), Kalamazoo Institute of Arts, (Michigan), Museum of Arts and History, (Port Huron, Michigan), Saginaw Art Museum, (Michigan), Lee Hall Gallery, (Marquette, Michigan), Depree Art Center, (Holland, Michigan).
Center Galleries, Center for Creative Studies, (Detroit), and Cleveland State University Art Gallery, (Cleveland), 1994, *A Place in Time: The Inlander Collection of Great Lakes Regional Painting* cat.
Columbus Museum of Art, (Ohio), 2000, *Illusions of Eden: Visions of the American Heartland* cat.; toured 2000–2001, to Museum of Modern Art (Vienna), Ludwig Museum (Budapest), Madison Art Center (Wisconsin), Washington Pavilion South Dakota).

Published:
Lawrence Schmeckebier, *Zoltan Sepeshy: Forty Years of his Work*

(Syracuse University: 1966).
Sadayoshi Omoto and Eldon Van Liere. *The Michigan Experience* (Michigan State University: 1986).
Dennis Nawrocki and Robert Thurmer, *A Place in Time: The Inlander Collection of Great Lakes Regional Painting* (Cleveland State University: 1994).
Robert Stearns, ed., *Illusions of Eden: Visions of the American Heartland* (Arts Midwest: 2000).

ISHPEMING (Plate 29)*
Pastel on paper, ca. 1936
19" x 14" s.–l.l.
Period frame: silver leaf

Exhibited:
Center Galleries, Center for Creative Studies, (Detroit), and Cleveland State University Art Gallery, (Cleveland), 1994, *A Place in Time: The Inlander Collection of Great Lakes Regional Painting*, cat.

Published:
Dennis Nawrocki and Robert Thurmer, *A Place in Time: The Inlander Collection of Great Lakes Regional Painting* (Cleveland State University: 1994).

DECK NO. 2 (Plate 6)
Watercolor on paper, ca 1936
21 1/4" x 27 1/4" (sight) s.–l.l.
Period frame: painted

51. GERRIT V. SINCLAIR (1890–1955)

Gerrit V. Sinclair was born in Grand Haven, Michigan, in 1890. He studied art at the School of the Art Institute of Chicago from 1910 to 1915. His best-known teachers there were John Vanderpooel and John Norton. In 1917 Sinclair enlisted in the United States Army Ambulance Corps and served in northern Italy and Austria. Scenes from his experience abroad are recorded in his paintings from the early 1920s. Following the war, Sinclair settled in Milwaukee, Wisconsin. There he joined the original faculty of the Layton School of Art when it opened in 1920. He continued to teach at the Layton School and at the Oxbow Summer School of Art in Saugatuck, Michigan until his retirement in 1954. Sinclair is recognized as both an important artist and teacher from the Great Lakes region. During his lifetime his paintings were exhibited at the Salon d'Automne in Paris, the Whitney Museum of American Art in New York, the Corcoran Gallery of Art in Washington D.C., the Carnegie Institute in Pittsburgh, the Art Institute of Chicago and in many other museums. He received numerous prizes and commissions for his work, including a WPA commission for a mural in the Federal Building in Wassau, Wisconsin. Sinclair was a painter of Wisconsin subjects. Through the course of his life he produced hundreds of canvases depicting scenes he observed in urban Milwaukee and in the rural farmland beyond the city's outskirts. His farm scene entitled *Spring in Wisconsin* was exhibited at the 1939 World's Fair in New York. Sinclair's mature style was a blend of realism and impressionism similar to that employed by so many Great Lakes painters. Still, Sinclair thought of himself as a modernist and consistently lectured his students about the abstract and structural essentials of composi-

tion, design and color. Gerrit V. Sinclair died in Milwaukee, Wisconsin in 1955. His paintings are in the Milwaukee Art Museum; the University of Wisconsin—Milwaukee; Milwaukee Public Schools; Priebe Art Museum, Oshkosh, Wisconsin; and many private collections throughout Wisconsin and Michigan.

MILWAUKEE FRUIT STAND (Plate 65)
Oil on canvas, 1916
20"x 24" s.–l.r.
Period frame: carved and gilded

Exhibited:
Milwaukee Art Institute, (Wisconsin), 1957, *Gerrit V. Sinclair Memorial Exhibition*, cat.
University of Wisconsin—Milwaukee, (Wisconsin), 1982, *Gerrit V. Sinclair: Paintings and Drawings*, cat.
Center Galleries, Center for Creative Studies, (Detroit), and Cleveland State University Art Gallery, (Cleveland), 1994, *A Place in Time: The Inlander Collection of Great Lakes Regional Painting*, cat.
Dennos Museum Center, (Traverse City, Michigan), 1996, *Painters of the Great Lakes Scene*, cat.; toured 1997, to Kalamazoo Institute of Arts (Michigan), Flint Institute of Arts (Michigan).

Published:
Dennis Nawrocki and Robert Thurmer, *A Place in Time: The Inlander Collection of Great Lakes Regional Painting* (Cleveland State University: 1994).
Michael D. Hall, *Painters of the Great Lakes Scene* (Dennos Museum Center: 1996).

THIRD WARD RED HOUSE (Plate 59)
Oil on masonite, 1936
20"x 24" s.d.–l.r and verso.
Period frame: painted and patinated

Exhibited:
Columbus Museum of Art, (Ohio), and Museo de Arte Moderno (Mexico City), 1996, *Visions of America: Urban Realism 1900–1945*, cat.; toured 1997, to Butler Institute of American Art (Ohio).
Dennos Museum Center, (Traverse City, Michigan), 1996, *Painters of the Great Lakes Scene*, cat.: toured 1997, to Kalamazoo Institute of Arts (Michigan), Flint Institute of Arts (Michigan).

Published:
Teresa del Conde, Austin Artega, et. al., *Visions of America: Urban Realism 1900–1945* (Instituto Nacional de Bellas Artes: 1996).
Michael D. Hall, *Painters of the Great Lakes Scene* (Dennos Museum Center: 1996).

GULLS AT GILLS ROCK (Plate 5)
Oil on masonite, 1937
20"x 24" s.d.–l.r. and verso.
Original frame: silver leaf

Exhibited:
Center Galleries, Center for Creative Studies, (Detroit), and Cleveland State University Art Gallery, (Cleveland), 1994, *A Place in Time: The Inlander Collection of Great Lakes Regional Painting*, cat.

Published:
Dennis Nawrocki and Robert Thurmer, *A Place in Time: The Inlander Collection of Great Lakes Regional Painting* (Cleveland State University: 1994).

52. CLYDE J. SINGER (1908–1999)

Clyde Singer was born in Malvern, Ohio, in 1908. From 1931 to 1932, he studied art at the Columbus Art School in Columbus, Ohio. As a student he greatly admired the paintings of George Bellows. He continued his training at the Art Students League in New York from 1933 to 1934. There, he was taught by several important American painters including Kenneth Hayes Miller, Thomas Hart Benton, and John Steuart Curry. Completing his New York studies in 1934, Singer returned to Malvern to set up a studio. His early works have a painterly quality that recalls the work of Bellows and his Ashcan school contemporaries. After his study in New York, however, Singer began working in a tighter, more detailed style better suited to the American Scene subjects he had begun painting. As his reputation grew, Singer was invited to submit work to the *Carnegie International*, the *Annual Exhibition of American Art* at the Whitney Museum of American Art, the *Corcoran Biennial* and other important exhibitions. In 1940, Singer accepted a position as assistant director at the Butler Institute of American Art in Youngstown, Ohio. He relocated his studio and continued to paint images of regional life as he observed it in Ohio. He also painted city scenes developed from sketches he made on various trips to New York City. In 1941, Singer painted a mural entitled *Skaters* for the post office in New Concord, Ohio. As one of the most durable of the regionalists, Singer continued to paint American Scene images into the 1980s. By his own count, he produced over 3000 paintings in his lifetime. His work has been included in over fifty major exhibitions and is illustrated in dozens of books and catalogues. Clyde Singer died in Youngstown, Ohio in 1999. His paintings can be found in the permanent collections of the Wadsworth Atheneum, Connecticut; Akron Art Institute, Ohio; the Butler Institute of American Art; Pennsylvania Academy of the Fine Arts; and the Gilcrease Institute of American History and Art, Oklahoma.

THE MEDICINE MAN (Plate 92)
Oil on burlap, 1932
27" x 34" s.d.–l.c.
Original frame: painted

Exhibited:
Art Students League, (New York), 1933, *Scholarship Competition*.
The Westmorland County Museum of Art, (Greensburg, Pennsylvania), 1972, *Clyde Singer: A Retrospective Exhibition of His Work From 1932 to 1972*, cat.
Westminster College Art Gallery, (New Wilmington, Pennsylvania), 1976, *Clyde Singer: A Retrospective Exhibit fom 1932 to 1976*, cat.
Columbus Museum of Art, (Ohio), 2000, *Illusions of Eden: Visions of the American Heartland* cat.; toured 2000–2001, to Museum of Modern Art (Vienna), Ludwig Museum (Budapest), Madison Art Center (Wisconsin), Washington Pavilion South Dakota).

Published:
New York Herald Tribune, (April 1, 1933).
Canton Repository, (April 23, 1933).

Robert Stearns, ed., *Illusions of Eden: Visions of the American Heartland* (Arts Midwest: 2000).

53. PHYLLIS SLOANE (BORN 1921)

Phyllis Lester Sloane was born in Worcester, Massachusetts, in 1921. Her family moved to Cleveland, Ohio, in 1928. She received her art training at the Carnegie Institute of Technology in Pittsburgh where she earned a Bachelor of Fine Arts degree in industrial design in 1943. For the next six years, Sloane worked as a designer in Chicago, Stillwater (Oklahoma), New York, and Cleveland. Through the period in which she built her design career, she also worked as a studio painter. Sloane first submitted her work to the May Show at the Cleveland Museum of Art in 1943. Four years later she won first prize in portraiture for her entry in the 1947 May Show. In 1960, Sloane taught herself silk-screen printing. From then on she displayed her prints, watercolors and oils regionally and nationally in many group exhibitions. She also mounted over a dozen one-woman exhibitions between 1960 and 1995. Sloane's style evolved over time. Her earliest work depicting scenes of industrial Cleveland and its environs was modernist in appearance. The stylized regional landscapes she produced in the mid-1940s combine lines, shapes and colors into flat arrangements that recall the paintings of Stuart Davis. Sloane's more recent paintings are highly realist in style. Consistently, however, her work has been addressed to problems of composition and design. Still active as an artist today, Phyllis Sloane currently divides her time between her Cleveland studio and her studio in Santa Fe, New Mexico. Her work is included in the collections of Case Western University, Ohio; New Mexico Museum of Fine Art; Philadelphia Museum of Art; Rutgers University, New Jersey; and the Cleveland Museum of Art.

APARTMENTS (Plate 50)
Oil on board, 1945
22" x 26" s.–l.r.
Period frame: combed and painted

Exhibited:
Dennos Museum Center, (Traverse City, Michigan), 1996, *Painters of the Great Lakes Scene*, cat.; toured 1997, to Kalamazoo Institute of Arts (Michigan), Flint Institute of Arts (Michigan).

Published:
Michael D. Hall, *Painters of the Great Lakes Scene* (Dennos Museum Center: 1996).

54. WILLIAM SOMMER (1867–1949)

William Sommer was born in Detroit, Michigan in 1867. His German parents were among the many northern Europeans in their generation that immigrated to the major cities of the Upper Midwest. Sommer began studying drawing with the Detroit sculptor Julius Melchers at the age of eleven. In 1881, Sommer apprenticed himself at Calvert Lithography in Detroit to learn a commercial trade. He remained at Calvert until 1888 when he left Detroit to work at various lithography shops in New York and Boston. In 1890 he traveled abroad to study for a year at the

Kunstakademie in Munich. Returning to the U.S., he spent the next fifteen years working in New York. In 1907 he moved to Cleveland, Ohio, where he took employment with the Otis Lithography Co. There he became friends with William Zorach, Abel Warshawsky, and others in the small circle of Cleveland painters discovering modern art. After viewing the 1913 Armory Show, Sommer began painting a number of works in which he explored cubism, expressionism, and fauvism. In the process, he evolved his own personal hybrid modernist style and became the leading postimpressionist in the Cleveland art scene. In 1914 Sommer moved to the rural Brandywine area some twenty miles south of Cleveland where he set up a studio in an abandoned schoolhouse. His Brandywine studio became a regional Mecca for poets, artists and others interested in discussing modernist philosophy and aesthetics. Though Sommer was offered several opportunities to exhibit his work in major art centers, he was totally disinterested in career building. Instead, he exhibited when he pleased in the annual May Shows at the Cleveland Museum of Art and in exhibitions presented in the small galleries and bookstores he frequented in the Cleveland area. Sommer was one of the most sophisticated artists in the Great Lakes region and one of its great masters of watercolor. The medium suited his spontaneous temper. Through the 1930s, Sommer painted hundreds of watercolor landscapes around his Brandywine home that must be counted among the most eloquent works produced by any American Scene painter. He also produced striking watercolor portraits and still life compositions that may have an American equal only in the paintings of Charles Demuth. After the death of his wife in 1945, William Sommer became withdrawn. He died in Brandywine, Ohio, in 1949. William Sommer's works are included in the collections of the Cleveland Museum of Art; the Butler Institute of American Art; Akron Art Museum; Case Western University; and the Columbus Museum of Art.

THE RABBIT HUTCH (Plate 39)
Oil on board, 1913
26" x 20" s.–l.r.
Period frame: carved and gilded

Exhibited:
The Cleveland Museum of Art, (Ohio), 1913, *Seventh Annual Exhibition by Cleveland Artists*, cat.
The Cleveland Museum of Art, (Ohio), 1950, *The William Sommer Memorial Exhibition*, cat.
The Akron Art Museum, (Ohio), 1993, *The Art of William Sommer*, cat.
Center Galleries, Center for Creative Studies, (Detroit), and Cleveland State University Art Gallery, (Cleveland), 1994, *A Place in Time: The Inlander Collection of Great Lakes Regional Painting*, cat.
Columbus Museum of Art (Ohio), 1997, *The Paintings of Charles Burchfield: North by Midwest*, cat.; toured 1997–98, to Burchfield-Penney Art Center (Buffalo), National Museum of American Art (Washington D.C.).
The Beck Center for the Arts, (Cleveland, Ohio), and The Burchfield-Penney Art Center, (Buffalo, New York), 2000, *The Poetics of Place: Charles Burchfield and the Cleveland Connection*, cat.

Published:
Dennis Nawrocki and Robert Thurmer, *A Place in Time: The Inlander Collection of Great Lakes Regional Painting* (Cleveland State University: 1994).
Nannette Maciejunes and Michael D. Hall, *The Paintings of Charles Burchfield: North by Midwest* (Abrams: 1997).

SEATED GIRL (Plate 27)
Watercolor on cardboard, 1926
25 3/4" x 19 3/4" (sight) s.d.–l.c.
Period frame: gilded

FEEDING TIME (Plate 68)
Watercolor on paper: ca. 1935
12" x 16" (sight) unsigned
Period frame: painted

Exhibited:
Dennos Museum Center, (Traverse City, Michigan), 1996, *Painters of the Great Lakes Scene*, cat.; toured 1997, to Kalamazoo Institute of Arts (Michigan), Flint Institute of Arts (Michigan).

Published:
Michael D. Hall, *Painters of the Great Lakes Scene* (Dennos Museum Center: 1996).

COWS AT MIDDAY (Plate 22)*
Watercolor on paper, ca. 1936
12" x 18" s.–l.r.
Period frame: painted

Exhibited:
Dennos Museum Center, (Traverse City, Michigan), 1996, *Painters of the Great Lakes Scene*, cat.; toured 1997, to Kalamazoo Institute of Arts (Michigan), Flint Institute of Arts (Michigan).

Published:
Michael D. Hall, *Painters of the Great Lakes Scene* (Dennos Museum Center: 1996).

FARM BOY (Plate 31)*
Watercolor on paper: ca. 1936
16" x 12" (sight) unsigned
Period frame: silver leaf

Exhibited:
The Beck Center for The Arts, (Cleveland, Ohio), 1999, *William Sommer and the Brandywine Vision*.

55. JOSEPH SPARKS (1896–1975)

Joseph Sparks was born in Jersey City, New Jersey, in 1896. Little is known of his early life. Records indicate that Sparks studied art in Detroit, Chicago, and in Paris. The list of his teachers includes the names of Percy Ives and Paul Honore, who both taught in Detroit, Leon Kroll, who taught at the School of the Art Institute of Chicago between 1924 and 1925, and Fernand Leger and Amedee Ozenfant, who both taught in Paris. A clearer history of his life and career begins in the late 1920s in Detroit where Sparks first began showing his work professionally. Supporting himself as an illustrator for the *Detroit News*, Sparks became a member of the Detroit artist group known as the Scarab Club and exhibited routinely in the Club's annual exhibitions. Between 1928 and 1947 he exhibited regularly in the *Annual Exhibition for Michigan Artists* held at the Detroit Institute of Arts. In 1930, Detroit's J.L. Hudson Gallery gave Sparks a solo exhibition and a year later he held his first New York solo exhibition at the Ferargil Gallery. By the mid-

1930s, Sparks had completed several public mural commissions in the Detroit area and had been invited to show his drawings and prints at the Memorial Art Gallery in Rochester, New York. An inveterate traveler, Sparks often left Detroit to draw and paint in Europe and Mexico. Returning home, he presented the work he had done abroad in exhibitions that were always well received. Stylistically, Sparks was a modernist who depicted his subjects in a cubist style that emphasized flat areas of color and tone set off by strong outlines. His regional landscapes from the middle and late 1930s address some of the same compositional and painterly issues found in Marsden Hartley's Maine and Nova Scotia landscapes from the same period. Joseph Sparks remained active as a painter into the 1960s and died in Detroit in 1975. His works are in the Detroit Institute of Arts; Detroit Historical Library; the Library of Congress; and numerous private collections in Michigan.

NET MENDING ROW (Plate 86)
Oil on canvas, ca. 1936
18" x 20" s.–l.r.
Period frame: varnished

56. ETHEL SPEARS (1903–1974)

Ethel Spears was born in Chicago, Illinois, in 1903. She studied design at the School of the Art Institute of Chicago, where her most notable teachers were Alexander Archipenko and John Norton. After graduation she undertook further study in Europe and at the Art Student's League in New York. Spears returned to Chicago in 1930 and remained there for the next thirty years, pursuing an active career as a painter, teacher, and printmaker. Spears was particularly fond of working in watercolor and gouache. Water media seems to have been well suited to her graphic, neo-primitive style. Her lively gouache and oil paintings of life in urban Chicago suggest that she had a strong interest in folk and naïve art. Her whimsical tempera painting entitled *Fourth of July* was selected for inclusion in the *American Art Today* exhibition assembled at the New York World's Fair in 1939. Sometime in the 1930s, Spears began teaching at the School of the Art Institute of Chicago, where she remained on the faculty for more than two decades. She was a regular participant in the annual regional exhibitions held at the Art Institute, where she presented her paintings more than twenty times between 1926 and 1951. She also exhibited in New York and California. Through the period of the WPA, Spears executed a number of mural projects for community houses and elementary schools in and around Chicago. In 1961, she left Chicago and resettled in Navasota, Texas, where she died in 1974. Ethel Spears was an active member of the arts organizations of her time; she belonged to the National Society of Mural Painters, and was a long time member of the Chicago Society of Artists, serving on the Society's board of directors and contributing block prints to the group's annual calendar for many years. Ethel Spears is represented in the collection of the Art Institute of Chicago. Her murals can be found at the Lowell School, Oak Park, Illinois; the United States Post Office, Hartford, Wisconsin; and the Public Library in Rochelle, Illinois.

FORTH OF JULY (Plate 96)
Gouache on board, ca. 1938
22" x 30" (sight) s.–l.r.
Period frame: painted

Exhibited:
New York World's Fair, (New York), 1939, *American Art Today*, cat.
The Art Institute of Chicago, 1940, *Annual Exhibition of Watercolors by American Artists*, cat.
Center Galleries, Center for Creative Studies, (Detroit), and Cleveland State University Art Gallery, (Cleveland), 1994, *A Place in Time: The Inlander Collection of Great Lakes Regional Painting*, cat.
Columbus Museum of Art, (Ohio), 2000, *Illusions of Eden: Visions of the American Heartland* cat.; toured 2000–2001, to Museum of Modern Art (Vienna), Ludwig Museum (Budapest), Madison Art Center (Wisconsin), Washington Pavilion (South Dakota).

Published:
Glenn B. Opitz, *American Art Today* (reprint of the original 1939 World's Fair catalogue), (Apollo: 1987).
Dennis Nawrocki and Robert Thurmer, *A Place in Time: The Inlander Collection of Great Lakes Regional Painting* (Cleveland State University: 1994).
Robert Stearns, ed., *Illusions of Eden: Visions of the American Heartland* (Arts Midwest: 2000).

57. JACK KEIJO STEELE (1919–2003)

Jack Keijo Steele was born in the northern Michigan town of Ironwood in 1919. His family and many of their neighbors were all of Finnish descent. At the age of eight, Steele moved with his parents into a working class neighborhood in Detroit, Michigan. After completing high school, Steele supported himself as a laborer on one of Detroit's automotive assembly lines. He also began his formal study of art and recalls sketching occasionally with Carl Hall when the two of them were enrolled at Detroit's Meinzinger School of Art. In 1940 Steele entered Michigan's prestigious Cranbrook Academy of Art to study with the Hungarian American painter Zoltan Sepeshy. As American involvement in World War II escalated, Steele left school to serve in the United States military as a war artist. After his discharge, Steele completed his studies at Cranbrook and began searching for employment in the city of Detroit. He married in 1947, and by 1949 had become a clay modeler in the styling department of the Ford Motor Company, where he worked until his retirement in 1980. From the late 1930s on, Steele painted American Scene pictures depicting urban life in the Upper Midwest. Heavily loaded with social and political content, Steele's theatrical depictions of blue-collar life in industrial Detroit stylistically blend the urban realism of Reginald Marsh with the fantastic realism of Chicago's Ivan Albright. Steele exhibited his work in the late 1940s and early 1950s in the *Annual Exhibition for Michigan Artists* at the Detroit Institute of Arts. Dismayed by the rise of abstract and Pop art, however, he soon withdrew from the art world to paint in isolation. He was rediscovered in 1992, still painting in the second floor studio of the Detroit-area house he had lived in for five decades. Jack Steele died in Dearborn, Michigan in 2003. His paintings are in several important public collections, including the Detroit Institute of Arts; Center for Great Lakes Culture, East Lansing, Michigan; Cranbrook Academy of Art Museum, Michigan; and in many private collections across the United States.

RESTING AUTO WORKER (Plate 32)*
Watercolor on paper, 1940
21" x 29" s.d.–u.l.
Period frame: patinated

RECESS AT ST. BONIFACE SCHOOL (Plate 74)
Oil on masonite, ca. 1947
24" x 35" s.–l.r.
Period frame: painted

Exhibited:
Cranbrook Art Museum, (Bloomfield Hills, Michigan), 1994,
Jack Keijo Steele: Urban Realist, cat.
Dennos Museum Center, (Traverse City, Michigan), 1996,
Painters of the Great Lakes Scene, cat.; toured 1997, to
Kalamazoo Institute of Arts (Michigan), Flint Institute of Arts
(Michigan).
Columbus Museum of Art, (Ohio), 2000, *Illusions of Eden:
Visions of the American Heartland* cat.; toured 2000–2001, to
Museum of Modern Art (Vienna), Ludwig Museum (Budapest),
Madison Art Center (Wisconsin), Washington Pavilion (South
Dakota).

Published:
Michael D. Hall, *Jack Keijo Steele: Urban Realist*, (Cranbrook
Academy of Art Museum: 1994).
Robert Stearns, ed., *Illusions of Eden: Visions of the American
Heartland* (Arts Midwest: 2000).

BULL AND THE RED HEAD (Plate 38)
Oil on canvas, 1951
20"x 32" s.–l.r.
Original artist-made frame: painted

Exhibited:
The Detroit Institute of Arts, (Michigan), 1951, *Annual
Exhibition of Michigan Artists*, cat.
Center Galleries, Center for Creative Studies, (Detroit), and
Cleveland State University Art Gallery, (Cleveland), 1994, *A
Place in Time: The Inlander Collection of Great Lakes Regional
Painting*, cat.

Published:
Dennis Nawrocki and Robert Thurmer, *A Place in Time: The
Inlander Collection of Great Lakes Regional Painting* (Cleveland
State University: 1994).

ASSEMBLY LINE (Plate 91)
Oil on board, ca. 1954
20"x 30" s.–l.r.
Period frame: painted and patinated

Exhibited:
Cranbrook Art Museum, (Bloomfield Hills, Michigan), 1994,
Jack Keijo Steele: Urban Realist, cat.
Center Galleries, Center for Creative Studies, (Detroit), and
Cleveland State University Art Gallery, (Cleveland), 1994, *A
Place in Time: The Inlander Collection of Great Lakes Regional
Painting*, cat.

Published:
Dennis Nawrocki and Robert Thurmer, *A Place in Time: The
Inlander Collection of Great Lakes Regional Painting* (Cleveland
State University: 1994).

58. LOUIS CHARLES VOGT (1864–1939)

Louis C. Vogt was born in Cincinnati, Ohio, in 1864. The son of a
successful businessman, Vogt began to paint and draw during his
early childhood. Turning away from the business career his family
expected him to pursue, Vogt elected to become an artist. The record
of his training as a painter is unclear. Some accounts place him in
New York in the late 1880s, where he may have received art lessons
from the academician Henry Siddons Mowbray, who was painting
decorative murals in the homes of wealthy New Yorkers at the time. It
is known that in New York during the 1890s, Vogt worked as an illus-
trator for *Harper's Weekly* and produced commissioned works for vari-
ous private patrons. Near the turn of the century, he traveled across
the United States to California, where he painted for a short while
before joining the army and being sent to the Philippines. By 1900,
Vogt was in China as a part of the international force caught up in the
Boxer Rebellion. Having seen the world, Vogt returned to Cincinnati.
Though already established as a professional artist, he enrolled in the
Cincinnati Art Academy in 1907 and 1908 to study with Frank
Duveneck. Completing this study, Vogt set up a studio in Cincinnati
and began portraying his home city. His classic oils and watercolors
depict the bridges, streets, office buildings, and monuments that com-
prise Cincinnati's urban landscape. Vogt's expressive realist style was
perfectly suited to capturing the energy of a Midwestern river town as
it transformed itself into a bustling hub of twentieth century industry
and commerce. In 1912, Vogt was honored with an exhibition of his
works at the Cincinnati Art Museum. He continued to paint into the
1920s. He died in 1939 and is remembered as an important
American realist who helped to set the stage for the Midwestern
American Scene painters of the next generation. Vogt's paintings can
be found in the Cincinnati Art Museum; the Cincinnati Historical
Society; and many private Cincinnati collections.

THE NEW CINCINNATI GAS AND ELECTRIC (Plate 54)
Watercolor on paper, 1929
9 3/4" x 13 3/4" (sight) s.–l.l.
Period frame: gilded

Exhibited:
Cincinnati Art Galleries, (Ohio), 1987, *Panorama of Cincinnati
Art II: 1850–1950*, cat.
Center Galleries, Center for Creative Studies, (Detroit), and
Cleveland State University Art Gallery, (Cleveland), 1994, *A
Place in Time: The Inlander Collection of Great Lakes Regional
Painting*, cat.

Published:
Gallery Staff, *Panorama of Cincinnati Art II: 1850–1950*,
(Cincinnati Art Galleries: 1987).
Dennis Nawrocki and Robert Thurmer, *A Place in Time: The
Inlander Collection of Great Lakes Regional Painting* (Cleveland
State University: 1994).

59. KENNETH A. WOOD (BORN 1913)

Born in Cleveland, Ohio, in 1913, Kenneth Wood studied at the
Cleveland School of Art. His most important teacher was Carl
Gaertner. Impressed by Gaertner's paintings of industrial Cleveland,
Wood began to create his own depictions of the mills, furnaces, and
freighters that shaped the landscape of the industrial valley known as
the Cleveland Flats. A great admirer of the painter Edward Hopper,
he sought to capture a mood of starkness and isolation in many of

these paintings. In 1936, Wood became the art director for the Bailey Meter Company, which was located in the working-class Cleveland neighborhood of Collinwood. A number of the scenes he painted over the next twenty years document the blue-collar world he observed from the windows of his third floor office. Wood began exhibiting as a professional in the late 1930s. His work was first accepted for the Cleveland Museum of Art's annual May Show in 1939. He was included in eighteen subsequent May Shows and won first prize in landscape painting for a work he presented in the 1944 Annual. Over the years, Wood exhibited his work nationally in such prominent museums as the Worcester Art Museum, Massachusetts, the Detroit Institute of Arts, the Milwaukee Art Institute, the Albright Art Gallery, Buffalo, and the Allyn Museum in Connecticut. Through the forties, fifties, and sixties, Wood continued to produce American Scene paintings inspired by the industrial milieu of Cleveland. In the 1970s he began collaborating with his wife, Ruth, to design murals, mosaics, and leaded glass panels for architectural application. Kenneth Wood continues to work in his studio in the town of Chesterland, which lies outside of Cleveland. His work is represented in the Cleveland Museum of Art; the Butler Institute of American Art; and numerous private collections in Cleveland.

WARM SHADOWS (Plate 90)
Gouache on paper, 1953
15" x 22" (sight) s.–l.r.
Original frame: painted

Exhibited:
Cleveland Museum of Art, (Ohio), 1953, *Annual Exhibition of Work by Cleveland Artists*, cat.
American Watercolor Society, 1953, *Exhibition of American Watercolors.*

60. SANTOS ZINGALE (1908–1999)

The son of Italian parents who came to the United States from Sicily, Santos Zingale was born in Milwaukee, Wisconsin, in 1908. He attended high school in Milwaukee and completed his college studies in the Department of Art at Milwaukee State Teachers College in 1931. After college, Zingale went on to the University of Wisconsin in Madison and earned a graduate degree. He then returned to Milwaukee to pursue a career as an artist. There, Zingale painted both easel pictures and murals for the WPA. His murals were commissioned for a high school in Racine, Wisconsin, and for the United States Post Office in Sturgeon Bay,

Wisconsin. In the 1930s, Zingale exhibited regionally in the *Annual Exhibition of Wisconsin Painters and Sculptors* held at the Milwaukee Art Museum. His work was also included in several annual exhibitions at the Art Institute of Chicago. He exhibited nationally in the *Great Lakes Exhibition 1938–1939* and in the *American Art Today* exhibition at the 1939 New York World's Fair. In 1946, Zingale joined the faculty of the art department at the University of Wisconsin in Madison. He retained this post for over thirty years until his retirement in 1978. In the period before World War II, Zingale painted brooding, often melancholy American Scene pictures that expressed his feelings of sympathy for workers and others whom he felt were oppressed by the modern world. In the decades following the war he made several trips to Italy that seem to have prompted a change in his art. His postwar pictures became more abstract in style and heroic in spirit. Over the course of his long career, Zingale exhibited his work at the Walker Art Center in Minneapolis, the Dayton Art Institute in Ohio, the Pennsylvania Academy of the Fine Arts, the Brooklyn Museum, and the Library of Congress. Santos Zingale remained active as a painter up until his death in 1999. His paintings are in the University of Wisconsin, Milwaukee; the Wisconsin Memorial Union, Madison; the Milwaukee Art Museum; and many private collections throughout the Upper Midwest.

UNEMPLOYED WORKER (Plate 28)
Oil on masonite, 1934
16" x 14" s.d.–l.l.
Period frame: silver leaf

Exhibited:
Galleria del Conde, (Milwaukee, Wisconsin), 1997, *Paintings by Santos Zingale.*

THE WHITE STATION—MADISON (Plate 49)
Oil on canvas, 1941
26" x 30" s.d.–l.r.
Original frame: painted

Exhibited:
Millikin University, (Decatur Illinois), 1948, *2nd Annual Exhibition of Artists of the Old Northwest Territory.*
Galleria del Conde, (Milwaukee, Wisconsin), 1997, *Paintings by Santos Zingale.*

Michael D. Hall

* Paintings designated with an asterisk are gifts to the Flint Institute of Arts from Pat Glascock and Michael D. Hall. All others are on permanent loan to the Flint Institute of Arts from The Isabel Foundation.

Selected Bibliography

General Texts: The American Scene

Apollo Book. *American Art Today* (Reprinted From the Original 1939 World's Fair Catalog). Poughkeepsie, New York: Apollo, 1987.

Baigell, Matthew. *The American Scene: American Painting of the 1930's.* New York: Praeger, 1974.

Boswell, Peyton. *Modern American Painting.* New York: Dodd, Mead and Company, 1940.

Dijkstra, Bram. *American Expressionism: Art and Social Change 1920–1950.* New York: Harry N. Abrams, Inc., 2003.

Gruskin, Alan. *Painting in the U.S.A.* Garden City, New York: Doubleday and Company, Inc., 1946.

Heller, Nancy and Julia Williams. *Painters of the American Scene.* New York: Galahad Books, 1982.

Montclair Art Museum. *Precisionism in America 1915–1941: Reordering Reality.* New York: Harry N. Abrams, Inc., 1994.

Park, Marlene and Gerald E. Markowitz. *Democratic Vistas: Post Offices and Public Art in the New Deal.* Philadelphia: Temple University Press, 1984.

Stearns, Robert, ed. *Illusions of Eden: Visions of the American Heartland.* Minneapolis: Arts Midwest, 2000.

Wooden, Howard. *American Art of the Great Depression: Two Sides of the Coin.* Wichita: Wichita Art Museum, 1985.

Wooden, Howard. *The Neglected Generation of American Realist Painters 1930–1948.* Wichita: Wichita Art Museum, 1981.

Books: Great Lakes Regional Painting

Barrie, Dennis. *Artists in Michigan 1900–1976.* Detroit: Wayne State University Press, 1989.

Barton, John Rector. *Rural Artists of Wisconsin.* Madison: The University of Wisconsin Press, 1948.

Carlisle, John C. *A Simple and Vital Design: The Story of the Indiana Post Office Murals.* Indianapolis: Indiana Historical Society, 1995.

Chew, Paul A., ed. *Southwestern Pennsylvania Painters 1800–1945.* Greensburg, Pennsylvania: The Westmoreland County Museum of Art, 1981.

Colby, Joy Hakanson. *Art and a City: A History of the Detroit Society of Arts and Crafts.* Detroit: Wayne State University Press, 1956.

Jacobson, J.Z. *Art of Today Chicago—1933.* Chicago: L.M. Stein, 1932.

Krane, Susan. *The Wayward Muse: A Historical Survey of Painting in Buffalo.* Buffalo, New York: Albright-Knox Art Gallery, 1987.

Letsinger-Miller, Lyn. *The Artists of Brown County.* Bloomington, Indiana: Indiana University Press, 1994.

Milwaukee Art Museum. *100 Years of Wisconsin Art.* Milwaukee: The Milwaukee Art Museum, 1988.

Omoto, Sadayoshi and Eldon Van Liere. *The Michigan Experience.* East Lansing, Michigan: Kresge Art Museum, 1986.

Prince, Sue Ann, ed. *The Old Guard and the Avant-Garde: Modernism in Chicago, 1910–1940.* Chicago: University of Chicago Press, 1990.

Robinson, William H. and David Steinberg. *Transformations in Cleveland Art 1796–1946.* Cleveland: The Cleveland Museum of Art, 1996.

University of Minnesota. *American Paintings and Sculpture in the University Art Museum Collection.* Minneapolis: University of Minnesota, 1986.

Yochim, Louise Dunn. *Role and Impact: The Chicago Society of Artists*. Chicago: Chicago Society of Artists, 1979.

Catalogues: Great Lakes Regional Painting

Adams, Robert Henry. *Chicago: The Modernist Vision*. Chicago: Robert Henry Adams Fine Art, 1990.

Albright Art Gallery. *Great Lakes Exhibition 1938–1939*. Buffalo, New York: The Patteran Society, 1938.

The Burchfield Art Center. *The Charles Rand Penney Collection of Western New York Art*. Buffalo, New York: The Burchfield Art Center, 1992.

Davies, Florence. *Michigan on Canvas*. Detroit: The J.L. Hudson Co., 1947.

Hall, Michael D. *Painters of the Great Lakes Scene*. Traverse City, Michigan: Dennos Museum Center, 1996.

Indianapolis Art League. *The Edge of Town: Painting the Indiana Scene 1932–1948*. Indianapolis: Indianapolis Art League, 1989.

Johnson, Liza and David Lusenhop. *Midwest Realities: Regional Painting 1920–1950*. Portsmouth, Ohio: Southern Ohio Museum, 1994.

Keny, James M. and Nannette V. Maciejunes. *Triumph of Color and Light: Ohio Impressionists and Post-Impressionists*. Columbus, Ohio: Columbus Museum of Art, 1994.

Leigh Yawkey Woodson Art Museum. *Wisconsin's New Deal Art*. Wausau, Wisconsin: Leigh Yawkey Woodson Art Museum, 1980.

Nawrocki, Dennis Alan and Robert Thurmer. *A Place in Time: The Inlander Collection of Great Lakes Regional Painting*. Cleveland: Cleveland State University, 1994.

Robinson, William H., et. al. *A Brush With Light: Watercolor Painters of Northeast Ohio*. Cleveland: Cleveland Artists Foundation, 1998.

Rockford College. *The "New Woman" in Chicago, 1910–1945: Paintings From Illinois Collections*. Rockford, Illinois: Rockford College, 1993.

Sackerlotzky, Rotraud. *Henry Keller's Summer School in Berlin Heights*. Cleveland: Cleveland Artists Foundation, 1991.

Books: Great Lakes Painters

Baigel, Matthew. *Charles Burchfield*. New York: Watson-Guptill, 1976.

Bauer, John I.H. *The Inlander: Life and Work of Charles Burchfield, 1893–1967*. Newark: University of Deleware and New York: Cornwall, 1982.

Bohrod, Aaron. *A Decade of Still Life*. Madison: University of Wisconsin, 1966.

Bohrod, Aaron, Robert E. Gard, and Mark E. Lefebvre. *Wisconsin Sketches*. Madison: Wisconsin House, Ltd., 1973.

Chapman, Manuel. *William S. Schwartz: A Study*. Chicago: L.M. Stein, 1930.

Du Bois, June. *Indiana Artists George Jo and Evelynne Bernloehr Mess*. Indianapolis: Indiana Historical Society, 1985.

Hull, Roger. *Eden Again: The Art of Carl Hall*. Salem, Oregon: Willamette University, 2000.

Junker, Patricia. *John Steuart Curry: Inventing the Middle West*. New York: Hudson Hills Press, 1998.

Lumsdaine, Joycelyn Pang and Thomas O'Sullivan. *The Prints of Adolf Dehn: A Catalog Raisonne*. St. Paul, Minnesota: Minnesota Historical Society Press, 1987.

Maciejunes, Nannette V. and Michael D. Hall. *The Paintings of Charles Burchfield: North by Midwest*. New York: Harry N. Abrams, Inc., 1997.

McClelland, Elizabeth M. *William Sommer: Cleveland's Early Modern Master*. Cleveland: John Carroll University, 1992.

Robinson, Jontyle Theresa and Wendy Greenhouse. *The Art of Archibald J. Motley, Jr.* Chicago: Chicago Historical Society, 1991.

Schmeckebier, Laurence. *John Steuart Curry's Pageant of America.* New York: American Artists Group, 1943.

Trapp, Frank Anderson and Douglas Dreishpoon et. al. *Clarence Holbrook Carter.* New York: Rizzoli, 1989.

Catalogues: Great Lakes Painters

The American Federation of Arts. *Cameron Booth.* New York: American Federation of Arts, 1961.

Case Western Reserve University. *August F. Biehle, Jr.: Ohio Landscapes.* Cleveland: Case Western Reserve University, 1986.

Charles Burchfield Center. *Retrospective: Virginia Cuthbert and Phillip Elliot.* Buffalo, New York: State University College at Buffalo, 1971.

Cleveland Artists Foundation. *Carl Gaertner: A Story of Earth and Steel.* Cleveland: Cleveland Artists Foundation, 2000.

The Cleveland Museum of Art. *The Henry G. Keller Memorial Exhibition.* Cleveland: The Cleveland Museum of Art, 1950.

The Cleveland Museum of Art. *The William Sommer Memorial Exhibition.* Cleveland: The Cleveland Museum of Art, 1950.

The Columbus Gallery of Fine Arts. *Paintings by Emerson Burkhart.* Columbus, Ohio: Columbus Gallery of Fine Arts, 1971.

Cranbrook Academy of Art Museum. *Jack Keijo Steele: Urban Realist.* Bloomfield Hills, Michigan: Cranbrook Academy of Art Museum, 1994.

Henning, William. *Adolf Dehn Retrospective: American Landscapes in Watercolor 1937–68.* Naples, Florida: Harmon-Meek Gallery, 1985.

Hirschl & Adler Galleries. *The Paintings, Drawings, and Lithographs of William S. Schwartz.* New York: Hirschl & Adler Galleries, Inc., 1984.

Horowitz, Fran. *Aaron Bohrod: Early Works.* Hopkins, Minnesota: F.B. Horowitz Fine Art Ltd., 1988.

Indianapolis Art League. *Floyd D. Hopper Retrospective Exhibition 1935–1969.* Indianapolis: Indianapolis Art League, 1987.

Kennedy Galleries, Inc. *Constance Richardson: Paintings.* New York: Kennedy Galleries, Inc., 1960.

Madison Art Center. *Aaron Bohrod: Paintings, 1965–1980.* Madison: The Madison Art Center, 1980.

Madison Art Center. *Santos Zingale.* Madison: The Madison Art Center, 1978.

Milwaukee Art Museum. *Joseph Friebert: Selected Works.* Milwaukee: Milwaukee Art Museum, 1989.

Minnesota Museum of Art. *Clara: Etchings by Clara Mairs.* St. Paul, Minnesota: Minnesota Museum of Art, 1976.

Museum of York County. *A Precisionist's View: The Art of Edmund Lewandowski.* Rock Hill, South Carolina: Museum of York County, 1992.

New Jersey State Museum. *Hughie Lee-Smith Retrospective Exhibition.* Trenton, New Jersey: New Jersey State Museum, 1988.

Parkersburg Art Center. *Emerson Burkhart: The Early Work.* Parkersburg, West Virginia: Parkersburg Art Center, 1986.

Schmeckebier, Laurence. *Zoltan Sepeshy: Forty Years of His Work.* Syracuse, New York: Syracuse University, 1966.

The Sheldon Swope Art Gallery. *John Rogers Cox Retrospective.* Terre Haute, Indiana: The Sheldon Swope Art Gallery, 1982.

Tarble Arts Center. *Paul Sargent, Robert Root and the Brown County Artists Colony.* Charleston, Illinois: Eastern Illinois University, 1995.

University of Wisconsin–Milwaukee. *Gerrit V. Sinclair: Paintings and Drawings*. Milwaukee: The University of Wisconsin–Milwaukee, 1982.

The Westmoreland County Museum of Art. *Clyde Singer: A Retrospective Exhibition of His Work From 1932 to 1972*. Greensburg, Pennsylvania: The Westmoreland County Museum of Art, 1972.

Youngner, Rina. *The Power and The Glory: Pittsburgh Industrial Landscapes by Aaron Harry Gorson*. New York: Spanierman Gallery, 1989.

CREDITS

Photography:

Charles H. Cloud III: Plates 1, 2, 3, 5, 7, 11, 13, 15, 19, 26, 29, 33, 37, 38, 41, 46, 51, 52, 53, 56, 57, 58, 59, 60, 61, 67, 70, 71, 72, 74, 75, 76, 77, 79, 80, 81, 82, 83, 88, 89, 93, 95, 96, 97, 103.

Paul Primeau: Plates 4, 6, 8, 9, 10, 12, 14, 16, 17, 18, 20, 21, 22, 23, 24, 25, 27, 28, 30, 31, 32, 34, 35, 36, 39, 40, 42, 43, 44, 45, 47, 48, 49, 50, 54, 55, 62, 63, 64, 65, 66, 68, 69, 73, 78, 84, 85, 86, 87, 90, 91, 92, 94, 98, 99, 100, 101, 102, 104, 105.

Conservation:

Conservation and Museum Services, Inc., Detroit, MI.
Ann Creager Paintings Conservation, Washington, D.C.
The FAR Company: Fine Art Restoration, Clarksville, TN.
McKay Lodge: Fine Arts Conservation, Oberlin, OH.

Consultants to the Collection:

David Lusenhop: Cincinnati, OH.
Nannette Maciejunes: Columbus, OH.

Interviews and Oral History:

Aaron Bohrod, Madison, WI; Edmund Brucker, Indianapolis, IN; Clarence Holbrook Carter, Milford, NJ; Joseph Friebert, Milwaukee, WI; Carl Hall, Salem, OR; Roman Johnson, Columbus, OH; Hughie Lee-Smith, Albuquerque, NM; Edmund Lewandowski, Rock Hill, SC; Phyllis Sloane, Cleveland, OH; Jack Keijo Steele, Dearborn, MI; Kenneth Wood, Cleveland, OH; Lois Zwettler Ireland, Hastings, MN.

Art Resources and Reference:

Rob Adams, Robert Henry Adams Fine Art, Chicago, IL; Tom Craig, Thomas Craig Fine Art, Pontiac, MI; Joe Erdelac, Joseph M. and Elsie Erdelac Collection, Cleveland, OH; Barton Faist, Barton Faist Gallery and Studio, Chicago, IL; Lawrence and Martha Fleischman, Kennedy Galleries, New York, NY; Ray Fleming, Robert Kidd Associates, Birmingham, MI; Fran Horowitz, F.B. Horowitz Fine Art Ltd., Hopkins, MN; Riley Humler, Cincinnati Art Galleries, Cincinnati, OH; James Kahllo, James Kahllo Fine Art, Shelbyville, MI; Mark Keily, Mark Keily Gallery, Dayton, OH; Diane and Rod Keys, The Keys Collection, Waterford, MI; David Klein, David Klein Gallery, Birmingham, MI; Ellen and Grant Kloppman, Vixseboxse Art Galleries, Inc., Cleveland Heights, OH; Wes Kramer, Kramer Gallery, Inc., Minneapolis, MN; Rex Lamoreaux, Rex Lamoreaux Collection, Pontiac, MI; Tom McCormick, Thomas McCormick Gallery, Chicago, IL; Richard Norton, Richard Norton Gallery, Chicago, IL; Dana Tillou, Dana E. Tillou, Ltd., Buffalo, NY; Jim and Randi Williams, Williams Galleries, Nashville, TN; Rudolph Wunderlich, Mongerson Wunderlich, Chicago, IL.

Research and Technical Assistance:

Georgi Bohrod, Carlsbad, CA; Ludger Brinker, Detroit, MI; Vince Carducci, Royal Oak, MI; Dave Chow and Marcyanna Parzych, Royal Oak, MI; Rane Hall, New Bedford, MA; Roger Hull, Salem, OR; Cece Kim, Chicago, IL; Albert Michaels, Buffalo, NY; Dennis Nawrocki, Detroit, MI; Sharon Theobald, West Lafayette, IN; Joan Zingale, Madison, WI.